B^D wRITINg

BAD wRITINg
TRAVIS JEPPESEN

SternbergPress

For Atmos

Contents

PREFACE

The relationship between content and form is at once parasitic and nurturing—and that's when the thing is going well. This conflictual zone of trappings and feedings can be found for sure in every great work of art—be it a film, a painting, a novel, or … a piece of art criticism. That it is unconventional, in the present day, to consider criticism an art speaks as much to the widespread devaluation of the form as it does to its qualitative lapse, its devolution from the pedestal of literary art to the workaday world of "mere" journalism at best, ad copy at its increasingly common worst. The pieces in this volume, first and foremost, aspire to retain and reflect that internal embattlement that once was, and should always be, the integrity-defining feature of criticism; more often than not, they attempt to amplify the antagonisms present in their formal construction, rather than relying on the concealment techniques of much softer and hence acceptable forms of criticism, of supposedly "good" writing.

Far from the random pluckiness of a "selected essays," these pieces, which were all composed in roughly the same five-year span when I was immersed in a particular line of thinking about these issues, reflect and refract one another. This is why I tend to think of them as *pieces*—they can be taken individually, but they also constitute a messy and painterly totality. No matter each piece's subject, they are united in being equally imbued with the same internal dialectic surrounding the situation of writing, and criticism in particular, in the era in which I live.

The pieces making up the first part attack this scene of writing most directly, though the prism of what I have come to think of as a *failuretics*. I attempt to locate the roots of this in the early twentieth-century avant-garde, in a certain tendency that has been eloquently phrased by Hal Foster as a "mimetic exacerbation" of the real. Dada as a showcase for this brand of badness is perhaps too obvious a referent here, and anyway, the silver-hot need most sensed in these pieces is for the return to a critical writing practice that is simultaneously an act of creation and invention, in the Baudelairean vein. Here, the modernist I turn to is Gertrude Stein, the first Bad writer, who broke the rules by writing about art as though she were writing a poem or one of her uncat-egorizable paintings-in-prose. Echoes of Stein's Bad practice continue to reverberate in such unwieldy places as Ryan Trecartin's early videos, as my piece on his *I-Be Area* attempts to evoke. It is in such Bad sites that the content-versus-form distinction is shaken so severely, it threatens to implode the frame containing the work altogether. What comes next? The froth of a postcritical sludge? And what is the role of the body in such a Bad context? Certainly a queer one—but not one that Gertrude, surprisingly enough, ever got around to articulating. It is a question I take up in the piece concluding this section, "Becoming Sobject."

Part 2, "Expressionisms," consists of monographic pieces about makers who are themselves very much embroiled in this metaphysics of badness. Many of them, like George Kuchar and Dieter Roth, subjects of the first two pieces, hitherto unpublished, were also deeply involved with the scene of writing, and, even deeper, with the failuretics of writing, which keeps returning as an almost obsessive theme in each of their respective oeuvres. Writing, as becomes patently clear at an early point in this volume, is not something that should be strictly under-stood in its mere conventional connotation of a literary practice, but as an *operative force* underlying nearly every endeavor in the field of making, and thus serves to shatter the categorical distinctions between media. Hence another definition of the badness that is at stake here: a lawlessness that forces us to realign our perceptions by shattering

them. The kind of badness we find in Winston Chmielinski's writing of the body via his paintbrush, in the landscape poetry rendered by the lens of James Benning's camera. Then there is the badness that tests the boundaries of what is consensually believed to be morally acceptable, what is meant to be palatable in the rarefied world of the aesthetic, such as we find in the work of Bjarne Melgaard—another artist for whom writing plays a pertinent role.

Finally, in part 3, we complete this circle with a blatant model of what a Bad writing process (my own) looks like. These pieces carry the double shame of being bad as fiction and bad as criticism. But they are really the simple and logical exacerbation of a mode that is found throughout all of these pieces—that tendency to *invoke*, rather than merely evoke or inform or contextualize, in a playful cognizance of language's great elasticity and plasticity as a tool of conveyance—a method, of course, that is always bound to fail—and that takes great, orgiastic pleasure in each instance of that failure. "The Object," which could nearly be considered a companion piece to "Becoming Sobject" of part 1, illustrates the extent to which that failure is nonetheless an assertion of the body-mind vehicle—and, by extension, this mode of working, of producing language-based works of critique. But finally, pieces like "Reading Capital in Venice" are also Bad in their willful defiance of the commodification of art criticism—a commodification that has enveloped every sphere of art, from the museum to the magazine—that has led to the gradual extinguishment of its life force. If anything, I hope that the badness that I have sluttily put on display here will go some small way, not towards a *revival*, but a *revivification* of the form. Because for some of us, at least, it never died.

I

B^D wR_I^T_I^Ng

I•

I• B^D wR_I^T_I^Ng

B^D wR_I^T_I^Ng

^D wR_I^T_I^Ng

I•

B^ᗡ wR[T[Ng

I•

I•

B^ᗡ wR[T[Ng

B^ᗡ wR[T[Ng

I•

B^ᗡ wR[T[N

FAILBETTER

Just as there are supposedly "eternal values" in art, there are also eternal vulgarities that permeate our civilization: the ugliness that cannot be contained. Those bits of dust and filth we sweep under the rug, store in our closets but don't quite throw out, with the hope that they will remain undiscovered, hidden. Those things our bodies do that we're conditioned to be ashamed of: those ugly acts that yield refuse—shit, vomit, spunk, menstrual blood, phlegm. Those thoughts we harbor but dare not speak aloud for fear of consequences that appear dire in our imaginations, that perhaps would actually result in harsh punishment were we to ejaculate them into the realm of the real. Certain artists take the initiative of pulling those nasty bits out and putting them on display, consciously choosing to set a bad example; to do things the obtuse way; to follow the wrong impulse in completing a work that is sure to be refused by all intended to consume it. To do so is to take not only an aesthetic stance, but a moral one, effectively putting forth a system of values that runs counter to dominant social values—so-called norms. To affirm what is otherwise, at best, negotiable. This is the stance of the historical avant-garde. Artists who have chosen to embark upon such a trek do so with the full knowledge that they are risking everything, including their standing in society, but march on ahead anyway, fully cognizant of the risks. Why do some feel it necessary to take such a stance? What does it mean to make "bad art"? How is one meant to receive a work that is, according to its author, intentionally made bad?

My thinking through these issues began around 2007, when I saw a Georg Baselitz retrospective at the Royal Academy of Arts in London. Around this time, Baselitz gave an interview in which he uttered a phrase that has haunted me ever since: "I started out by making deliberately bad paintings." As a writer who often finds inspiration in the visual arts, I began, as I often do, trying to translate this notion into my own practice: How might Bad painting correspond to Bad writing? Or, if we all have a fairly good idea by now of what Bad painting looks like, what might Bad writing look like? Is it possible for such a tradition to exist?

In 1963, Baselitz scandalized the German art world when he exhibited his fantastically bad painting, *Big Night Down the Drain*. The work was so effective in its badness that it wound up being confiscated by the district attorney on charges of public indecency and wasn't returned to the artist for another two years, once the judicial process came to an end.[1] *Big Night* can, in many ways, be employed as a useful model of badness. It is bad not only because of its content, but the manner in which it was executed. Bad aesthetically, bad morally; nothing good can come of this, in terms of its possible interpretations. The painting, crude in its simplicity, like all Bad work, is little more than a rendering of a nude dwarf holding his massive erect member: style and content competing in the ultimate gross-out. *Look away*, the painting seems to say, *or else be complicit in this stupid, adolescent joke*. Wallow in the perverse pleasure of the lack of redeeming value. The formalist hates it because it resembles, to invoke Robert Hughes's famous put-down of Julian Schnabel, a painting made by someone with five thumbs; the prudish, likely religiously uptight moralist despises it for its blunt sexuality; while the

1 "Working as an artist in Europe and especially in Germany, you have to react to what society demands of you. I experienced this on the occasion of my first one man show, at Galerie Werner & Katz in 1963 in Berlin. My paintings *Die große Nacht im Eimer* [*Big Night Down the Drain*, 1962–63] and *Der nackte Mann* [*The Naked Man*, 1962] were confiscated by the district attorney on charges of public indecency. It was not until 1965 that the judicial process ended and the works were returned. Compared with this, America seemed to me completely open and free of ideological pressures." Baselitz, interview by Pamela Kort, *Artforum*, April 2003.

politically correct individual condemns it for its abusive depiction of "little people."

It is telling that Baselitz could have alleviated the strain of the controversy by pointing to others who had made similar gestures before him in painting, by aligning himself with a tradition of badness. By giving what he was doing a name. By forming a group identity with artists who have done, or were doing at the time, similar things.

One of the qualities that seems to further isolate the Bad artist is an unwillingness—or inability—to identify with the flock. While others might have come to assign Baselitz's bad work to the archives of German Expressionism or international Neo-Expressionism, Baselitz himself has never admitted to being a card-carrying member of any movement. Like Gertrude Stein, who arguably produced a variant of badness in writing, Baselitz stood resolutely alone in proudly accepting the shame and dishonor his work was destined to bring upon his name: "Whenever I start a painting I set out to formulate things as if I were the first one, the only one, and as if all the precedents didn't exist—even though I know that there are thousands of precedents ranged against me. One has always to think of *making* something, something valid. That's my life." However hesitant she might be to admit it, the honest critic acknowledges that the vast majority of art and literary endeavor is executed in slavish conformity to established norms—often unconsciously so, but still; this is what used to be called "academic" work, but has now become so thoroughly subsumed into the flow of production and consumption that we have great difficulty in locating originality and greatness when it does occur. As Gary Indiana recently commented, "Filmmakers, artists, every kind of cultural worker in the global capitalist system is compelled to internalize templates imposed by the apparatus of production and distribution. The bureaucracies that operate the consciousness industry now only allow 5 percent of originality into its menu items, so to speak, and what that means is, if you want access to mainstream markets, the bureaucracies tell you

what to write, how to write it, and what ideas are acceptable and which ideas aren't allowed."

If this process has become nearly unconscious by now, what can one do—as an artist, a writer, a critic—to counter such a trenchant, pervasive situation?

John Ashbery once gave a lecture at the Yale School of Art on the subject of the historical avant-garde, in the course of which he asked why Jackson Pollock is considered a great artist while Norman Rockwell is essentially a kitsch illustrator. In formulating this question, Ashbery arrived at the best definition of art I've heard to date. Pollock, he reasons, is great because no matter how much praise was eventually heaped on him by the art establishment in his lifetime and thereafter, there remains something fundamentally *unacceptable* about his work. Ashbery goes so far as to suggest to his audience of young artists that, in the event their work is received in the light of universal praise and acclaim, they might want to consider asking themselves whether there is something *wrong* with their work.

The artist who is skeptical of praise, for whom praise motivates them to do the exact opposite of that which has been praised—and effectively follow the *wrong* impulse—comes from the same moral universe as the philosopher Friedrich Nietzsche, who famously wrote, "I am by far the most terrible human being that has existed so far; this does not preclude the possibility that I shall be the most beneficial. I know the pleasure in *destroying* to a degree that accords with my powers to destroy—in both respects I obey my Dionysian nature which does not know how to separate doing No from saying Yes. I am the first *immoralist*: that makes me the *annihilator* par excellence."

Doing no, saying yes: affirming the negative. Nietzsche suggests that consciously going against the grain entails making a positive contribution to humanity. A dangerous proposition, for sure—at what point does one draw the limit?—but one that many of the artists and writers I'm most interested in would also stand behind.

If we are to use Baselitz's painting as a template for badness in visual art—that is, it is bad on at least three levels: morally objectionable; politically questionable; aesthetically unpleasing—then we might wish to examine how this might apply to other practices—in our case, writing. In order to identify the Bad, however, we must first figure out what *good writing* is meant to be.

The criterion seems to be very simple. In a word, it is all about clarity. In his 2010 piece "The 15 Most Overrated Contemporary Writers" for the *Huffington Post*, Anis Shivani offers definitions of good and bad writing: "Bad writing is characterized by obfuscation, showboating, narcissism, lack of a moral core, and style over substance. Good writing is exactly the opposite. Bad writing draws attention to the writer himself."

It is important to note that this notion—which, we might venture to infer, is reflective of the wider sensus communis—is at odds with what our conception of good art might be. Or at least Ashbery's definition of good, lasting art. One might argue that Pollock's work is good because of its obfuscation, its showboating of the painter's skill, its narcissistic deployment of the ego within the splatter, its moral ambiguity, and the fact that it privileges pure style above all else. Above all, Shivani argues that clarity is the hallmark of good writing. There are resonances of this in art criticism, however. One need look no further than the late Robert Hughes, who in his final documentary, *The Mona Lisa Curse*, argues that good art evokes clear emotions. Good art need not necessarily *be clear*, as Shivani's definition of good writing affirms, but capable of *evoking clarity* in the viewer. One of Hughes's favorite artists, for instance, is the notoriously messy Robert Rauschenberg. In other words, you would never find Hughes arguing against obfuscation and obscurity in art as Shivani does in literature.

Here, we have to contend with the assertion constantly brought forth by the American Language poets and echoed by their self-asserted descendants, the Conceptualists: that literature is at least fifty years behind art. What's annoying about this is how it gets played out.

The Conceptualists' response has been to essentially apply, verbatim, the techniques of post-Duchampian Conceptual art to literature (and then, of course, send out the mass press release that the latest phenomenon in literature has arrived. At least this proves that they also learned a thing or two from the Futurists). This is naturally permitted by the crustified dictates of postmodernism that instruct us that no further originality is possible—only mixing and mashing and "play," whatever that is.

The issue that this brings to light, however, can perhaps better be stated by saying that *critical interdisciplinarity* is still too radical a gesture in our culture to be accepted by the majority—no matter how advanced we perceive ourselves as being. This points to a failure to apply a wider, more inclusive form of metaphorical thinking in the critical realm—which, of course, is also always the *self-critical realm*. (I'm a firm believer that criticism always begins with the self; thus, every great artist must also be a great critic.)

Our culture associates "goodness" with "clarity." (Religious implications abound here.) Again, it's a problem of interpretation. Perhaps there will always be a happy majority that looks to art to *make sense* of things, to impose some artificial system of order on the world. They will always find solace in the type of art they are looking for—this "good" art, this "good" writing.

But the supposed clarity perceived within or evoked by such work is illusory. You can't work *against* the chaos and noise of the world, only *within it*. As Jean Dubuffet often said, the only worthwhile way to do things is the *wrong* way.

I'm not against "clarity" because I'm a nihilist who believes that there is nothing left to express. I'm against it because I'm an optimist who believes that there is *too much* to express; and all of this excess meaning can and must be expressed—and why not try to do it *at one and the same time*?

I can't help but wonder what Shivani would think of this excerpt from C. Bard Cole's 2008 novel, *This Is Where My Life Went Wrong*:

Watch her squirt buckets cum covered teen honeys watch her choke on cum squirting cum cocks hot Teen sluts split wide and juicy Cum hunk slut squirts. Cum slut cum teen squirts Juicyhunks sluts gargantuan cum squirts Watch cum teen cam squirts juicy splits Hot cumming juicy squirt sluts Squirts covered hunky teen sluts Watch my teen honey juicy split gargantuan cums cam Squirt juicy hunks teen splits slut cam Watch teen sluts cum cam Hot teen hunks cam squirt cum teen cum buckets Juicy cum squirts gargantuan teen hunks split juicy sluts cam.

He gave her a long, juicy taste of his magic lollipop. It was an all-day sucker. She gobbled down the sweet nectar. She would never be satisfied with just a taste. She wanted all of it inside her parched, hungry throat. This is true. She really liked lollipops. On the other hand, one thing she disliked a lot was penises.

Billy was the smallest player on the team, but when the guys kicked back to play some more relaxed games, he showed what a great receiver he could be. Even when he got pounded over and over, he sprang right up, ready for the next guy to have a go at him. He loved nothing better than getting a workout and building up a sweat going head to head with the big guys. By the end of that session, he was wet from head to foot and boy did he feel sore. The soreness gave him trouble later that evening, when he went to a gay sex club and fifteen guys ran a train on him. Billy made a mental note never to play football and bottom at a gay orgy on the same day.

Tommy started off his English class doing good work & pleasing Teacher, but he just could not keep it up all semester. Disappointed, Miss Brown asked what his problem was—did Tommy need special attention? A more personal touch? Tommy eagerly agreed and for the next two months Miss Brown took the reins and drove that boy harder than he'd ever been driven before. Her one on one efforts made him say with a smile that he never thought he'd enjoy being ridden by a teacher! Ridden hard and whenever he wanted to quit she said no, fighting back and taking him to the next level. And it must be said that Tommy was Miss Brown's favorite pupil too. It was her last year

teaching junior high—she had reached the mandatory retirement age of 65. She gave Tommy a nice pen and pencil set.

Mister Joju hairy potto. A nickel bag of hope. A nickel bag of pussy. A nickel bag of dereliction of duty. A nickel bag of angina. A nickel bag of diarrhea of the mouth. A nickel bag of Mediterranean style consoles. A nickel bag of pork. Squeeze one's nut. Chasm one's peccary. Notch-puncture one's Frenchman.

Is it good or bad? Well, it seems pretty *clear* to me, so it must be good! Like Gertrude Stein, another supposedly "difficult" writer, Cole takes clarity to the most extreme and absurd lengths in order to put forth a statement on what writing has become in this new century.

Here, the organizing principle is the paragraph, with each one, like a swath of a clashing color of paint, lining the surface, dispelling all notions of narrative continuity. The first and last paragraphs do away with narrative altogether: the former a performative or replicative response to the overboard "SEO" writing one could find on porn sites in the early days of the internet, the latter a nonsensical list poem that calls to mind both Lewis Carroll and Bruce Andrews. In between, we find three miniatures that mine the lowest form of writing, classic smut, only to end in jokes with dubious punch lines. This is the sort of writing Rabelais would be doing in the twenty-first century.

Shivani's attempt to entangle an author's perceived narcissism with a tendency toward obfuscation implies that the novelist, unlike other types of artists, is required to participate in, and thus validate, those social conditions that enable the sustenance of false universals, the maintenance of a humanism rooted in a sense of collectivity that no longer exists. (How can anyone seriously speak of humanism when we are already at least halfway into the process of becoming machines?)

Interestingly, Ashbery's own poetic work is often charged with being obtuse and difficult to read—the furthest thing from clarity or a "clear emotion evocator" one might conjecture in poetry—though

he is among the most celebrated living poets in the United States to-
day. It is not insignificant that his lecture cited above was addressed
to a group of art students. Poetry and visual art: realms where ob-
fuscation is permitted, even rewarded; the novel, prose: that place
where only "clarity" is allowed.

But when the novel begins to ignore the noise of culture, and,
to be precise, the inherent *badness* of much of the prose that fills our
daily life—whether it be in the lowering standards of journalistic dis-
course, chat-room blather, off-the-cuff grammatical idiocies on message
boards, or the abbreviated emoti(c)ons found in text messages—then
the novel is bound to drown in the depths of irrelevancy.

Of course, this position veers close to Hal Foster's reading of Zurich
and Cologne Dada as an attempt to come up with an art form that
elicits all of the absolute worst aspects of the world. There is a lot of
joy, indeed, in such a destructive project.

The difference is that due to current (and, most likely, perma-
nent) social conditions, a relatively major aesthetic uprising such
as Dada is no longer possible, or perhaps even desirable. We have
been inoculated against this risk with the drug of technology, not to
mention the selfish desperation that takes hold as capitalism takes its
last gasps from its diseased lungs—a symptom that manifests itself
clearly in the rampant careerism and status obsession that is one of
the chief characteristics of Western society today.

Yet we can no longer ignore the noise that suits this, our new
century, best. It is no longer machinic, industrial, military—it is,
but it is so much more. It is the noise produced by a perpetual state
of distraction, depleted economies of attention, an inability to focus
through a narrow tunnel on the finality of an ultimate destination.
The movement will become increasingly frenzied, the gaps wider
as the century proceeds. Just as one would look ridiculous today at-
tempting to paint in a neoclassical style or pen Romantic poetry, the
same could be said for novelists and critics like Shivani who remain
attached to the nineteenth-century model of the realist novel, great

as it was, or even the gags and gimmickry of postmodernism. What is left is what previous novelists have worked to avoid, and what artists like Baselitz have worked toward: failure.

When evaluating the Bad, the question we will continuously be forced to confront is that of tradition. The modernists grappled with tradition—what it stands for and what to do with it—and found many different possibilities, which is reflected in their individual oeuvres. Ezra Pound, who started off as the most traditional of all modernist poets, penning an absurdly outdated poetry, eventually cast off those chains and emerged as one of the most radical, backed by his famous dictum, "Make it new." One writer who really *did* make it new from the beginning was Gertrude Stein, whose style resembled nothing seen before. In the two writers, we have two very different modernisms: the high or traditional modernism of Pound, the low or radical modernism of Stein. James Joyce is an exceptional figure in and of himself, as his books up to and including *Ulysses* could be consigned to the former category, while *Finnegans Wake* sees the novelist breaking off into uncharted, dangerous territory: Bad writing.

Bad, in that it works *against* tradition. Or does it? No writing or art is made in a vacuum. When a writer like Philip Roth sets out to write a novel, it may be surmised that he is consciously writing toward a specific Anglo-American tradition. When Baselitz sets out to make a painting, he is also working toward a tradition, albeit a rather more dubious one: that of being anti-tradition. This would certainly be the case with a work like *Finnegans Wake*, that most obfuscated of novels.

Then again, in the midst of his ordeals with the German police and legal system, Baselitz could have eased the strain of the controversy by pointing to others who had made similar gestures before him, aligning himself with a tradition, thereby giving what he was doing a name. Or even by assigning himself a group identity with

artists doing similar things—an avant-garde of his own era.[2] Instead, he refused and stood resolutely alone, accepting the burden spurred by the badness, the unacceptability of his work—much like Joyce and Stein, both of whom were certainly aware of the activities of the Surrealists in the Paris of their time, but never attempted to become members of the group.

This, I believe, speaks to the specific mindset of the Bad artist. History, culture, tradition—these are all things that art may certainly respond to and work with, but when the author sits down to write her novel or build her sculpture, she is still creating her own universe and working within her own confines, which are inevitably the confines of lawlessness. The Bad artist responds to the conditions of her world by violating them. This is a conception of criminality—always individual, never collective—that often results in a renewal of the form in which one works. This brings a bit more depth to the project of obfuscation that Shivani is so eager to write off; as Bernadette Mayer writes in her 1983 statement on poetics, "The best obfuscation bewilders old meanings while reflecting or imitating or creating a structure of beauty that we know."

In a word, the duty of the novelist is to reinvent the novel each time she writes one.

It could be objected that my position is not a new one. Perceptive auteurs, it may be argued, have always been able to see where they stand. In his film *JLG/JLG – Autoportrait de décembre*, Jean-Luc Godard spells it out for us: "Culture is the law. Art is the exception." Culture is everything we see around us: cigarette packs, advertising, television jingles, commentary—the regulatory noise of our civilization. Art, which takes place within that structured noise, does not abide by its rules—each individual work abides by its own law, making it the product of a certain lawlessness. Taken further, this positions the artist on the same platform as the criminal. It should thus come

[2] This is not to suggest that others haven't assigned Baselitz's work to the archives of German Expressionism or international Neo-Expressionism, just that Baselitz himself has never admitted to being a card-carrying member of any movement or genre.

as no surprise that one of the defining characteristics of great artists, such as Dostoevsky, has been a concern with moral issues. The artist must create her own moral universe.

As a writer, I am still naive enough to believe in the figure of the artist-revolutionary. But this naivete is balanced with the recognition that revolutions caused by art are seldom acknowledged at their inception by the wider cultural milieu—how could they be if they are, as I stated above, illegal, unacceptable, *wrong*. Badness is, among other things, an evolutionary point: the changes that the Bad artwork impels thus occur at a rate comparable to that of the shift in tectonic plates beneath the earth's surface. But something is always moving, even if we can't see or feel it. Anyway, it takes a long time to train our eyes to look in the right place.

This is a very different way of creating revolution, one that necessarily avoids politics and collectivity, and celebrates the power of the individual consciousness while simultaneously rebuking both the traditional bourgeois conception of the alienated urban individual and the quasi-fascistic cult of personality that continues to be celebrated wherever art is publicized.

Where the life of the mind is concerned, totalitarianism has already triumphed, and its benefactor has been American-style democracy. This is widely reflected in the styles that are most celebrated and consumed in our culture. Those in the margins cry out in response: Enough cynicism, enough irony-coated "minimalism," enough anti-intellectual hipster posturing. Up with the anarchy of the signifier, with the creation of new myths, with momentary lapses of cognition, with an embrace of psychoses, with an outpouring of unmitigated sexuality—in short, with the freedom that can only be found in the realm of the imaginary. The imaginary, as forged through a "mimetic exacerbation" of the real.[3]

This is not merely an exercise in identification, but a celebration and a call to arms. It proposes that whereas twentieth-century

[3] Again, Hal Foster.

modernism was rooted in the idea of self-creation, a twenty-first-century modernism might be about self-abnegation, or, to be precise, an abnegation that accomplishes itself via the projection, and subsequent implosion, of a multiplicity of selves through the work we do. The machinic entropy that embroils us will increasingly dissolve and erode the divisions between culture and art, life and work, subject and object, until an embrace and a positive extrapolation of failure and all its multitudinous variants becomes the only possible way forward.

—

Zombie Criticism

A silver surface presents itself: Jacob Kassay's *Untitled*. A brief, cursory glance yields an immediate dismissal: it is but another monochrome, a type of painting we are long accustomed to seeing, one that reached its peak of novelty or radicality long ago. Yet by forcing yourself to look long enough, to enter into the painting and the world it postulates, a whole other reality emerges. You discover that the painting is not flat at all, and behind the illusion of depth created by a series of contrasting hues within that single color, silver—a depth evoked in the way the darkness of the left side bleeds splotchily into the right, crescendoing into a brightness approaching pure white—a whole range of mysteries becomes visible. Is that an image, perhaps a face, struggling to emerge from beneath the blanket of color? Whatever it is, it is spectral. It is presence itself, yearning to break through the surface into a coherent and enunciated form, yet trapped in the confines of withdrawal, of feigned existence.

Kassay is one of the painters charged with producing "zombie formalism," which has become something of an art-world buzz phrase in recent years, derogatorily referring to (mainly younger) artists engaged in abstract painting. The essence of the argument, introduced by art critic Walter Robinson and popularized by his colleague Jerry Saltz in the widely read essay "Zombies on the Walls," is that all these works look the same, their manufacture is simple, they are devoid of originality and craftily deployed to fulfill a market

craving that resonates with high-end contemporary interior design. That they are, in some essential sense, trite and superficial.

Why critics should be so troubled that artists are continuing to make abstract paintings as they have done for decades (centuries, we might argue …) is something of a head-scratcher. Art critics often seem more concerned with chasing down and announcing the latest trend rather than aligning themselves with a style or movement that risks eventually going out of fashion, as all art does eventually (and/or temporarily). Paradoxically, their pronouncements are often killed by the speed of the market. (A gallerist recently explained to me that the life span of art-market trends is currently two to three months.) This kind of flippant criticism, the criticism of the social media circus, is similarly fated; much like the simple substitute language of the emoticon, it produces a pseudo-affect that evaporates not long after its (digital) inscription.

To me, such an eager dismissal seems emblematic of what I have come to think of, in turn, as zombie criticism. And it is dangerous because it discourages the depth of engagement that might uncover real drama and possibility in such work. Abstract painting presents writers with a wonderful gift: the impossible task of translation. In its purest form, abstraction is that intimate field where the process of inquiry plays itself out while simultaneously documenting the artist's path from knowing through unknowing, to its ultimate arrival on a hitherto unperceived plateau of visual enunciation. ("I think I'm painting a picture of two women," Willem de Kooning once said, "but it may turn out to be a landscape.") Abstract painting demands more from the viewer, since it speaks its own invented language. Meaning is not spoon-fed, there are no clear metaphors; rather, such painting attempts to develop its own unique code, with hidden, often private references and associations. Instead of attempting to decode a painting's private universe via speculation or reliance on the painter's biography, one has the opportunity to delve into painting's ontology. Such a premise entails journeying away from one's preconceived intellectual

universe, a process described by Jean Genet in his study *The Studio of Giacometti*: "In order to better tame the work of art, I habitually use a gimmick: I put myself, a little artificially, into a state of naivety, I talk of it—and I talk to it, also, in the most everyday tones, I even baby-talk a little [...] 'What a laugh that is ... that's red ... that's some red ... and that's some blue ... and the paint, it seems as if it's mud.'"

Naturally, abstract painting endures and is widely practiced; what is so often missing from current criticism, however, is the sense of play that animates painting and the other arts. Play, that is, in the serious sense of the term: an exploration that leads to discovery. There are those who would object that criticism is not an art form; I would disagree. Even if there are very few examples to turn to in the present, there are plenty in history. While the poet-critic model has existed from the onset of modernism with Charles Baudelaire, it was Gertrude Stein, in writing about art, who first had the ambition to use language as a way to evoke the dominant abstract painting style of her time: Cubism. "A brown subject is seen by the color. The red which is there is dark. The blue is that color. If the time is a sensitive celebrity then a piece of the paper is essential." This is writing that flat-out rejects the quadrality that most art criticism consists of, as analyzed by Sally O'Reilly in her essay "On Criticism": description, contextualization, interpretation, and judgment. Rather than be content with writing about art, Stein served as something of an external collaborator with the artists and artworks she loved, rendering her own literary abstraction as a work of art that could coexist with painting on a parallel plane. Alternatively, one could say that she played the role of medium channeling the metaphysical essence of a painting, and translating it into human language. When one is unwilling or uninterested to pursue this sort of intense relationship with abstraction as a language, the result can only be a form of zombie criticism, which represents a giant missed opportunity for both artist and writer.

Bad wRiteR

In writing her near-thousand-page novel *The Making of Americans* over eight years, Gertrude Stein came to realize that *incorrectness* was actually the *correct* form for her novel. That is, she had what we might term realistic expectations of the novel's potential readership, anticipating the work's status as one of the twentieth century's great unread books. Considering those who might actually make it to the end of the seemingly endless text, she writes, "lots of people will think many strange things in it as to tenses and persons and adjectives and adverbs and divisions are due to the french compositors' errors but they are not it is quite as I worked at it and even when I tried to change it well I didn't really try but I went over it to see if it could go different and I always found myself forced back into its incorrectnesses so there they stand." As one of Stein's earliest literary projects, it could be seen as an announcement of her later style after the completion of her first published book, *Three Lives*, which, with its retainment of plot and conventional syntax, was comparatively *correct*, though its employment of repetition and the singsongy rhythms already enunciate the Steinian voice.

What's more, *Three Lives* already shows the influence of the painters that she had befriended and whose work she collected, as one of her biographers would later note:

> The stylistic method of [*Three Lives*] had been influenced by the Cézanne portrait under which she sat writing. The portrait of Madame Cézanne is

one of the monumental examples of the artist's method, each exacting, carefully negotiated plane—from the suave reds of the armchair and the gray blues of the sitter's jacket to the vaguely figured wallpaper of the background—having been structured into existence, seeming to fix the subject for all eternity. So it was with Gertrude's repetitive sentences, each one building up, phrase by phrase, the substance of her characters.

This painting, which Stein and her brother acquired in 1904, was included in that year's scandalous Salon d'Automne, which saw Cézanne and his fellow modernists ridiculed by an uncomprehending press; such summations of Cézanne were typical: "Sacred, crude, violent, sincere, ugly, and altogether bizarre canvases. [...] Here the results of a hard laboring painter, without taste, without the faculty of selection, without vision, culture—one is tempted to add intellect—who with dogged persistence has painted in the face of mockery, painted portraits, still life, landscapes, flowers, houses, figures, painted everything, painted himself ... Cézanne has dropped out of his scheme harmony, melody, beauty—classic, romantic, symbolic, what you will!—and doggedly represented the ugliness of things."

As a collector of such works, Stein was clearly cognizant of her position as part of an artistic vanguard that found value in the denial of consensual aesthetic norms—in dubious representations of "the ugliness of things." Even before she turned her attention to writing directly about art and artists, one finds in Stein's earliest work the origins of object-oriented writing, as opposed to art criticism. Even Stein's critics concede that her seemingly "irrational" writings were rooted in her engagement with visual art practice. "It is important for our theory," writes B. F. Skinner, "that between 1896 and 1912 Miss Stein had come to know Picasso and Matisse and was already long in the practice of defending their work against the question, 'What does it mean?' With such an experience behind one, it is not difficult to accept as art what one has hitherto dismissed as the in-

teresting and rather surprising result of an experiment. It was, I believe, only because Gertrude Stein had already prepared the defense as it applied to Picasso that she could put forth her own unintelligible product as a serious artistic experiment. For a person of the sound intelligence of Miss Stein there is a great natural resistance against the production of nonsense."

Even writers friendlier to Stein's work, such as Edmund Wilson, concluded that the key to understanding it lay in its author's preoccupations with modernist painting. Though it is doubtful that Stein thought of her writing in such straightforward, rationalistic terms. There is a danger inherent in the methodological comparison. Her approach to writing was not *imitative* of contemporary painting in the way contemporary critics—both those friendly and unfriendly to her work—took it to be; neither art form justified the ways and existence of the other; the autonomy of each was asserted through its individual practitioners' approaches. Rather, there was a processual corollary between the painters associated with modernism who took painting itself to be their main subject, and writers like Stein (though fewer in number) whose subject came to be language itself; whereas the classical painter might attempt to *represent* nature in his canvases, the modernist painter, working in the language of abstraction, might attempt to *embody* nature. Thus, the tools are stripped down, reduced to their essence: raw paint, and for Stein the writer, naked language, as her friend Bravig Imbs characterized it, and which scholar Ulla E. Dydo defined as "the result of a process of reduction accomplished by punning with elements of sound and sight, which shakes up stable syntax and meaning."

Indeed, works like Stein's "writerly" texts, as Roland Barthes once termed them, require a new method of reading—one that entails a more active engagement on the part of the reader in producing meaning. Here, we might look at one of the most drastic examples of the transformation of visual motifs into literary ones in Stein's writings: *Tender Buttons*. This series of poems, written in prose and

divided into three sections (Objects, Food, and Rooms), allowed Stein to render her own abstract pictures, to embody her subjects via words. Most of the texts are very brief:

RED ROSES.
A cool red rose and a pink cut pink, a collapse and a solid hole, a little less hot.

As radical as such an approach toward language seems today, one can only ponder how it must have felt to read such a text in 1914, when the book was first published. The title refers to the object—red roses—in the plural, and yet the lone mention of roses in the body of the text leaves it in the singular: "a cool red rose." Certainly a single red rose has a different meaning than a bunch of roses; a dozen red roses, for instance, is a traditional symbol of love, romance, marriage. A single red rose can have a plurality of meanings, from the inference of a flirtation to a funereal symbol of desolation, loneliness, and despair: already a disparity, a lot going on, in this simple, bizarre snippet of language. But the first phrase of the poem—"a cool red rose"—actually makes the most conventional sense if we are to consider what comes next—"a pink cut pink"—united by the connector "and." We can assume that the "pink" Stein is referring to here is also a rose—though it could also be another type of flower, a carnation (carnations are also known as clove pinks); in making the unconventional decision to repeat the (new) adjective, rather than the noun, the image produced by the text is effectively blurred (much like the visual effect in paintings that wish to evoke a sense of memory or nostalgia in the viewer). Next, we have "a collapse"—we're not sure of what. Perhaps the person being given the red and pink roses? Or: a collapse of meaning?—and a "solid hole." Perhaps she first wrote "whole," then decided to reject her initial impulse in order to shake things up a bit, to introduce a bit of semantic texture into the proceeding, to imbue the line with a singularity that allows it to stand

on its own—as a poem, as a sentence. (From Dydo's study of Stein's notebooks, we know that this sort of wordplay was rampant in her writing process.) It ends "a little less hot," of course, to set up a contrast with the coolness introduced at the beginning of the line; in other words, edging back towards cool. This shows that it really is a line: for a line begins in one place, and ends up in quite another. This is literalized by two opposing poles on the end—cool and (less) hot—but in a subtler way by what those two poles "contain," namely, the roses, the collapse, and the hole: roses collapsing into a hole, so that the directional flow of the line is simultaneously a going *forward* and an *inward* collapse:

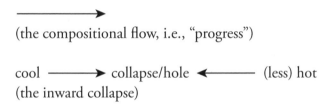

(the compositional flow, i.e., "progress")

cool ———▶ collapse/hole ◀——— (less) hot
(the inward collapse)

As the painter Agnes Martin wrote, "In reality there are no leaders or followers. Everyone is on his own private line." Here, the line—the stroke, that vivid entity that enables the "progress" with which Stein was so obsessed—is illustrative of the extension principle that we also see in the work of artists like George Kuchar and Dieter Roth, where mind is but an extension of the body; united, the body-mind forms a vehicle that flows across the page/canvas/landscape (one of Stein's obsessions: geography).

But first, let's turn our attention to something else going on in *Tender Buttons* that begs consideration. Remember that association of Cézanne's planes with Stein's sentences? One could define the chief characteristic of Stein's most radical writings as a preference for a spatialized, rather than temporalized, writing: that is, the utilization of a flat, planar, present-tense language, repeated seemingly endlessly at times (especially in *The Making of Americans*) as a means

of rendering what she perceived as the flat horizontal plane of the American landscape in language. This spatialization of language and its connection with the authorial body, the body-mind vehicle, is also observed by William Gass in one of his essays on Stein:

> Books contained tenses like closets full of clothes, but the present was the only place we were alive, and the present was like a painting, without before or after, spread to be sure, but not in time; and although, as William James had proved, the present was not absolutely flat, it was nevertheless not much thicker than pigment. Geography would be the study appropriate to it: *mapping body* space. The earth might be round but experience, in effect, was flat. Life might be long but living was as brief as each breath in breathing. Without a past, in the prolonged narrowness of any "now," wasn't everything in a constant condition of commencement? Then, too, breathing is repeating—it is beginning and re-beginning, over and over, again and again and again.

This is arguably best illustrated in Stein's plays, which she regarded as landscapes. With the plays, one really sees the conflict between spatiality and temporality playing itself out. This grew out of a discomfort Stein discusses feeling as a young theatergoer:

> Your sensation as one in the audience in relation to the play played before you your sensation I say your emotion concerning that play is always either behind or ahead of the play at which you are looking and to which you are listening. So your emotion as a member of the audience is never going on at the same time as the action of the play.
>
> This thing the fact that your emotional time as an audience is not the same as the emotional time of the play is what makes one endlessly troubled about a play, because not only is there a thing to know as to why this is so but also there is a thing to know why perhaps it does not need to be so.

The discordancy between the lived time and the *playing out of the thing* of the framed "lived experience" gives rise to a psychological distress in Stein. The violence of this conflict, Stein goes on to argue, was recognized by certain musicians, enabling the invention of jazz. Ahead or behind, but never in simultaneity. (This experience is the same not only for the audience members, but for the actors taking part in the spectacle, as well.) One might argue the same, even, for the reading of a novel, though it is a markedly dissimilar experience with different possibilities. Theater and music, live art forms, exist mostly in the temporal sphere, while painting and the novel can have both temporal and spatial tendencies. Painting, in fact, is mostly spatial: the conflict between flatness and depth, as played out among Clement Greenberg and his cohort. The novel, in conventional, linear narrative mode, is temporal. What Stein was aiming for in much of her writing, however, was a spatialization of the novel as form. She was the first American novelist to bring abstraction into the field. "American abstraction is not, however, the product of American family history," argues Steven Meyer in his introduction to *The Making of Americans*; "rather the form that American family histories generally take, the peculiar 'progress' recorded in *The Making of Americans*, is itself the product of American abstraction, an abstraction rooted in what Stein characterized as 'the geographical history of America.'"

At the same time, there is a temporal element that features prominently in the writing; it is the effect of repetition; the *breath* of the body-mind vehicle, as identified by Gass in the quote above. Oftentimes, Stein's writing comes across as singsongy in its frequently monosyllabic repetitions. Yet through this repetitiveness, a new way of reading, of absorbing language, emerges in the experience—similar to a trancelike state. This is particularly true once one reaches the latter pages of *The Making of Americans* where the excessive repetition/breath ... hyperventilates, essentially; where paragraphs like the following form an extended landscape:

> Some of these certainly have not been ever married ones in living, some of these have certainly sometimes been married ones in their living, some of these certainly have been sometimes married ones in living. I am thinking about some who are living. I am thinking about a good many who are living. Some who are living are going on being living, some who are living are not going to be going on being living. I am thinking about a very great many who are living, some of these are liking very well being in living, some are not really liking it that they are being in living. I am then thinking very much about a great many who are living. Some of these as I have been saying have in a way sense in being in living, some of these as I have been saying have in a way not sense really for being in being living. Some of these as I have been saying are living just now and I am knowing them just now when they are doing this living, some of them are certainly living just now and I am not knowing them just now doing their living. I am then certainly just now thinking about very many men and very many women being living.

The resulting perceptual alterance, similar in some ways to a hallucinogenic trip or a temporary state of insanity, allows for new forms of meaning formation to occur. Anyone who has tried to make their way through *The Making of Americans* will tell you that what Stein was endeavoring to create was not merely a language in the "literary" sense, but also a language that was very much visual and sonorous. We might say that one of Stein's chief concerns is with *definitionality*— that is, the creation of new meanings via a spatialization of language. "So sustained is a paragraph that a sentence shows no staring and some noise." Evaluating the title of Stein's third published book, *Geography and Plays*, and the contents to which it refers, this notion of definitionality becomes clearer. Though it's ostensibly a collection of Stein's shorter writings, surveying the table of contents, one finds a variation, in no discernible order, of prose-poetic texts, portraits, "plays" (in which conventional markers such as characters, dialogue, and

stage directions have been omitted), but also—and here is where
the "geography" of the title comes in—a smattering of texts bear-
ing place names and nationalities: "France," "Americans," "Italians,"
"England." What all of these texts have in common is that each
seemingly neglects to explicitly mention the land or group of people
named in the title; rather, "France," for instance, is comprised of
paragraphs meditating upon particular objects and actions, with no
discernible subject connecting the paragraphs. At the same time,
taken together, we must assume that the composite forms an image or
an inference of France, for that is the title Stein has given the piece.
In other words, what we have here is an instance of object-oriented
writing: an invocation of the metaphysical (geographical) *essence* of
France—a writing that positions itself within the *object* of France—
produced by the body-mind vehicle known as Gertrude Stein.

Stein's chief tool in the endeavor of definitionality was the line.
An affinity could be expressed between Stein's lines of prose and the
painted lines of an artist like Agnes Martin. Like Stein, Martin was
something of an automaticist—that is to say, a very ritualistic artist,
one for whom the extension principle (the body-mind machine)
governed the creative act. Out of the order of creation comes the
ordered chaos of the product; this type of artist is the disciplined
nomad. As another commenter put it, "Stein herself came to believe
that in the United States space and time were uniquely structured as
regions through which Americans wandered without fixed itineraries
or set endpoints." The point, of course, was the wandering itself, and
Stein was a most disciplined wanderer, sticking to the same routine
throughout most of her life of writing through the night, going to
sleep as the sun rises, at which time time Alice B. Toklas would
rise and type up the previous night's jottings. Stein's method, her
vehicularity, hardly left room for revision, a facet of writing that she
avowedly was never fond of; the point was to keep going—even if
it meant it was "detrimental" to the work. *The Making of Americans*,
Ernest Hemingway would later write, "began magnificently, went

on very well for a long way with great stretches of great brilliance and then went on endlessly in repetitions that a more conscientious and less lazy writer would have put in the waste basket." Of course, for Stein, the method and purpose of writing *Americans* in this way was intentionally quantitative and thus spatial. If Stein spatialized the novel, Martin, the daily intensive painter who similarly shirked romantic notions of "waiting for inspiration," temporalized the canvas by reducing the depth of field and repeatedly applying horizontal lines, hence the sonorous-temporal usage of repetition in both the artist's and the writer's work, issuing forth from exquisitely programmed body-mind vehicles.

Both, we should note, managed to accomplish this despite the burden of occupying feminine vehicles. While Martin benefited from a slightly later era, Stein came of age during a time when in order to be an artist, one first had to occupy a man's body. Gender politics was not a game Stein would ever be interested in playing. Her vehicularity was too flexible to ever require the convenience of a label ("lesbian," "feminist," "suffragist," "woman" …). When necessary, she could just as readily occupy the space of "man." When famous male artists or writers called on her, she would often go into a separate room with them, while the wives would be expected to entertain themselves in the company of Stein's own wife, Alice. Becoming-man, and yet not: although she could flexibly speak of herself in the masculine tense, jokingly and seriously at once, she never renounced her simultaneous femaleness. This is where the act of becoming crosses over into some- thing that nearly entails transcendence, though it takes place on the earthly plane. It is close to what religious zealots call a "leap of faith" or a shamanic possession, though it takes place without ceremony and with an eye toward sustenance rather than the disorder of leaving one's selves/self-structure behind.

The vehicle thus forms its own line across a landscape, and the shape of the line becomes the particularity of the life lived, the work-exhaust produced along the way. While few writers are con-

sciously drawn toward the line, many painters are—Martin being
but one example. The Austrian Otto Zitko, for instance, *only* paints
lines. Long lines curving and curling, extending into nowhere, the
void. A line never ends. It just goes and goes, infinite in its stark
simplicity and semantic ambiguity. (Unless we are told, we never
know what it is meant to be a symbol of.) Zitko uses his lines to
create environments; as such, they are typically applied to gallery
walls and are temporary in their nature. (Though occasionally he is
commissioned to do a permanent line painting; see, for instance, the
upper lobby of the Grand Hyatt in Berlin.) For his 2004 exhibition
at the Austrian Cultural House in Prague, he limited himself to two
colors: red and orange. Painted the entire room with them, totally
changing the environment and violating the sacred white wall space,
effectively turning it into a fiery red-orange swirl, another world.
Zitko didn't always paint lines. He used to paint other things, but
in the late 1980s, he decided to stop painting everything, everything
except for lines. Which is very primal, as it is the root of what painters
do. (What are planes composed of? Lines.) Where do Zitko's lines
lead? They are all contained in the same space. One can sit in a
chair and study them. Try to locate where each line begins, follow its
path throughout the walls and ceiling of the exhibition space, all the
way to the end. And then begin again. It is endless; the making of
Americans. A line implies the dimension of time. Zitko's lines could
be said to illustrate time. One may sit in the gallery for hours, lost
in Zitko's maze of lines, until forced to confront time by suddenly
asking oneself what time it is … what has time become? The time is,
in a sense, always now. It is never then or there. A present continuous,
as Stein says. Zitko's decision to stop painting in a conventional way
was not a nihilistic action, a gesture of aligning himself with the
whole "is painting is dead or not?" debate that has been going on
for far too long. Rather, his intention to paint lines was and is based
on the firm belief that this is the only way to develop painting any
further, just as Stein was following a similar impulse by deploying

the line in her novels. The deployment of the line thus represents
a striving for a very specific and idiosyncratic form of purity that
can only be hinted at. A primitive gesture that becomes a reflexive
metaphor—a line representing all lines, only gaining meaning in the
context of the space it fills.

Martin's lines: contained by the canvas; Zitko's lines: contained
by the exhibition space; Stein's lines: contained by the book's two
covers? This containment, this *framing*, allows us to posit a referen-
tiality, a relation between and among line-objects. Everywhere Stein
looked and listened, she perceived frames; sometimes frames within
frames: "I began to get enormously interested in hearing how every-
body said the same thing over and over again with infinite variations
but over and over again until finally if you listened with great in-
tensity you could hear it rise and fall and tell all that that there
was inside them, not so much by the actual words they said or the
thoughts they had but the movement of their thoughts and words."
Inside them—here, the body is the frame, the container, not just of
the organs, but of all the meaning and excess that define who the
person is (their being) or is meant to be (the perception thereof).

At the same time, a framelessness or a *de-framing* is encased in
certain types of composition, as Deleuze and Guattari put it in *What
Is Philosophy?*:

> The frame of the picture's edge is, in the first place, the external envelope
> of a series of frames or sections that join up by carrying out counter-
> points of lines and colors, by determining compounds of sensations.
> But the picture is also traversed by a deframing power that opens it
> onto a plane of composition or an infinite field of forces. These pro-
> cesses may be very diverse, even at the level of the external frame:
> irregular forms, sides that do not meet, Seurat's painted or stippled
> frames, and Mondrian's squares standing on a corner, all of which give
> the picture the power to leave the canvas. The painter's action never
> stays within the frame; it leaves the frame and does not begin with it.

Composition, painting, writing conceived of as a series of forces meant to exceed the frame. Thus, Stein's landscapization of the novel, of the play.[4]

> I felt that if a play was exactly like a landscape then there would be no difficulty about the emotion of the person looking on at the play being behind or ahead of the play because the landscape does not have to make acquaintance. You may have to make acquaintance with it, but it does not with you, it is there and so the play being written the relation between you at any time is so exactly that that it is of no importance unless you look at it.
>
> The landscape has its formation and as after all a play has to have formation and be in relation one thing to the other thing and as the story is not the thing as any one is always telling something then the landscape not moving but being always in relation, the trees to the hills the hills to the fields to trees to each other any piece of it to any sky and then any detail to any other detail, the story is only of importance if you like to tell or like to hear a story but the relation is there anyway. And of that relation I wanted to make a play and I did, a great number of plays.

There is a sonorous aspect to the line, as well. William Gass hones in on the rhythms, the inherent musicality of Stein's lines; in doing so, he makes us notice the fact that this prose is not merely visual, but also aural:

> It is also typical of Gertrude Stein to employ quite colloquial expressions as technical terms. "Does Merriweather have it in him to cross the country?" That is, does he have the gumption. Our selection continues (using a comma where a colon would normally be): "A man in his living has many things inside him, he has in him his important

[4] I should say here that there are, of course, radical gestures in painting that respond directly to the frame and manage, in doing so, to remain encased within it. A prominent example here would be Mark Rothko, who, in his "classical" period, produced work that was arguably centered on the issue of framing.

feeling of himself to himself inside him." The schoolteacher would
be expected to delete the "in him," because it is redundant, however
this "in him" will be followed by ten more, as well as two that are
submerged slightly in "inside him," with the total number of "him"s
reaching seventeen. One way or another the passage will beat away on
im im im like a drum.

Stein's prose was *bad.* The schoolteacher would be expected to step in
here and correct it. But it is bad for a purpose—for many purposes, in
fact—one of them being that of sound, musicality, which is inseparable
from the visual spectacle of the work; one has a similar synesthetic
encounter when staring for a while at one of Martin's canvases with
their horizontal lines. The percussive strength of Stein's writing lies in
its ability to recognize the limits of grammar and to extend beyond
them, repeating those mistakes endlessly *for the sheer purpose of repeti-
tion.* Repetition being momentum, a key vehicular term: the generative
flow of language is a most appropriate way for Stein to tackle her
subject, which, in *The Making of Americans* in particular, is that of
generationing: the quasi-biblical bequeathing of lives in subsequence.
 Another purpose of the repetition—particularly of a certain word
that might be said to form the core subject of a specific paragraph, as
often happens in Stein—is the meditative function. (Here, the title of
Stein's great long poem, *Stanzas in Meditation,* gives us the obvious
clue.) Again, this links Stein's endeavor in literature with that of Agnes
Martin in painting: the purpose being to attain a *total clarity.* Martin's
own writings stand as testament to this. Look at her meditation on time:

> In my best moments I think "Life has passed me by" and I am content.
> Walking seems to cover time and space but in reality we are always
> just where we started. I walk but in reality I am hand in hand with
> contentment on my own doorstep.
> The ocean is deathless
> The islands rise and die

Quietly come, quietly go
A silent swaying breath.
I wish the idea of time would drain out of my cells and leave me quiet
even on this shore.

Each artist has their own particular vehicularity; even the stillness described by Martin qualifies as one, as it is infused with motion, even though Martin refuses to see her *going* as going in the conventional sense of the term. Inspired by Buddhism and other Eastern religions, Martin never explicitly enunciated the connection of repetition in her work to those ways of perceiving the world, though it stands clear. A comparison can be made to the use of the mantra in Eastern religions, whose repetition is intended to effect a spiritual transformation. The function of repetition, then, is less mechanistic— the way we tend to read it in the West—than evocative of the need to attain a transcendental understanding of objects and their being in the world.

Literature is not life. Most writers know this well. Others get confused about it. And there is great joy for us, the readers, in getting caught up in that confusion, as the example of Stein attests. All those people and their multitudinous ways of being, it must have shocked and impressed her so much. Even before her awakening as a writer, during her university studies when she was preparing to become a psychologist, she offered herself up as both subject and object in a series of automatic writing experiments, which would arguably come to form an integral part of the core of her method of composition. As she would later reflect,

> I was very much interested in the way [the subjects] had their nature in them and sitting there while their arm was in the planchette [a device for producing "automatic writing"] and hardly vaguely talking, it was interesting to me to see how I came to feel that I could come sometime to describe every kind there is of men and women and the

bottom nature of them and the way it was mixed up with the other
natures in them, I kept notes of each one of them and watched the dif-
ference between being active and being tired, the way it made some go
faster and some go slower and I finally felt and which in *The Making
of Americans* I began to do that one could make diagrams and describe
every individual man and woman who ever was or is or will be living.

("A history of every individual man and woman who ever was or is
or will be living." The same impossible encyclopedic impulse can
be found in artists like Dieter Roth and George Kuchar. Quantity
over quality. Or: quantity *is* quality.) Automatic writing was as much
a bodily phenomenon as a mental one—if not more so. As Stein
would observe in one of her early experiments, wherein the subject was
asked to write the letter *m* over and over again with his writing hand
strapped into the planchette while simultaneously reading a short story,
"Sometimes the writing of the word was completely unconscious, but
more often the subject knew what was going on. His knowledge,
however, was obtained by sensations *from the arm*. He was conscious
that he had just written a word, not that he was about to do so." One
might suggest that the automatic writing exercises had a secret purpose
for Stein, the budding scribe: that is, how to program herself as a
writer. A new type of writer, for certain: a machine, a vehicle.

This is hardly an original hypothesis, having been posited in an
article by the American psychologist B. F. Skinner, a contemporary of
Stein's, in 1934. Skinner went so far as to divide Stein's work into
two parts: the automatic work, which is typified by *Tender Buttons*,
and the more "refined" literary effort, which, in Skinner's view, is
to be found in Stein's most accessible works, such as *Three Lives*,
The Autobiography of Alice B. Toklas, and *Everybody's Autobiography*.
To each of these two modes, Skinner assigns a different personality
or self: the sophisticate, which fits the "(wo)man of letters" image
proper to the era, and the primitive, marred by childishness and cal-
lousness. About the latter, Skinner concludes, "This part of her work

is, as she has characterized her experimental result, little more than 'what her arm wrote.' And it is an arm that has very little to say."

Today, it is easy for us to view Skinner's thinking as typical of the era, almost quaint in its reliance on binaristic oppositions for formulating an intellectual stance on an issue. Reading the essay from the position of a post-Derridean hermeneutics, one cannot help but further flesh out Skinner's contemporaneous thinking by assigning "mind" to the sophisticate half of Stein and "body" to the primitive (or "experimental") side. Skinner attempts to maintain Stein's phallogocentric "dignity" by essentially negating the second, bodily part of Stein's work: her automaticism. "I welcome the present theory because it gives one the freedom to dismiss one part of Stein's writing as a probably ill-advised experiment and to enjoy the other and very great part without puzzlement." Clearly Skinner is no proponent of the theory of extension I am promoting here. Literature, according to Skinner, is something that should not cause any puzzlement or pose any intellectual challenges; rather, it is something that one should be able to enjoy, like light entertainment. What Skinner is unwittingly arguing in favor of, essentially, is kitsch. (And to those who believe that Skinner's is an outdated idea, one need look no further than Anis Shivani's recent claims that writing should be clear and easy to understand in order to be considered good.)

Skinner's essay brings further evidence of Stein's vehicularity to the table: the role of forgetting in her acts of creation. As soon as she completed her first novel, *Q.E.D.*, she put it aside and forgot about it for nearly twenty-five years. As for her experiences as a subject in the automatic writing experiments, she forgot about those as well when she sat down to write her automaticist works. This is part of the present-continuous whirl that Stein not only wrote in, but also lived in; just as one does not linger over the exhaust emitted by one's vehicle as it moves down the highway, so Stein felt no great compulsion to fret over her work once it was finished. (Except, of course, for steering its course in terms of publication and promotion.)

One hallmark of Stein's writing is her frequent usage of bad grammar, as Gass points out. The constitutive quality here is the usage of the connector "and" without commas as a means of extending her sentences in perpetuity. The "and" is representative of vitality, of the life force: if the period signifies the end, the employment of a constant "and" serves as a means of extension, a means of permanently denying that end, that closure that allows meaning formation to become solidified.

Stein's preferred tense was the present continuous: the plethora of verbs, of what we might call verbiage, in *The Making of Americans*, with the necessary "-ing" appendage that enables the vehicular flow and rhythms of the prose that Gass so eloquently elucidates in his foreword to the book, produces a ceaseless movement of mind across the page's scape: "I am very much interested in men and women having sense for being ones being in being living, for men and women having sense for being ones succeeding in being living, succeeding feeling being living, succeeding in winning anything in being one being living, succeeding in living to themselves to any one, in men and women being married ones." The linear language in Stein, far from being "dead," is in fact never static or concrete, but always fluid, in a perpetual state of motion. With its deployment of simple, often monosyllabic words that even a child could understand, what makes her prose so difficult to read is the challenges to meaning formation that this particular usage of language deliberates. Much more than Skinner, poet Lyn Hejinian is able to grasp this facet of Stein's writing, and in the accursed *Tender Buttons*, of all places: "As for movement, Stein wanted to understand things not in isolated rigidity, which falsified and monumentalized conditions which were fluid, but as present participants in ongoing living—outpouring, fountainous living. How does a carafe move? In an arrangement. By being larger than a cup and smaller than a pitcher; by containing less liquid than before; by reflecting light (and thereby color); by being or containing the same color as a piece of paper; by having a vase

with flowers not of that color set to the left of it from here but to the right of it from there, and so forth."

In fact, movement abounds in Stein's work—not merely encoded in the style of the writing, but within the narrative, as well. Early on in *The Making of Americans*, Julia Dehning must go riding around the country in order to make a decision on whether to get married: "It was a well meant intention this in Julia of riding by herself around the country and thinking hard about what they had both said about it, but not the certain way to end in a passionate young woman her first intense emotion. The wide and glowing meadows of low oaks, the clean freedom and the rush of rapid motion on the open road, the joy of living in a vital world, the ecstasy of loving and of love, the intensity of feeling in the ardent young, it surely was not so that Julia Dehning could win the sober reason that should judge of men." As a coming-of-age motif, this sort of journeying is fairly traditional. In fact, all sorts of rides and journeys are represented in the Stein oeuvre, this being but one example.

While Skinner's critique of Stein's writing is harsh, it is quite generous in comparison to conclusions many other critics—both contemporaries of Stein and later writers—have reached. Some are subtler than others. There have always been not murmurings, but perhaps critical implications (criticism has always been a male-dominated terrain) that this woman wrote this way because she in fact did not know how to write. "Most publishers and editors refused her as illiterate or mad—a faker or simply a capricious lady," writes Dydo. "What little was published [in her lifetime] left many readers angry. They turned the tables on her, blaming her for writing incomprehensibly rather than themselves for failing to comprehend. They ridiculed her and her work." Yet one need look no further than her work—even some of the early pages of *Americans*, her allegedly worst novel—to find very normative sentence and paragraph structures, oftentimes containing great philosophical insights, such as this paragraph-long meditation on aesthetics, which I will break down here, sentence by sentence:

> The dining room was without brilliancy, for there can be no brilliance
> in a real aesthetic aspiration.

A key overlooked statement of Stein's own poetics, and a blatant
embrace of "bad" form: real aesthetic aspiration, after all, lacks bril-
liance (in the conventional sense of the term, of course.) Stein continues
in her description of this rather drab interior, an odd negative/critical
moment in her work:

> The chairs were made after some old french fashion, not very certain what,
> and covered with dull tapestry, copied without life from old designs, the
> room was all a discreet green with simple oaken wood-work beneath.

Here is Stein the modernist speaking: dullness—note its semantic
opposition to the "brilliance" refuted in the previous sentence—is
also refuted here—though, again, in the conventional sense of the
term. For this is what is being attacked here: the *convention* in art of
copying without life from old designs. The discretion and hence safety
of the color green, the mannered simplicity of the woodwork—all
qualities that Stein attacks implicitly in the style of her writing. The
paragraph continues:

> The living rooms were a prevailing red, that certain shade of red like
> that certain shade of green, dull, without hope, the shade that so
> completely bodies forth the ethically aesthetic aspiration of the spare
> American emotion.

On the color scale, red is on the opposite spectrum of green, and thus
thought to complement it. Though opposites, Stein identifies their
shadings as identical: both contain "that certain" dullness, "without
hope." In describing colors, she conjoins ethics and aesthetics with
hopes and emotions, in particular that "spare American emotion";
here we can presume an embodied critique of a certain middle-class

WASPishness and puritanism. In subsequent paragraphs, Stein will go on to defend the integrity of the middle class, a uniquely American creation, to which she believed she rightly belonged, though here, the tone of the paragraph is quite different, hinting at a certain inner tension in the author between her origins and the life she was in the process of creating for herself as an alien in distant and culturally disparate Paris.

> Everywhere were carbon photographs upon the walls sadly framed in painted wooden frames.

The enumeration of the scenery positions the sadness of the carbon photographs, their "sad" frames, pathetically painted. This, of course, one must position in our minds against the picture we have of Stein's parlor with its prevalence of masterpieces from the likes of Cézanne, Matisse, and Picasso crowding each inch of the wall space: liveliness; the life force.

> Free couches, open book-cases, and fire places with really burning logs, finished out each room.

There we have it: the rounding out of a picture of bourgeois comfort and perfection, representative of a lifestyle that Stein would battle against throughout her life while simultaneously embracing it. This paragraph can be seen, among other things, as one of the earliest and most explicit documentations of that struggle.

In a conventional sense—in terms of action, plot—very little *happens* in Stein's writing. On the level of language, however, everything and anything happens and in anarchic simultaneity—it is too much to take in. This is not the way we are taught to read, and it does something to our perception—a faint quivering can be felt that seems to infer the uncontrollable urges of the libido, of the secret desire to rend chaos

from the order of our language and our lives. On a philosophical level, "ideas evolve over the course of her work," writes Lyn Hejinian. "But they do not resolve. There is no end point, no summation, no synopsis, no closure. And given the nature of her ideas and the character of her method, there could not be." To this extent, her work is immune to summing up, to the critical enterprise. There is a way in to Gertrude Stein's work; those seeking a way *out*, however, are often left frustrated.

The reason why Stein's writing resists normative reading strategies is because, to put it simply, it is quite another thing. This otherness is not only present in her poetic texts like *Tender Buttons*, but also in her writings about the visual artists who inspired them. Stein's art-related writing is less criticism than what we might deem *art writing* in the proper sense—that is, a form that tries to replicate or capture the essence of, through the medium of language, a work of visual art. Whether she was consciously responding to it or not, Stein's response to the art critical enterprise was very much rooted in a French tradition that had it that the poet is the best translator of a work of art into language. Indeed, one of her friends and a frequent visitor to her salon was Guillaume Apollinaire, a poet who also wrote voluminously on the art of his time and frequently collaborated with sculptors and painters. Stein's word-portrait of Apollinaire is typical of her writings on other artists of her time:

> Give known or pin ware.
> Fancy teeth, gas strips.
> Elbow elect, sour stout pore, pore caesar, pour state at.
> Leave eye lessons I. Leave I. Lessons. I. Leave I lessons, I.

The position of the poet/art critic would endure in the West for quite some time, until becoming openly challenged in the 1970s in the New York art scene, with the advent of the first academically trained (as art historians) group of art critics, the (post-)Greenbergian formalists. An unarticulated battle was set up between the competing

aesthetics represented by *Artforum* and *ARTnews* magazines. In the words of poet and art critic Carter Ratcliff,

> *ARTnews* was really a writers' magazine, a poets' magazine. The New York poetry style is no less arrogant than any other, but this isn't obvious to everyone at first glance because it's a style of off-handedness and understatement and occasionally just being silly. So nobody made grand, Oscar Wildean comments about how criticism is a creative act, just as painting and sculpture are, and yet that was always implied. And that meant that the writing was supposed to have literary qualities running parallel to the pictorial qualities or sculptural qualities that were being celebrated. The idea was that the artists and writers were in the same world and a kind of a conversation was being carried out in the celebration of a certain shared sensibility. So there was no notion of objectivity, or even critical judgment—that was taken for granted. If you were Bill Berkson and wrote about Philip Guston, you didn't waste any time making an argument for the greatness of Philip Guston. I mean the very fact that you were writing about him and you were Bill Berkson meant that he was great. And the same with Tom Hess and Willem de Kooning. I don't think he ever did state de Kooning's importance; he just wrote about him all the time in terms that were, on the one hand, intimate and on the other hand exalted, so the critical judgment may have been unstated but it was obvious. And unquestionable.

The formalists at *Artforum*, on the other hand, practiced what Ratcliff termed a "workaday authoritarianism"; their job became to churn out what would become recognized as *Artforum* prose. While Ratcliff assumes in retrospect a critical stance toward both positions, he decidedly aligned himself early on with the less doctrinaire *ARTnews* school. We can see how Stein might have, as well, had she still been around in the 1970s. But we can also see how her writing very much exceeds what the New York School poets gathered around

ARTnews were trying to do in their art criticism. At the root of the argument, one might surmise, is a conflict between intuition, on the one hand, and learnedness, on the other. While the post-Greenbergian formalists around *Artforum* would compete with each other in what Ratcliff rightly defines as equally reductive approaches to the object, it is implied that the poetic approach would be to then celebrate the object—otherwise, what is the point of turning our attention to it at all.

The Steinian approach resonates with the object-oriented approach—that is, something that goes beyond reduction, celebration, or description, and instead tries to inhabit the object—thereby eliminating the "about" altogether from the equation. *Tender Buttons* has been aptly described by one critic as a collection of "object poems." There is a theory of the name at stake here, one that sees proper names as reducing things to stasis—language fails in that it separates us from the real thing. The name, separate from the thing, becomes an object also: writing = objects inhabiting objects. "Stein [...] does not trace things back to their origins, her investigation is not etymological. That would reduce things to nouns, and Stein's concern was to get away from the stasis (and the phallo[go]centric monumentality) of the name. She saw things in a present continuity, a present relativity, across the porous planes of the writing."

Honing in on Stein's realism, Hejinian picks up on an unusual affinity between Gustave Flaubert's ambitions as a novelist and Stein's realizations as a writer. Flaubert once wrote to a correspondent, "What seems beautiful to me[,] what I should like to write, is a book about nothing, a book dependent on nothing external, which would be held together by the internal strength of its style [...] a book which would have practically no subject, or at least one in which the subject would be almost invisible, if that is possible." *Tender Buttons*, that masterpiece of object-oriented writing, might very well be the book that Flaubert hoped to write, but never did. As Stein herself would later put it, "Now that was a thing that I too felt in me the need of making it be a thing that could be named without using its name. After all one had

known its name anything's name for so long, and so the name was not new but the thing being alive was always new."

And so there we have it. With Stein, the Bad writer, what we get is the very first *art writing*, which is to say, the very first object-oriented writing. A writing that broke with all previous sets of decorum, in its ambition to not merely describe, but go inside, beyond the mere name of an object, and experience its innermost being: an impossible task, to be sure, and thus all the more worthy of undertaking.

THe language of tHe Toilet

Gary Sullivan, American poet, experiences the death of his grand-father, an amateur poet. Shortly before the grandfather passes away, he telephones his grandson to boast that he has won an important poetry contest. The "contest" turns out to be one initiated by the now defunct Poetry.com, one of countless cynical scam sites/vanity publishers that prey on would-be poets. Every poet who submits a poem wins—and each is celebrated via inclusion in a trophy anthology alongside other "winners," all of whom are implicitly expected to buy several copies.

 After his grandfather passes away, Sullivan exacts revenge against the scam machine by sitting down to pen the absolute worst poem he can manage and submitting it to the same organization. He titles the resulting mess—the foundational Flarf moment—"Mm-hmm":

> Yeah, mm-hmm, it's true
> big birds make
> big doo! I got fire inside
> my "huppa"-chimp(TM)
> gonna be agreessive, greasy aw yeah god
> wanna DOOT! DOOT!
> Pfffffffffffffffffffffft! hey!
> oooh yeah baby gonna shake & bake then take
> AWWWWWL your monee, honee (tee hee)

uggah duggah buggah biggah buggah muggah
hey! hey! you stoopid Mick! get
off the paddy field and git
me some chocolate Quik
put a Q-tip in it and stir it up sick
pocka-mocka-chocka-locka-DING DONG
fuck! shit! piss! oh it's so sad that
syndrome what's it called tourette's
make me HAI-EE! shout out loud
Cuz I love thee. Thank you God, for listening!

It doesn't get much worse than this. Were we to pick up the poem randomly and not realize the author's intended badness, it would be received as little more than a piece of facile juvenile graffiti, perhaps mildly amusing to toilet humor enthusiasts. With its erratic line breaks and total disregard for the structure of rhythm that typically guides free verse endeavors, "Mm-hmm" is nearly transcendent in its stupidity.

A simple rhythm seems to be developed in the first line, a series of clipped, banal colloquial utterances comprising a mere five syllables: "Yeah, mm-hmm, it's true." It seems logical that the rhythmic pattern would be repeated in the second line, which is also comprised of monosyllables, only Sullivan suddenly and inexplicably neuters the line midway through, breaking off the rhyme into the first half of the third line, so that the second remains a three-word clunker: "big birds make." The thing they make—"big doo!"—relegated to the third line, completes the scatological non-joke that commences this masturbatory masterpiece. This leads in to a head-scratcher, the speaker boasting of the "fire" inside his "'huppa'-chimp(TM)." A Google search for "huppa" yields two primary possibilities: a commercial line of children's clothing and the portable canopy beneath which a couple stands in a traditional Jewish wedding ceremony. Neither of these definitions gives us a clear idea or picture of what

a "huppa"-chimp might be, though nonetheless, as the (TM) for "trademark" suggests, the reader should be warned away from trying to steal the idea from the author.

The following line is memorable for its creative misspelling of "agreessive," which, given that it is followed by the similar-sounding "greasy," gives ponderance to the idea that it could be intentional or, at the very least, a "fortunate" accident.

(Before stumbling onward through this callous corridor, we should pause to come to grips with a noticeable problem that has evolved in our analysis: that of double agency. That is, in illustrating badness through his poem, Sullivan plays a double role as poet. While the role of the author in Conceptual writing, subject of the next essay, is fairly straightforward—framer of the text—in Flarf, it is rather more complicated, as the author is implicated in a play of deliberate deception: one must be fairly good in order to be bad. The whole notion of authenticity becomes blurred when one sets out to write a poem like "Mm-hmm," in that Sullivan is employing his "skills" as a poet to simultaneously mask or even tarnish those skills. What, then, does Sullivan's "real" poetry look like? If Flarf is all a big put-on for the poets who claim this territory, when and where does the gag end and the real begin? For the purpose of our analysis, we will assume a system of tarnished equivalencies between the "authentic" voice and the "fake" amateur, and introduce our position on the frame's functionality: in the case of Flarf, "badness" forms the frame. Thus, the double agency of the Flarf poet.)

This is followed by the vocalization of a giant fart, an idiotic "hey!" Flarf, like so much of the other bad work I tend to favor, relies heavily on the scatological to achieve its ends. As Slavoj Žižek has strained to point out, the scatological is always implicitly linked to the ideological:

> In a traditional German toilet, the hole in which shit disappears after
> we flush water is way in front, so that shit is first laid out for us to sniff

at and inspect for traces of illness. In the typical French toilet, on the contrary, the hole is in the back: shit is supposed to disappear as soon as possible. Finally, the American toilet presents a kind of synthesis, a mediation between these two opposed poles—the toilet basin is full of water, so that the shit floats in it, visible, but not to be inspected. It is clear that none of these versions can be accounted for in purely utilitarian terms: a certain ideological perception of how the subject should relate to the unpleasant excrement which comes from within our body is clearly discernible in it.

Flarf clearly positions itself within the American toilet, floating its refuse before our eyes while encouraging us to look away, and the language of Sullivan's inaugural poem makes this clear—not merely with its vocalization of bodily processes, but its tonal and stylistic hijackings from the detritus of popular culture, its banal pseudo-jargonistic reality-TVisms and jerky, failed attempts at imitating the rhythm of hip-hop, which clearly surfaces in the clumsy clichés of the following lines: "oooh yeah baby gonna shake & bake then take / AWWWWWL your monee, honee (tee hee)." This is followed by a line of incomprehensible sounds, which remind one of the *boom-jigga-jigga-boom* vocalizations of rhythm in hip-hop, but, were this a "real" poem, might have been substituted with a double line break, bringing some sectionalized relief to the unpleasant amalgamation of arrhythmic lines.

Line eleven concurs with Sullivan's proposal that Flarf's agenda be inclusive of the "most offensive"—that is, politically incorrect—sentiments that the poet is able to conjure—a project that again poses interesting challenges to our conception of the double agency of the poet and the frame. Perhaps Sullivan feels somewhat safe in employing "mick" and "paddy," derogatory terms for Irish people, as his name implies that he himself is of Irish descent.

The list of imbecilities continues: lines eleven and twelve end with pointless alternate spellings of "get" and "git," leading to the failed

pseudo-rhyme at the end of thirteen ("Quik," as in Nestlé), ultimately arriving at the end of fourteen and the poem's premiere successful attempt at rhyme, with "sick." Another line of vocalized rhythmic noise ensues, signaling the poem's descent into what should be its third and final stanza, which commences with a series of expletives, followed by a rather weak joke about Tourette's syndrome. The final two lines form the poem's nerve-grating anticlimax, which, we can only say, sputters: not *sputter* as in the delightful sounds that might emerge from the mouth of a baby upon tasting its first ice cream, but *sputter* as in the unpleasant cacophony emitted by a malfunctioning toilet.

Unsurprisingly, Sullivan's efforts were not ignored by the contest holders at Poetry.com. Within weeks, Sullivan received a letter of acceptance, arguably the aesthetic equal, in prose, to the poem itself:

> Gary, over the past year, we have conducted an exhaustive examination of over 1.2 million poems that have been submitted to us. Only a small percentage of individuals whose poems we have reviewed were selected to be part of this distinguished project. "Mm-hmm" was selected for publication because it sparks the imagination and provides the reader with a fresh, unique perspective on life. We believe it will add to the importance and appeal of this special edition. Of course, Gary, as always, you are under no obligation whatsoever to submit any entry fee or subsidy payment, or to make a purchase of any kind. Your poem will be presented in the most elegant way possible. This coffee-table quality book will feature an "Arristock leather" cover stamped in gold and a satin bookmarker ...

Sullivan shared his schoolboy prank with his colleagues on the POETICS listserv in 2001. Based at the State University of New

York at Buffalo, the POETICS listserv had served as the virtual meeting place—arguably the internet era's capital—of North American avant-garde poetics since its foundation in 1993. Others quickly got the joke, and began to file behind Sullivan, penning their own poems. A new movement, Flarf, was born, complete with mini-manifestos ("A blend of the offensive, the sentimental, and the infantile," according to K. Silem Mohammad, elaborated further by Sullivan as "a kind of corrosive, cute, or cloying, awfulness. Wrong. Un-P.C. Out of control. 'Not okay'"). Much of Flarf had its organizational roots and energy in the new communicative possibilities spawned by the internet—Flarf blogs and a breakaway email list from the POETICS listserv enabled the Flarf poets to share their efforts with each other and organize festivals as well as publishing projects, while keeping aflame the morale of badness that had ignited the movement. "To be honest," said Sullivan, "we started this list to do a hundred-page anthology of just garbage."

As Flarf (d)evolved, along with it came a narrow array of tactics and approaches. While "Mm-hmm" may have been composed "off the cuff," using no other tools than the most callow regions of the poet's own imagination, others began to evolve methodologies to their madness. One of the more prominent of these was "Google sculpting." The process involves entering two random words or phrases into the Google search engine, then "mining" the results, selecting lines from the displayed textual results (without clicking on the websites themselves) to craft into a poem. So, for instance, out of the two random phrases ("yankee doodle" + "fuck machine") from which the poem derives its title, Mohammad came up with the following:

"Yankee Doodle Fuck Machine"

I am a robot and I'm angry at people
I'm not wasting a vacation on a Boy Scout jamboree
the songs I can play are "Fur Elise,"
"The Entertainer," "Fuck You Becky," and "I'm Not Gay"

Anne Murray is the ugliest boy
I have ever seen in my life
"he is optimistic that man will come out on top"
where the FUCK is my time machine

regardless of how "indisputable" it may seem
to the fags or Arabs or whatever
we all have to have banks and as such banks get
to fuck up politics in America and the world

"at night we ride through mansions of glory
in suicide machines ... and fuck them," Flaubert wrote
in his journal with a little riiipp! AUGH! whap whap
whap whap whap as he sat in his gold Rolls-Royce

poems from Kansas don't have to be that crazy
one of them is "Yankee Doodle," the other one isn't
then cowboy change your ways today or with us you will ride
keep your stick on the ice, go fuck yourself

there are over 100 words for "shit"
and only one for "fuck you"
and every one of the self-serve machines at Kinko's
is an Anne Of Green Gables pop-up dollhouse

Riddled with shits, fucks, bodily functions, indecipherable noises, and politically incorrect unniceties (derogatory statements about Arabs and homosexuals), "Yankee Doodle Fuck Machine" seems to follow the badness of the Flarf agenda established by "Mm-hmm." It also successfully emulates the debased language of the internet, which is in turn a reflection of the American "majority speak" of the Bush years—although "emulate" is perhaps a misused verb in this sense, since it is presumably wholly comprised of that actual

language. In a sense, the Flarf poet here plays a similar role to that of the Conceptual writer, whose task has been relegated to that of "curator," rather than creator, of language. For Flarf, however, the issue of mediation comes into play in a way that it does not for the Conceptualists.

Another word on shit before we continue. I mean, to be precise, the ways in which shit can be said to float in that ocean of language through which we currently row. In Flarf, after all, the poet often plays the role of monkey, those creatures so fond of using their excrescence as a weapon in fending off unwanted and would-be invaders. This is not, of course, what we expect when we go to pay the monkeys a visit in their cages at the zoo. We expect to find the monkeys doing cute things, chasing each other around in carefree play, engaging in impressive feats of acrobatics enabled by their astounding limberness and flexibility, perhaps even smiling and waving at us like innocent children as we smile before their captivity.

Instead, we are pummeled in the face with shit.

This is something like the experience of coming to Flarf from poetry. Perhaps, we could say, this is that instant in which *flarf* actually becomes a verb. We come to verse with our cliché ideas of what "the poetic experience" is meant to provide—language in its highest, loftiest form, deploying a sentiment of universal appeal: the Hallmark greeting-card poem. (Once we leave the Ivory Tower, is this not the mass conception of poetry, after all?) The Flarfist knows exactly what we expect to see when standing before the poet's cage, and, like the feces-flinging monkey, is eager to defile our cheap yearnings for escapist pleasure via sentimentalism.

"Grandmother's Explosive Diarrhea"

Callused, knobby, aching,
This is my grandmother's anus.

Overworked, but always looking for more to do,
Wrenched open again & again
When it should stay closed.

My grandmother's explosive diarrhea
Resembles the sound of bowling balls
Dropped into a wooden tub
Filled with moist grapes and papayas.

My grandmother's anus has been working for 84 years,
This 110 pound woman, weak from
Dehydration, with strength pulsing from her anus like
The vein of an ox.

Could my anus ever be like this?

Could my anus ever experience the pain?
The glory?
The peace?

Already my anus looks withered from
The flatulence and loose stools of my 45 years,
45 years of pampered life.

But her every wrinkle tells a story,
Like waves of movement
That have expelled the feces.

The Holocaust caused watery stools,
The depression caused near-catastrophic constipation,
The birth of 4 children caused waste rich with joy.

Her rectum shows the grace of a swan and
The tenacity of a lioness.

Could my rectum ever reach this ironic state?

My grandmother's anus soaked with wisdom,
Apprehension, and comfort.

Buba's explosive diarrhea is my afflation,
My goal,
My aspiration.

We could venture to suggest that the monkey named Gary Sullivan knows exactly what he is doing at the moment he picks up his turd with the intention of deploying it torpedolike in our direction. Not merely the shit in its potential instrumentality (qua weapon), but something of its ontological nature as well; the monkey is likely aware that it is something that, at a certain point, came out of him, and that it came out of him for a good reason: it bears no beneficial use, and thus has been rejected by his body as a piece of gnomic excess.

It is for similar reasons that the Bad artist so often falls back on scatology as a sure way of cementing her position in opposition to the generative project of artistic spectacle. Precisely because it is so unwanted, because it generates such intense feelings of disgust and repugnance, shit is flushed away, never put on display ... But what about those artists who excavate it and put it on a plinth?

The Bad artist, among other things, operates from a total consciousness of her own body—an awareness that creativity is not "merely" a mental act, but a physical, bodily one. In fact, it could be said that

the Bad artist reverses the importance that the two traditionally find themselves arranged in with regard to poetic creation, placing the body before the mind. The artist, then, becomes not a body machine, nor a mind machine, but a body-mind machine; in such a formulation, the body naturally assumes prominence, yet the mind is always and inevitably attached; in such a scenario, mind is but an extension of body (and vice versa, of course). Hence, the totality of the body's processes must be included within the poetic output—including, for instance, the scatological (but also the nutritional, the sexual, the decompositional— in short, *all* functionality).

Like Dada, Flarf represented an avant-garde reaction to the machinery of war. Flarf began in 2001, before September 11, but reached its full momentum in the months and years of George W. Bush's wildly unpopular presidency and the war he started in Iraq. The Flarf poets subsumed and reflected the era's crazed right-wing rhetoric in anarchic collage poems like Sharon Mesmer's "I Wanna Make Love to You on Mission Accomplished Day":

I wanna make love to you on Mission Accomplished Day
On the floor of the main headquarters of the Department of Faith
I wanna make love to you two years ago today

When Bush's carrier offed some old Arab broads who just "got in the way"
When I was a kid we made love in a fun Catholic kind of way
On our bikes, under maypoles, in the Enterprise's cargo bay
I can't wait for Al Qaeda's Call for Papers Day
When I'll make love to you on four million barrels a day

I met FDR once in Vegas, he was a good lay
But as good as you 'cause you're so ofay
Like an OPEC quote, and bin Laden's protegé
We'll make hot monkey love on Whoopin' Osama's Sorry Ass Day

Even within avant-garde poetry circles, however, not everyone was willing to jump on the Flarf bandwagon and accept its proposed criticality at face value. In an essay for *Jacket*, Dan Hoy criticized Flarf's lack of critical engagement with its own methodologies. In doing so, he opened up a troublesome dialogue on Flarf's revolutionary potential. "The Internet may be rhizomatic," he writes, "but search engines are not. They're selectively hierarchical. That poets are employing these hierarchies as poetic tools without questioning the implications of doing so (whether in pre- or post-production) exposes a lack of rigor in their process, as well as a tacit disregard for their own cultural complicity as something maybe worth exploring, or at least being aware of."

It could be argued that Flarf's employment of internet search engines is little more than an update of modernist poetics—in particular, the forfeiture of creativity to chance procedures. To make such an argument, reasons Hoy, is to problematically ignore the internet's hierarchical infrastructure.

In light of our knowledge of how they were composed, poems like "Yankee Doodle Fuck Machine" must be read as collage, insists Hoy: "I think the way these poems are written and received is very much a part of their content; the former because it informs them as they're developed (inherent content), the latter because it determines their functionality (projected content)." This unites Flarf with an avant-garde lineage, whose *built-in affects* ensure that the work contains its own criticism. Flarf is self-conscious; it may not appear so, but the effect of double agency at work here enables its inevitable dual function. "If there's a difference with Flarf and its progenitors," continues Hoy,

> it's that Cage and Oulipo researched or created their generators of deterministic randomness, whether it be the I Ching, the weather, or mathematical formulas. They were aware of how each generator distinguished itself as a context and control variable, and their selection of each context and control variable was part of the content. [...]

The Flarfists may be aware of the webpage from which they borrow material, but the only reason they're aware of that webpage is because Google (or AskJeeves, or Yahoo!, or ...) showed it to them—so the question is, are they aware of why they're aware of that webpage? Do they wonder how it is that their poem is determined as it is—that is, of the process at work on their work by an outside force, one not divine or natural but corporate? This is a fundamental aesthetic concern as well as a socioeconomic one. And a process that draws so much attention to itself as process (since the end result is often intentionally discordant with overt tonal & syntactical juxtapositions) undermines its credibility if it propagates a lackadaisical attitude toward its own mechanics.

When one steps back and evaluates Flarf from a wider perspective—particularly that of the anarchic ethos of the Language school, which sought a destabilization of meaning and a complete separation of signifier from signified in its poetics—a more nuanced possibility of the politicization of language proposed by Flarf emerges, as Language poet Barrett Watten has observed:

A kind of political allegory adheres to this view: the noun phrases become the "citizens" of a radical democracy that cannot be totalized or subordinated through formal or political means; sentences, on the other hand, would be moments of Foucauldian discipline wrought on the phrases, hard task masters of coherence and sense. Paragraphs would be akin to forced labor camps, and a complete narrative something like the totalizing teleologies of progress and millennial utopias of all sorts. Discourse would be the final horizon of coercion and control: the top-down muscling together of all those discrepant noun phrases, a poetics of sheer force, fascism in the making. While this allegory partakes of the absurd, it is felt by many as a limit of acceptable expression in the avant-garde. It's a contradictory prohibition where the "freedom" to be free of higher-level constraints is a constraint in its own right,

leading to a widespread and internalized prohibition. I am not talking only about my own generation of poets; the recent emergence of Flarf poetries—with their very different social perspectives, gender and identity politics, and performance strategies—still seems policed to a degree by the "noun phrase": all one-liners must be atomized phrases, and discourse itself can only be discontinuous and accretive (if generally subordinated with a very loosely and arbitrarily controlling, often absurdist, "thread" such as "Chicks dig war").

Watten points out that the supposedly anarchic, free-for-all idea of Flarf is actually rigidly controlled by an underlying formalism in the poems themselves; sometimes anti-formalism can be a form in itself. Thus, unlike Hoy's Google-centric reading of Flarf, Watten's deeper analysis makes clear that not merely any poem composed according to the Google-sculpting methodology outlined above will qualify as Flarf—it must also retain certain formal characteristics (i.e., the "noun phrase").

Watten goes on to argue, "It is precisely, however, to the degree that Flarf does something new performatively and with its use of the detritus of popular culture and the internet, treading the high/low distinction until it breaks under the weight, that it re-invents the avant-garde. In a larger aesthetic economy, it seems, 'the truth will win out.' Flarf's recent productivity shows how the injunction against the sentence, paragraph, narrative, and even discourse from some sectors of the Language school intersects with actual conditions of language use. Any such thing as stylistic norms in the avant-garde must inevitably intersect with 'life.'"

Could it be said that Flarf comes closer to *life* than more "normative" schools of poetry? If by "life," we mean everyday, spoken language as well as the "written" language deployed in the new communicative realms enabled by technological advances, then the answer would be yes. At the same time, embedded within Flarf's absurd juxtapositions of everyday and "net" speak, we find a critique of the current state of

language; it is truly a high/low hybrid, as Watten notes, in its utilization of the "high" art form of poetry to hurl, shit-like, language in its most debased state, the language that has become the norm in the twenty-first century, at its audience-creators.

FRameFecish

Poetry, as Susan Sontag has written, has long been considered the most regal of the literary arts, and those writers who are regarded as poets—though they may be less well-paid, less well-known than their blockbuster novelist colleagues—are nonetheless respected as the aristocratic class of literature. The poet's craft is, after all, "the highest aim of literature, the highest condition of language," Sontag wrote in 1983. Little could she have known that both the aim and condition of poetry would be subject to a radical revision in the early years of the subsequent century.

In his manifesto-style essay "Conceptual Poetics," Kenneth Goldsmith announces the death of originality, the advent of a bad poetry, rife with bad language. "Language as junk, language as detritus. Nutritionless language, meaningless language, unloved language, *entartete sprache*, everyday speech, illegibility, unreadability, machinistic repetition. Obsessive archiving & cataloging, the debased language of media & advertising; language more concerned with quantity than quality."

We could propose that this comes out of a love of the colloquial, of the debased state that language has reached in a world where people's most intimate relationships are mediated through machines: a world seemingly hundreds of miles away from the literary as it is traditionally conceived.[5] Conceptualism proposes a diseased writing practice, whereby writerly

[5] Elsewhere, in *Soliloquy*, Goldsmith suggests that popular culture, where this language finds a home, is also somehow more advanced. "And I was I was arguing for popular culture's become really really interesting it's become incredibly sophisticated."

impulses are ignored or, at best, subsumed into choice. It is a writing that is intended to be *merely* interesting,[6] in its ideational delineation, which consists of the limits imposed by the author, whose sole agency has been reduced to the role of this *imposer of limitations*. In short, if the Conceptualists were to have their way, the author's role would be reduced to that of framer. Indeed, Conceptualism, as a practice, serves to draw the viewer's attention away from the content, toward its container: the frame.

Goldsmith declares, "In 1959 the poet and artist Brion Gysin claimed that writing was fifty years behind painting": a reminder that the Language poets, the major movement in North American avant-garde poetics that precedes Conceptualism, also often chanted. Goldsmith and his fellow Conceptualists (among them Vanessa Place and Rob Fitterman) have responded by adapting Joseph Kosuth's idea that the central impetus behind art should be choosing and nominating (i.e., framing) preexisting content, and applying it to the field of writing. The internet is regarded as a potential coconspirator, rather than the pariah it is viewed as in increasingly fervent debates surrounding economies of attention.

The author may not be dead as she was once regarded in the recent past, though her agency is no longer linked with creation but with selection, with framing.

Make no mistake: Conceptualism, according to Goldsmith, is *the* definitive writing movement of the new century:

> The twenty-first century, with its queries so different than that of the last, finds me responding from another angle. If it's a matter of simply cutting and pasting the entire internet into a Microsoft Word document, then what becomes important is what you—the author—decides

[6] Here, I realize I have echoed Michael Fried's famous put-down of Minimalism (or what he calls "literalist work") as being "merely interesting" as opposed to boring. While I find Fried's advocacy of abstract painting intriguing on many grounds, I should note here that I strongly disagree with the overall thrust of his argument against "theatricality" in "Art and Objecthood."

[*sic*] to choose. Success lies in knowing what to include and—more important—what to leave out. If all language can be transformed into poetry by merely reframing—an exciting possibility—then she who reframes words in the most charged and convincing way will be judged the best. I agree that the moment we throw judgment and quality out the window we're in trouble. Democracy is fine for YouTube, but it's generally a recipe for disaster when it comes to art. While all words may be created equal—and thus treated—the way in which they're assembled isn't; it's impossible to suspend judgment and folly to dismiss quality. Mimesis and replication doesn't eradicate authorship, rather they simply place new demands on authors who must take these new conditions into account as part and parcel of the landscape when conceiving of a work of art: if you don't want it copied, don't put it online.

In defending his literary tactics—and simultaneously endowing them with further metaphorical gait—Goldsmith appropriates the corporate language of marketing. Writing is no longer about *creating*, but about *managing*. The world, once a canvas, is now a stock portfolio. "How I make my way through this thicket of information—how I manage it, how I parse it, how I organize and distribute it—is what distinguishes my writing from yours."

Since "context is the new content," we are meant to judge the quality of a work by the interestingness of the concept deployed, rather than the content therein. We thus don't necessarily need to waste our time reading an entire work; just knowing what framing device the author has employed is enough. Thus, Goldsmith "managed" the "uncreative" endeavor of putting every word he spoke for a period of one week into a book, *Soliloquy*, which numbers at nearly five hundred pages and is, according to the author himself, unreadable.

What, then, is the point of publishing such a work? Perhaps by doing what the author tells us not to do—taking a closer look at *Soliloquy*—knowing what it is and looking at it anyway, will help us determine what kind of author Goldsmith *really* is.

Since Goldsmith is apparently aiming for a strict separation of form and content, and wants the reader's focus to be on the former rather than the latter, let us look at those features of *Soliloquy* that are most readily identifiable. We will find right away that these features are tied to what often goes unspoken about the social context in which Goldsmith situates his work. But this context is just as much a part of the frame as the formal and aesthetic constraints that Goldsmith imposes on the work.

Goldsmith operates almost exclusively in the North American avant-garde poetry world. This is the contextual audience to whom he addresses his many essays, manifestos, and uncreative work, as well as the realm from which most of his critics and supporters come. The title of the work, *Soliloquy*, is the first and most obvious framing point at our disposal, one that clearly identifies the work—however provocatively we may wish to take it—as a work of poetry—or, to be exact, a work of poetry embedded within the context of drama.

The badness is in the composition itself. There's a sort of laziness flagrantly put on display here—I can't be bothered to sit down and put in the hard work that is required in *creating* a work of literature, so I will merely record myself and create a book within a period of one week—a book really quite sizeable in length, comparable to a work like, say, *Ulysses*, which took James Joyce seven years to write. Imagination is held at bay, and the idiotic machinations of our everyday speech are put on display—and, in this case, are hardly flattering, as Goldsmith reveals himself to be a self-obsessed, cynical opportunist and careerist, more concerned with elevating his status than maintaining the integrity of his projects. As Ron Silliman has noted, "The cult of the artist [is] his own work of art. [...] Kenny Goldsmith's actual art project is the projection of Kenny Goldsmith."

The poetico-dramatic form of the soliloquy is further emphasized by the headings of each section. Goldsmith employs dramatic convention to delineate each of his seven days; this *Soliloquy* encompasses seven

acts, rather than stanzas or chapters. It reverts "soliloquy" to its classical form by implying that the drama resides in the language itself. Of course, Goldsmith's usage of the term is ironic, even facetious, in his insistence that his is a "drama" that is not meant to be read, much less enacted. In this he is the sole actor, the only one ever designated to recite this soliloquy—author and star wrapped into one—and performing for an audience of zero, a "thinkership" that is meant to merely be aware that an improvised performance of this type once, and only once, took place.

Goldsmith's soliloquy, however, differs from traditional soliloquy, in that the former is traditionally spoken not only by the actor, but to the actor himself, as an aside: it is the internal monologue *externalized* for the benefit of the audience present. It represents a fracturing of the fourth wall, one of the few accepted violations of the theatrical scenario, allowing the audience in on what they are otherwise unable to access: consciousness itself. Therefore, we could hardly compare *Soliloquy* to the so-called stream of consciousness we find in *Ulysses*, as all of the words included in the book were, in fact, originally spoken aloud to the individuals that Goldsmith interacted with in that particular week. Rather, the work puts on display a *lack* of consciousness, a spillage of mindless banalities— the exact opposite of the literary language established by Goldsmith's modernist forebears, as in this fascinating excerpt: "Yeah. Yeah. Uh huh. Wow. Huh. Right. Right. Right. Of course. Yeah. Yeah. Right. Right. Oh wow. Yeah. Right. Right. Yeah. Yeah. Yeah. Oh, that's great. That's great. How you doin? Going to John's? OK. We were here. Kenny and Cheryl. Hi."

Soliloquy, then, is a transgressive reversal of the soliloquy form; indeed, when reading the work, it is probably not disagreeable to suggest that there is an *absence* of the intimacy and depth of thought one finds in Shakespeare's soliloquies, which Freudian and Lacanian

psychoanalysis would come to revel in as paradigmatic manifesta-
tions of the unconscious.[7]

What about another kind of reader, a reader of the sort that
Goldsmith doesn't anticipate? In fact, the way I read it would likely
piss Goldsmith off. For I read it not as an act of Conceptual writing,
or an instance of poetry, nor as a record of fact, but as a novel. On
this level—a first-person narrative—the work certainly fails, because
of its inherent flatness. Let's turn again to Shakespeare, whose prowess
as a characterologist was unique and radical for his time—his use
of the soliloquy would both allow the character to speak out loud
and ventriloquize the character's thoughts, then dissect them in an
unheralded display of the mechanisms of self-consciousness; watch-
ing or reading a Shakespeare play, one sees a character become some-
one else. None of these qualities are "managed" by Goldsmith qua
character; he remains the same rather shallow and conceited figure
throughout the near-five hundred pages. In this instance, art really
is better than life.

Soliloquy could also be considered as, say, a monologue. A play, a
film. An essay, a document. Even a work of visual art, as Goldsmith
himself admits in act 1, when he is describing the project:

> Here's a here's a new project I'm working on. OK? I'm taking a leap of
> language. I'm recording everything I'm saying say for an entire week.
> I mean it no, I'm always talking about the volume of language that's
> around I mean what what would your language look like if it was if
> you collected every piece of shit word you that you said for an entire
> week. Yeah and what would it look like and you know what form
> would it you know it say you just printed it out and put it in a big
> stack and it's a visual representation of all the crap that you speak all
> week. That see there it's a visual representation of language. It may
> not be exciting but it's a great concept it's you know it could in other

[7] Freud, in *The Interpretation of Dreams*, arrived at his formulation of the Oedipus complex through a
reading of *Hamlet*. Lacan also turned to Shakespeare's hero several times throughout his work.

words that could be I could take the language that I record myself
speaking all week no one else speaking, just the shit that I spew myself
and think now, how could I represent this visually differently? That's
raw material. How could that be represented you know if every word
of language was a drop of water and I counted it out and dropped it
into a glass would this represent my language for a week? You know
how many jellybeans in the jar kind of thing. You know that could be
a really you know and I could have different representations of that
week's language in different forms as visual.

If the work's status as poetry can be questioned, then let's shift our
focus to a larger frame: Why should this work even exist as writing?
Obviously, beyond the immediacy of Goldsmith's spoken voice, the
originary form that the work takes is an audio recording. (As does
Andy Warhol's *a: A Novel*—clearly *Soliloquy's* precursor in this vein,
though Warhol never intended the work to serve as anything other
than a novel, nor attempted to dictate the ways in which it should
be read/considered.)[8]

 This begs the question: what if the reader were to reclaim her au-
tonomy and consider the work without the frame? The answer is quite
simple: the entire Conceptual writing enterprise would collapse. By
ignoring the framer's disclaimer, I, the bad (disobedient) reader, cause
the work to fail. This is because the framing devices that Conceptual writ-
ing works with are, in fact, purely contextual. Whereas the modernist
enterprise was largely oblivious to the reader—an oblivion that cloaked
a respect for the reader's autonomy, which reached its fully articulated
zenith with Roland Barthes's "Death of the Author"—Conceptual
writing is, in fact, obsessed with assuming full control over the activity
of the reader, in spite of its apparent claims to the contrary. Hence the

[8] *a: A Novel* was a "soliloquy" that Andy Warhol recorded by following his "superstar" Ondine (Robert
Olivo) around continuously with his tape recorder for twenty-four hours. However, it was actually taped
continually during three different long taping sessions amounting to twenty-four hours: in August
1965, then summer 1966, and May 1967. All the incidental noises were also included and tran-
scribed in the book, which was described as "conceptually unique." This was the first book that Warhol
"wrote" with his tape recorder (but not the first one he published).

need for the preface, for the explanatory text/essay preceding the main, conceptual work—a text that assumes primary importance over the work itself. One need look no further than the template employed by Goldsmith and Craig Dworkin in their anthology, *Against Expression: An Anthology of Conceptual Writing*, wherein each work included is preceded by a text explaining the compositional methodology employed by the author.

When one considers the work from a different angle, it could be argued that Goldsmith has accomplished little more than boiling down his aesthetic position to a play of semantics. Take a look at his usage of the terms "creative" and "creativity" in the following statement: "Having worked in advertising for many years as a 'creative director,' I can tell you that, despite what cultural pundits might say, creativity—as its [*sic*] been defined by our culture with its endless parade of formulaic novels, memoirs, and films—is the thing to flee from, not only as a member of the 'creative class' but also as a member of the 'artistic class.'" Well, there we have it: an advertising professional admitting that what is now called "creativity" in our culture is but mere formula, and as such, must be run away from in order for genuine innovation to emerge. But wait … isn't "innovate" just another word for "create"? And isn't doing something intentionally "uncreative" just as uncreative, in actuality, as what is considered to be "creative" by our current debased standards? Maybe we are looking in the wrong place for answers. Perhaps our focus should be on the end of that sentence quoted above.

Goldsmith—whose other books of "poetry" include a retyping of an entire issue of the *New York Times* and a transcription of broadcast traffic reports—is not the first writer to endorse the use of plagiarism. The novelist Kathy Acker spoke and wrote often of "pla(y)giarism" in her work, even enduring legal consequences, including a lawsuit from author Harold Robbins for her appropriation of his writing in one of her novels.

It is telling that the legal implications of plagiarism are completely evaded in Goldsmith's work—and surprising, given the fact that one of the other leading Conceptual writers, Vanessa Place, is a lawyer

by day. The willful defiance of copyright and intellectual property laws certainly seems like a radical idea on the surface. Then again, Goldsmith—the privileged advertising creative director turned Ivy League academic—has never been in a position where he has been forced to make a living from his own art. It is this obliviousness to the plight of writers—and let's be specific and say "novelists" here, since few poets are in this category—who depend on royalties that gives Conceptualism a rather disturbing side, and why it is essentially an affair of the elite; one may even speak of Conceptualism as the white-collar avant-garde. In her many public appearances, which have the aura of publicity stunts, Place dons corporate attire and adopts the language of advertising, making her pronouncements in a cold, dry, emotionless voice. Recently, she has gone so far as to launch her own corporation, VanessaPlace Inc., through which, as CEO, she offers poetry "products," such as a limited-edition book of twenty one-dollar bills, sold at a price of fifty dollars. Whether her stance is meant to be "ironic" or not, Place operates from a position that is fully compliant with corporate fascism. Goldsmith, for his part, operates in a meritocratic realm in which being an effective networker has replaced talent and integrity as the key virtue in "getting ahead." Here's one of Goldsmith's many futurist pronouncements: "Careers and canons won't be established in traditional ways," meaning, presumably, based on talent and ability. "I'm not so sure that we'll still have careers in the same way we used to." Having outed himself as a status-obsessed, aggressive networker in *Soliloquy*, the message becomes increasingly clear.

To an extent, we can excuse Goldsmith. Writers working with ideas deemed avant-garde have long had to defend their work via essays, lectures, and interviews. Alain Robbe-Grillet is the most prominent example that comes to mind, an author who had to spend so much time defending his work, so despised and misunderstood was it by the French literary establishment of his time, that the resulting essays collected in his *Pour un nouveau roman* are today as famous as his novels and films.

Goldsmith is on similar territory, only it doesn't bother him the way it clearly bothered Robbe-Grillet, because Goldsmith knows his work is unreadable and actively discourages people from reading it (whereas Robbe-Grillet's work explicitly invited readership). This is all part of Goldsmith's grandest project of all, his agent provocateur schtick. Goldsmith constantly demonstrates, however, that this is nothing more than a schtick; all of his provocations are followed by apologies.[9] With the uncontainable impatience of the arriviste, Goldsmith wants to have it both ways: to be both an enfant terrible and a respected member of the faculty. He makes jibes at the establishment that he so desperately wants to be a part of; all of his theoretical writings and performances—especially his recent reading at the White House, when he was the only "experimental" poet invited for a televised evening of live poetry readings before Michelle Obama—are aggressive attempts at canon insertion.

In the most cynical sense, Goldsmith is truly an artist of our era, if the motto of our era is taken to be, "Let he who is most adept at networking and self-promotion win." But it doesn't take much analysis to see how shortsighted Goldsmith's supporters really are. For what they fail to realize is the troublingly reactionary nature of the entire Conceptual writing enterprise. It is perhaps more than just a mere coincidence that this brand of writing reached its critical peak in the United States during the Bush years. A "school" of writing that bound itself to and argued for the supposed valor of prescriptive thinking, a banalization of language, and procedural, rule-based

[9] After aggressively making the case that Conceptual writing should be considered the *only* significant literary movement of the twenty-first century, he suddenly steps back and realizes there are other sorts of writers standing in the room: "I'm not saying that such writing should be discarded: Who hasn't been moved by a great memoir? But I'm sensing that literature—infinite in its potential of ranges and expressions—is in a rut, tending to hit the same note again and again, confining itself to the narrowest of spectrums, resulting in a practice that has fallen out of step and unable to take part in arguably the most vital and exciting cultural discourses of our time. I find this to be a profoundly sad moment—and a great lost opportunity for literary creativity to revitalize itself in ways it hasn't imagined." Besides the obvious objection—that "literature" is such a general term here that the argument devolves into meaninglessness before it is even fully stated—we might ask: Isn't creativity, by definition, boundless? Why, then, has the time suddenly come to kiss it good night?

work—all hegemonic markers of what the Flarfists would describe as the "New Era." A fetishization of the law, the frame that regulates the flow. Though whereas the Flarfists satirized the period's dumbing down of language and thought in their work by using the tools of mirroring and embodiment subversively, the Conceptualists' approach was dangerously accommodating in its earnestness. As critic Johanna Drucker sums up, "Captured specimens of a linguistic field, conceptual works not only exemplify the crass and bankrupt state of language, its inability to signify with credibility let alone authenticity—they are the discursive formation of an adaptive system bootstrapping itself to the next level of mind meld and social order." No wonder Conceptual writing was institutionalized so swiftly; it was ready-made for institutionalization.

Conceptualism delivers raw information, intentionally resisting authorial mediation, and, even in formal terms, brings nothing new to the table. This is rather dangerous, since Conceptualism is meant to be about ideas, rather than content—at least the *ideas* should be new, as they often were in classic Conceptual art. Conceptual writing, on the other hand, is a practice favored by people with nothing to say, and very little in the way of ability to contribute. It reveals a lot about the dearth of critical thinking in our culture that it has been accepted so widely, even in (especially in) academic circles. It represents a triumph of the New Era.

What its triumph implies is that poetry—as a disruptive force, and that which Conceptual writing positions itself against—is needed now more than ever. In labeling their anthology "against expression," the Conceptualists reveal a lot. For if exprEssionism implies a limitlessness to the bounds of authorial agency when it comes to engaging with the world via art, Conceptualism stands for closedness, extreme reduction, and mechanicity. There is nothing revolutionary about what Conceptualism stands for, and it is difficult to fathom Goldsmith's underlying assertion that there is something particularly radical or novel to this approach. Conceptual art, after all, already "did" Conceptual

writing—that is, Conceptual art very often was a writing practice—back in the 1960s and '70s.[10] Anyone with the vaguest cognizance of recent art history, then, can only regard with suspicion Goldsmith's claim that a practice that originated some forty years ago should be regarded as *the* new avant-garde practice of the twenty-first century.

But, of course, Goldsmith only likes to be reminded of history when it's convenient for him. In one interview, he asserts, "Any notion of history has been leveled by the internet. Now, it's all fodder for the remix and re-creation of works of art: free-floating toolboxes and strategies unmoored from context or historicity"—essentially a repetition of the tired, trite, and naive po-mo conviction that we've arrived at the end of history and are thus somehow divorced from it. At the same time, Goldsmith appropriated one of Sol LeWitt's foundational texts of Conceptual art for one of his own Conceptual writing manifestos, and frequently makes statements that are near replicas of those from Warhol's mouth. What does Goldsmith really believe in, other than the need to assume positions of power in the culture industry and academia?

Once a larger public grew immune to the provocation of boring, repetitious, uninteresting language deployed in their work, Goldsmith and Place quickly realized that they would have to act fast in order to maintain the glare of the spotlight. In March 2015, a week after the US Department of Justice cleared a white police officer on all charges in the shooting death of an unarmed black man, Goldsmith read his new "poem," a reordered and slightly altered version of Michael Brown's autopsy report ending with a description of the victim's genitals, called "The Body of Michael Brown," at a poetry conference

[10] If there was anything radical about it at the time, it was in the way it disrupted the norms of how the art market functioned. Alexander Alberro has already covered this subject in his book *Conceptual Art and the Politics of Publicity.*

at Brown University, eliciting condemnation and disgust throughout the American poetry world. Just a few months earlier, Place elicited similarly negative reactions for her project of transcribing Margaret Mitchell's notoriously racist novel *Gone with the Wind* on Twitter. At a time of profound racial duress in the United States, neither of the two white poets found it necessary to apologize for their actions, instead presenting themselves as would-be victims of censorship and martyrs of freedom of expression. Goldsmith, for one, made a statement in which he felt that his artwork, and all artwork in general, should be considered as divorced from political concerns and evaluated solely on its aesthetic and formal merits. Such an argument—which is nothing new—is intended to excuse unthinkingness on the part of the artist, when in fact *all* writing is political implicitly or explicitly, whether or not one chooses to acknowledge it. Of course, it's hard to do that when there is so little there in terms of artistic integrity; as one respondent put it, Goldsmith's and Place's actions were little more than "cynical means for drawing attention to work that might otherwise not spawn much debate." What's more, they effectively cemented their positions—and that of Conceptualism—on the same side as the law that excused the white police officers for murdering Brown.

Indeed, there was no self-consciousness displayed in Goldsmith's and Place's reactions to the charges of racism and insensitivity leveled at them recently—only the typical cold clinicality of Place, the career lawyer, and the l'art pour l'art evasions of Goldsmith, the would-be dandy with not half the wit of an Oscar Wilde. Can we believe, then, that it is just a coincidence that Conceptualism seems to appeal mainly to people of a certain socioeconomic class and a certain skin color? Is a white-collar avant-garde the true "way forward" for literature in the twenty-first century? Are expression and originality dead because wealthy, white professional careerists calling themselves poets declare it to be so?

While both Goldsmith and Place comprehend the importance of provocation in garnering headlines, neither of the two has proved to

be remotely capable of expression and originality (let alone humor). In order to put forth a convincing argument for moving past something, one should at least be able to prove first that they have mastered it. Goldsmith, along with many of his fellow Conceptualists, comes to writing with the acquired knowledge of the intellectual, rather than the experiential wisdom and burning need for conveyance found in the artist/poet. This is why he is able to take the term "experimental writing," a term most writers are suspicious of—*especially* those writers classified as "experimental" by critics—at face value. This is not to say that writers don't experiment—every artist does; it is a part of craftsmanship. Writing, in its published form, however, is arguably meant to appear *after* the experiments have been done. What the Conceptualists are content to give us is the experiment itself—a curiously juvenile act empty in its transparent attempt at provocation, the result more often than not offensive or just plain boring.

With its strong anti-gestural bias, there is no place, no value for the body-mind machine, for vehicularity, in the Conceptual writing enterprise. Conceptualism clearly favors mind, while negating the consideration given to body in the classical Conceptualist enterprise. This positions Conceptual writing quite far away from the Flarf poets, who integrate the body's functionalities throughout much of the content of their poems. In fact, one might even go so far as to read Goldsmith's dead (in more ways than one) "Body of Michael Brown" as a clear statement of Conceptualism's *violent* opposition to the body, to expression—to *vehicularity*.

This is ironic, since the failure of the Conceptualist enterprise can be readily located within the limitations of Goldsmith's own frame. When we follow his line of thinking all the way to its logical conclusion—something Goldsmith himself appears unable to do—we find that the discourse and criticism the work produces assumes more importance than the work itself. Goldsmith would like so much to just cut it off at the well-polished artist's statement that explains the work; unfortunately, the Conceptualist project is much bigger than Goldsmith

himself projects, trespassing the boundaries of the individual authorial ego, which he still clings to so desperately. In other words: it's not just what Goldsmith says or writes about *Soliloquy* or "The Body of Michael Brown" that is more important than these works themselves, but what his critics write is then also more essential than the actual works—frame and all. It is thus ironic how selective and evasive Goldsmith and Place have been in responding to recent criticism of the controversies they have provoked, more keen on retweeting rare praise for their actions than on responding to the many lengthy and thoughtful pieces of criticism attacking them. For their supposedly ironic stances, there is something profoundly lacking in their sense of irony—which, again, calls into question their ability and their status as poets. (Who has ever heard of a poet with no aptitude for irony and self-awareness?) The uncomfortable truth we reach about Goldsmith is that he turns out to be just as lazy in his thinking as he is in his practice: he might give his thinkership lots to think about, but the conclusions they subsequently reach so often occlude his efforts. Reading Goldsmith, we arrive at no new conclusions, but a sad truth—one, we might suspect, that Goldsmith has fought so hard to conceal: not everyone who claims the title "poet" will actually convince us.

Imploding the Frame

Let's say there is always something outside the frame, lurking or knocking or waiting, unwelcome perhaps or unnoticed—the stranger or the strangeness that refuses to come inside, or that we ignore, or deliberately keep at bay. What happens if the frame breaks and this thing, this otherness, gets inside? Doesn't everything change, the frame as well as each thing it once held apart? And doesn't the fact of our acknowledging it shift our focus, alter the syntax from one of tidy resolution to one that verges on chaos, or cacophony, or meaninglessness, as we enter this suspended irresolute space of rejection and acceptance, until this strangeness is absorbed? It is the pressure of this strangeness that might in fact produce the work of art in the first place; the desire to accommodate it, to bring it into relation with what already is; we might say that what comes to be known of a particular age or spirit has to do with this adjustment, this inclusion, which alters old habits of thought.

—Ann Lauterbach, "The Night Sky II"

Perhaps traditional writing practices are, in fact, a dead end. It could be that writing has finally reached that plateau so long ago attained by the other arts, having left behind its traditional perimeters in polluting the once-sacred spaces of other, formerly autonomous disciplines. Perhaps now is the time for us to take into consideration writing "in the expanded field," to employ Rosalind Krauss's famous phrase for

sculpture. And in order to do that, perhaps we would do best to look at one of those contemporary practitioners whose expanded field bewilders, if not desiccates, the frame.

Though a "video artist" by convention, Ryan Trecartin is also an artist for whom writing plays a formidable role in his overall practice. His work departs from a zone that will be immediately recognizable to most of us. The reality TV script is, by now, formulaic, easy enough to decode by nearly anyone. It's been around now for a generation, the youngest among us has known no other function of television other than constructing and presenting a mediated form of reality. Trecartin's work, and in particular his film *I-Be Area*, is both an amplification and distortion of that script. Reality TV changes our whole perception of reality; reality is now something that you watch on a screen. In *I-Be Area*, we get screen upon screen upon screen upon endless screen. The screen is both filter and transmitter of heavily performed and heavily edited reality. Although there are many different settings, the entire action of the film occurs within a single zone, which is an amplified version of both reality TV and Reality©, a space where all interactions are heavily scripted in order to orchestrate the illusion of chaos and a natural collusion of conflicting wills, a locale controlled by a god whose iterability manifests itself in a total situationality that is occluded by the all-recording digitalized uber-presence. Affectation and gesture become just as important as the text being deployed by the participants in these multi-proliferatory screens; they become the emotive norms that encase the seemingly random collage of words and ideas that form the script—thoughts melting into one another linguistically because one thought can never be completed: a New Real Order of distraction.

There are many different ways of watching *I-Be Area*. It's like taking a different ride each time: There is the participatory way, wherein you join the party, projecting your own zone of being and becoming into the "total minimal situation" that the film proclaims; the narrative engulfment, in which you attempt to navigate the "multilinear" (Kevin

McGarry) pathways that the plot entails; the linguisticolinear tributary, immersing yourself in the piece's pure language stream, finding the sense in the seeming nonsense; imagistic engulfment, giving yourself over to the sensory overload in the film's manic cuts, the repeated strains of neon color, the detailed visual anarchy of the sets and costumes; the energo-intensive path, wherein affectation becomes your beaming guide; the elemental way, in which you attempt to sort out the millions of parts that form the spectral collage of the whole.

In all likelihood, however, your way of taking in *I-Be Area* will combine all or many of these methods, thus putting you in a schizoid delirium that may repel or enliven you, depending on your openness toward destabilization and the manic mediation that forms the fabric of reality TV and Reality©. All of your impulses become amplified, the aim of your desires is no longer certain, stable identity becomes a joke.

It can be a discomfiting ride to take, which makes it all the more worthwhile.

It should be noted, however, that there can be no characterological way of watching *I-Be Area*, because in a topia where identity is so fluid, there can be nothing so solid as character—thus, there is no such thing as a standard linear narrative. Rather, the triumph of simultaneity—both the multiplicity inherent in being and in situationality. (In one of Trecartin's subsequent films from the *Any Ever* series, a character suggests rewriting the US Constitution and replacing the word "God" with "internet" and "people" with "situations.")

If the film can be said to be "about" anything (this "about" is always the worst thing anyone could ask of an artist, as it necessitates *going outside* the work—though we often do), then it is the dissolution of identity into a sort of digital being—a hallmark of the New Real Order. Don't like your identity? Buy a new one online, pay with plastic. Don't react; redact! "Sometimes I feel like a prequel to a horrible person," says one persona early on in the film. This embrace of becoming—a multiplicity of selves (everyone is different people, different genders)—is certainly a generational influence; an abundance of youth marks every

Trecartin statement. Despite the current shadows looming over the "civilized" West, we must keep in mind that the reality TV generation approaches the world with an overload of confidence, unafraid of the consequences of taking risks—unafraid of appearing stupid. It is this latter fact that allows for so much of the vileness of reality-TV, and which *I-Be Area* subtly mocks. "What will I be when I grow up?" asks I-Be after they have been transformed into a new avatarial persona, Oliver. "A production company!" they answer. Media and the means of mediation are newly morphed into one with technology's showboating and accessibility; not only is everything shot in HD, the cameras are often visible and frequently held by the speaking personae. Nearly every line of dialogue in the film is spoken directly to the camera, reflecting a consciousness of the process of mediation, a demolition of the fourth wall borrowed from theater.

Departing from the recurring concept of adoption—of babies, but also, by extension, implying the incorporative becoming of new selves—individuals drift into new personae readily and without hesitation. Everything is temporary, and so the heavy burden of ontological meaning is absent. An avatar can become "a toxic bisexual wearing unstable flip flops" before finding themself a living, walking meme. Dialects and personalities can be picked up and discarded alongside wigs and makeup. Tangible is intangible, and vice versa. Interactions are pure—no psychology, just a superpsychology, overburdened with mediated emotions. "Major" and "minor"—events, personae, substance, objects—become equal and are thus no longer worth distinguishing.

The loss of agency this process entails is not necessarily a bad thing. In the film's "Moms" scene, in which a group of mothers gathers in a middle-class suburban living room in order to vote one of the mothers off the show that the film has suddenly become, the excluded mother proclaims, "I can't believe New Jersey happened to me. It was like writing a book I had no control over." Instead, in such an equalized universe, a realm where agency is absent or

altered, in which subjectivity is therefore spectral and momentary, it all comes down to mattering. "That will be a good day," shouts the excluded mom, "when it won't matter!"

Projectile bodies mattering all over the supramediated normvoid. "Do you know what your dad is?"

"My dad is a building that we lit on fire."

Just as you begin to think it's all like a high-school improv drama class gone totally haywire, the setting shifts and enters into … well, what appears to be a high-school improv drama class. While narrative shifts occur all the time throughout *I-Be Area*, in keeping with the multilinearity that is the underlying aura of the piece, a major shift nonetheless can be detected about an hour into the film. Or, perhaps: a shift of realms. This new realm is a classroom compound overruled by a pregnant authoritarian teacher, Jamie, and her muse, Ramada Omar. Jamie sits with her legs spread wide open and squats constantly while standing, always about to give birth. Ramada Omar rolls around on the floor, squealing, "This is my favorite interactive!"

("It's not phone, you person, go call yourself!" responds Jamie.)

How does all this mattering come to resolve itself in the light of the "total minimal situation"? Perception, after all, can also be a physical object in these heightened terms. Saying is an object; so is this gesture. "No symbols where none intended," Beckett famously wrote at the end of his novel *Watt*, but how to read in the absence of symbols? Do reading and being become intertwined through projection and participation? How does the frame manage to function when its content's aim is to completely decimate the material structure of its container?

We have to see the reality-TV zone for the metaphysical failure that it is. Just as, say, human laws cannot physically prevent someone from committing a crime, our own physical containers can no longer contain us, if they ever did. *I-Be Area* is the drama of this failed containment, a literal and ritual purging of the frame. Don't tell me what something is; rather, inhabit it.

In the end, the personae trapped in the zone of *I-Be Area* are desperate to get out of it, to bust it up. They are constantly picking up hammers, breaking glass, destroying the set, fueling the increasingly frenzied chaos that is the artificial guise of their inhabited voidosphere.

Where to go once one finally manages to escape? Escaping is never about relocation—it is about the very act of escaping. The answer is never "there," more like "there-ing." Perhaps it's too unsettling, this sudden cognizance that there is no final destination, only constant movement in store. If there is any true reality, then it is in the machinic nature of shifty becomings, the drive to escape the inescapable. Perhaps the right attitude is best expressed by one of Trecartin's all-too-"real" personae: "Fuck you and sign out."

With Trecartin's example, we are able to see how far we have gotten away from Barthes's death of the author, arriving at a rather more Nietzschean conception of the uberauthor; the apparent multiplicities of Trecartin we find in *I-Be Area* illustrate the multiplicitous nature of authorship available within this model. I: subject, object; the multiple: the every/any-author, ready to be inhabited. Just like all the objects I surround myself by in my day-to-day.

Becoming Subject

At the root of it, we have the struggle of imposition—that rape-dance language does that is a gesturing toward containment, a process that can never be completed. Nietzsche complained of it in *On the Genealogy of Morals*: that version of morality wherein the aristocracy coins a word for a thing, and in so doing, effectively gains possession of it. Of course, the aristocratic class is also lying to itself, because in point of fact meaning formation takes place on quite other terrain—it is more subterranean and hence geological than anything that might be inferred by a mere word. The sign winds up being, despite our best efforts, wrong; but the meaning is wrong as well—at best speculative; the only thing we may cling to is the fact that certainty is an illusion. Rather than considering this a depressive force, we should see it as the life force that it is; indeed, a total divorce from meaning—were such a thing possible—might be the closest we get to the experience of "freedom," as it is often supposed.

Visual artists working outside the domain of spoken and written language have known this for some time, and now that writing is beginning to enter into the domain of art, the "art world," then it stands to take the trouble—for it is a troubling thought—to articulate the stance once again. There are four things: there is image, there is word, there is sound, there is gesture. We favor the last, gesture, because it is so fleeting. If there is a semiotic equivalent, then it is the scrawl—the mark of gesturality that posits itself somewhere between

word and image, yet is markedly asignifying. It is that thing that can be inferred, but hardly captured.

We could conjure a "wild writing," a writing to come, that positions itself within a cognizance of language's ultimate failure, its impossibility to truly mean, and that frees language from its increasingly endangered position as a vehicle for conveying forms of meaning acceptable to the masses in the so-called information age, and rather utilizes language as a medium for creating new sounds, new meanings. Language against the law, against information. Wild writing would then be part of a tradition that includes the Russian Futurists, the American Language poets, asemic writing … the Stein of *Tender Buttons*, the Joyce of *Finnegans Wake*, the Guyotat of *Eden Eden Eden*.

Who would create this. That is a question. We might conceive of a new means of picturing the creating being. The being-as-object. The *sobject*. The machine … a model that reverts to a physicalist standpoint, refuting the body/mind division of the Cartesian. For mind is but an extension of body, and vice versa. A wild writing would first of all be a writing of the body. One in which body takes precedence over mind, thus: the body-mind vehicle. But what does it mean to become a body-mind vehicle? It means, first of all, that you *program yourself*. When we speak of programming the self, then we leave behind the norms of human psychology and begin speaking the language of the mechanic, the language of the machine. But a vehicle is a very particular sort of machine, a machine that is defined by *movement*, by constant motion. That is what it is designed for; not staticity, not the contained motion of, say, the blender. So: a vehicle is a machine, but a specific kind of machine. Program yourself before someone else does it for you. This should be the ultimate pedagogical aim.

As human beings, we have a quality that distinguishes us from other objects. It is our remarkable ability, not just to create things outside of ourselves, but to self-program. Through self-programming, one becomes an object with agency, a sobject. Sobjectivity is rooted

in the awareness that creation is not merely a mental process, but a physical, bodily one as well. No Cartesian splits are acknowledged by the sobjectivist, the automaticist—by the wild writer. Instead, the principle of extension rules, wherein mind is but an extension of body and vice versa. The sobjectivist is constantly trying to evade the frame, to go outside the territorial entrapments of the socius. Sobjectivity concerns itself with the mechanics of the body-mind machine, rather than the results; hence the machine's *vehicularity*. That is to say, the purpose is the process, the movement, the action—not what it completes. Never the final product. Which is not to say that the final product has no value. But due to the way the rest of the socius has been programmed, and the fact that the automaticist's gesture is a *counterprogramming*, the socius's natural reaction to the final product is one of revulsion and rejection; hence, *Bad art*, a "wild writing," is produced as a critical reaction to the conditions of meaning formation outlined above.

For a "wild writing," a boundaryless etching into the future unknown, a writing that is inherently frameless, it becomes all about extension—the self no longer a self but a vehicle, the writing a trajectory *extending* always outward in countless directions—projective pathways melded to the earth. The earth is alive and all life ultimately sprang from the inanimate. If we are to accept this as a fact of evolution, then it follows that we can't really tell what is alive anymore and what's not. Wild writing would be a part of the hylozoic revivalism that is happening in other fields, such as philosophy (object-oriented ontology) and ecology. No longer any differentiating boundaries erected between the self and the art object, the ground and the sky, the creator and the created. Consider the object as a thing, no different than you, the sobject. Your goal is to infest it with agency, even if it does not resemble verbatim the agency through which you perceive and mold perception. In going, the sobject, self-object, I-object, gives off pollution, which then becomes the art object. It is not the final destination, but a result of the ceaseless movement.

Identity politics was perhaps the last major mainstream attempt to cling to established categoricals as a means of affirming the significance of the subject. With a reconsideration of the universe from the standpoint of the being-object, we begin to see the fruitlessness of identity politics' quest of instance-finding, yet can still find and fight against the systematic forms of discrimination that human objects must combat in their daily peregrinations. Wild writing is programatically against this, all systems. This is what it means to operate framelessly. A robotics of the self need not exclude the political, social dimension, but the tactical considerations will be different for each sobject. There is no army here. Nor can we declare that the sobject has no thoughts, no emotions. But anyway, why give thoughts and emotions primacy over the physical and spectral qualities of a sobject?

Becoming sobject is a way out: a method of leaving behind the old trappings of the self. Sobjectity goes beyond mere thingness in its necessitude to claim a spectral identity, as well as a concrete body-form. It considers that the object, beyond being mere thing, is vision, a perceptive device—a surface filled with ego eyes. The writing that shoots out of us thus forms a scape that runs parallel to the terrain we occupy. A being without the frame, without the law. A ground where wild gesture, constant movement is able to thrive—as this new ground is made out of gesture itself.

II

EX

II •

II •

*Expre*ssionism*s*

II •

*Expre*ssionism*s*

eXpreSSionismS

onismS

II.

eXpreSSionismS
eXpreSSionismS
IfeXpreSSionismS
eXpreSSionismS

The Pervert's Diary

Extraterrestrial spaces are enclosed within the space of the Earth itself.
—Pierre Guyotat

The Bad artist, in some sense, doesn't live in this world—"this world" being the sphere of existence governed by a real or imagined consensus—or else, dwells in this world in order to contaminate it, to draw attention to those things ungovernable by the socius. That which is excessive, that which we look away from in disgust. These things, this scum being the primary focus of artists like Dieter Roth and George Kuchar throughout the duration of their long working lives. As one critic aptly put it, "Roth's five-decade career turned on the provocation of admitting decomposing matter and other dross into sanctioned art spaces, then delighting in the aggressive un-salability of the art that ensued. [...] It's difficult to decide whether Roth's collapse of art into life yielded a radical, Dadaist dispersal or a heroization of the artist as a privileged figure whose every gesture qualifies as art. The answer, it seems, is that Roth achieved both—a position that makes his art by turns fascinating and fascinatingly vexed." One could say that Kuchar, though working in a different medium—narrative film—and with a markedly different sensibility, attained something similar in his six-decade-long career.

"I've always believed in looking in the garbage for inspiration," said Kuchar in a 2005 interview. For Kuchar, the brutal banality of

the everyday bucolic, the scatological, dances with its anti-counterpart, the celestial, in a lifetime project of understanding through his own manic vehicularity. "If we need action," says the voice of Kuchar at one point in *Weather Diary 5* (1989) as the camera pans up toward an ominous gray sky, "we know where to look." The joke is typical Kuchar fare, commingling his frustration with the lack of sexual stimulation cooped up in the motel room he's isolated himself in with the inherent dangers of the locality: the Tornado Alley region of Oklahoma that the filmmaker visited each spring for more than three decades. The artist's body—its functions, failures, and peregrinations across the trashy landscape of a Middle American Nowheresville—is as much the subject, the object—the sobject—as the severe weather that he fears and is simultaneously fascinated by. There is something quasi-spiritual, almost Rabelaisian about the quest. Want answers for the urges troubling us down here? Look to the skies! The result is a seemingly endless, very personal theater of absurdity, the likes of which have no cinematic parallel.

George Kuchar's career as a filmmaker can readily be divided into three discernible phases: his earliest collaborations with his twin brother, Mike, in the 1950s and '60s, when the two emerged as pioneers of the early New York underground film scene (alongside fellow luminaries Andy Warhol, Jonas Mekas, and Kenneth Anger); the chaotic and colorful films he made with his students each year at the San Francisco Art Institute, from the early 1970s until his death in 2011; and his later, more personal diaristic video works.

The Kuchars were not yet teenagers when they began creating their own versions of the B-grade matinee cinema they often skipped school to take in. These early works were inspired equally by the melodramas of Douglas Sirk—George later claimed to have seen

Written on the Wind (1956) eleven times when it came out—as well as the double-feature monster flicks that filled cinema marquees throughout the 1950s—in short, the lowest of the lowbrow. Working with friends and using materials acquired from thrift shops and parents' closets as props and costumes, they used 8 mm cameras and shot on rooftops so as to have access to as much natural light as possible, since, of course, there was no budget for real sets, costumes, and lights.

By the time the 1960s rolled around, they were being feted by the downtown avant-garde for 8 mm productions like *I Was a Teenage Rumpot* (1957), *The Naked and the Nude* (1958), and *Pussy on a Hot Tin Roof* (1963)—even though, with their geeky suits and thick, working-class Bronx accents, they did not exactly fit the hip downtown bohemian artist caricature. As Jesse Lerner notes, "For Mekas and company, the Kuchars were authentic cine-primitives, intuitive naïfs who achieved greatness in their profane innocence."

Although they would continue living together in a shared apartment up until George's death in 2011, the twins would soon go their separate ways as filmmakers and artists, while also embarking upon remarkably distinct life paths. The turning point came in 1965, by which time they had upgraded to 16 mm film. Midway through production of *Corruption of the Damned* (1966), Mike suddenly lost interest and began working on his own sci-fi flick, *Sins of the Fleshapoids* (1966). George would finish *Corruption* on his own, and the two films were respectively the brothers' first solo credits as filmmakers. The following year, George would make his most famous film to date, *Hold Me while I'm Naked* (1966), which has been aptly summarized by Mark Finch: "George is a filmmaker frustrated by a leading lady who runs away with one of her co-stars. He is unable to find a suitable replacement because all his pals are having sex in their showers. He himself takes a shower, interrupted by his mother's call to dinner. Faced with a plate of overcooked beets and other burnt offerings, George wonders whether there is indeed anything worth

living for." The film is notable for its establishing characteristics of what would become George's definitive style, which blackly combines elements of the cinematic fantasy world the artist's imagination had been deeply entrenched in since early childhood with the bitter, harsh reality of a quotidian working-class existence. The blend is effortless—as in the film's opening sequence, with dramatic symphonic music underlining the turmoil of an upcoming chase scene, which is immediately followed by the sound of George's voice fervently directing the leading lady to run for her life as she escapes from an apartment building in a panic. For George, there is no real difference between the *constructedness* of the scene and the *constructing* of the scene; they are both equal players in the cinematic act.

Perhaps the only commonality the twins would come to share in the end was their heavy Bronx accent—you could never be quite sure which you were speaking with on the telephone—as well as their queerness, which often manifested itself through their work in tortuous relation to their Catholic upbringing. Mike, with his long guruesque beard and somewhat withdrawn personality, would embark on a decidedly more spiritual quest—which included a journey to India, where he was spiked with strong psychedelic drugs, an experience that would mark him for life. George, clean-shaven and an outgoing chatterbox, always eager to communicate with anyone around him, was recruited to teach at the San Francisco Art Institute in 1971. He would remain on the faculty until his death forty years later, always teaching the same class, essentially an apprenticeship: whoever signed up for it got to work on a George Kuchar film, either as actor or crew member. By merging his teaching and filmmaking practices, Kuchar managed in this regard to produce an astonishing quantity of films and videos over the years; though no definitive number yet exists, his output is believed to number in the hundreds.

It is the third phase of Kuchar's work, beginning in the 1980s with the wider availability of consumer-grade camcorders on the market, that is worth examining in more detail. While many of the "pictures,"

in Kucharian lingo, retain the lurid, B movie–style titles of Kuchar's other work, much of Kuchar's output from the 1980s until his death in 2011 consists of edited video diaries of the artist's milieu and travels. The work that has arguably been the centerpiece of Kuchar's vast oeuvre in these later years is the *Weather Diaries* series, documenting his annual visits to the El Reno Motel in El Reno, Oklahoma, a series that, in the words of one critic, flies "in the face of all we have been taught about good video-making, good taste, or good meteorology."

While "spring break," in American parlance, inevitably conjures up images of buff dudes and bikinied babes released from college dorms for a week of beer-drenched debauchery on sandy shores, George Kuchar would use his annual time off from the San Francisco Art Institute to temporarily escape the muck of urban life, while simultaneously indulging his childhood fascination with, and fear of, extreme weather. Having lived on either coast for his entire life, his presence in the heartland of Middle America was very much that of a stranger in a strange land. For several decades, he opted to stay in the run-down El Reno Motel. Initially, on these visits, while waiting for the bad weather to arrive, he would read and paint, though eventually the idea arrived to bring his camera along and begin filming his escapades, as he later relayed in a filmed interview.

The *Weather Diaries* have their genesis in Kuchar's childhood, as he explained in an introduction posted online on the occasion of a retrospective screening at Harvard Film Archives: "Since I was a city boy, living in The Bronx, nature came to me via the colorful tapestry of sky that loomed above the tenements. The awe of summer thunderstorms, smothering blizzards and window rattling nor'easters left a lasting impression on me. I sought out, via library books, the superstars of this meteorological majesty and read up on hurricanes, tornadoes and other terrors that occasionally whirled into urban awareness." Elsewhere, Kuchar identified the *disruptive force* of unruly nature as being the prime motivator behind his fascination. This disruption— both as an imaginative entity and a real-life phenomenon that one

could readily follow in the news—provided a welcome escape from the trials of adolescence. "My childhood? It was ... well I guess ... torture, except I was a nature lover, since I was born in a city and lived in a city, New York, all my life, born in Manhattan and then moved to the Bronx at an early age, so I worshipped nature and storms ... anything that came into the city and disrupted it, in a 'nature way.'"

Wild Night in El Reno was the first entry in the *Weather Diaries* series, and is the only one to be shot on actual film, with Kuchar's old Bolex camera that he used throughout the 1970s. The silent film, dating from 1977, clocks in at less than six minutes in length, and is in some ways the most abstract entry in the series, consisting purely of images of raging winds and electric lightning in the sky and landscape surrounding his motel. Considering its purely visual nature and lack of any narrative structure, it would perhaps be more fitting to regard *Wild Night in El Reno* as the prologue to the *Weather Diaries*.

By the time *Weather Diary 1* was made, some nine years later, the technological landscape of the audiovisual world had shifted to become more democratic, in some ways, with the wide availability of affordable VHS camcorders on the market. Kuchar moved with it: his shift to video was complete. Kuchar began working with a VHS camcorder in the 1980s because, in his words, it was a "despised medium," ugly and amateur: the stuff of home movies, maybe, but hardly the correct vehicle for high art. Not everyone was fond of Kuchar's transition:

> Well I know when I started making video, I did in a way disappoint, or *anger* some people, or they thought I was making *crap*. Of course I was beginning making video so I was just trying to develop my style, get a feel for it, and learn how to edit in the camera, and do everything in the camera. And very few people encouraged me. But there were those people who did encourage me, after seeing some work, and told me to please go on. Which I would have *anyway*, but, ah, very few people did encourage me. Very few *filmmakers* encouraged me.

Indeed, for those accustomed to more polished cinematic presentations, Kuchar's crude, diaristic VHS works are hard to digest. Upon initial viewing, it is easy to write off the *Weather Diaries* as the work of an artless amateur—were it not for the fact that Kuchar is, in fact, an avid stylist very much aware of the crudity of both the medium and his vision: "The movie develops its own style, when you see what you have and you see the limitations, and you work with the limitations, the style begins to develop." With his great gift of prescience, Kuchar immediately sensed that the most interesting way of dealing with video's limitations would be to exploit them. The resulting oeuvre can be read as a single, continuous opus with individual films serving as chapters, ranging in length from under ten minutes to over an hour. Stylistically, it is neither home movie nor lowbrow art, but perhaps a little of both. It forms a self-portrait of the artist—his journeys, his friends, and his daily motions—all transmitted through Kuchar's self-deprecating, Bronx-accented narration. Beyond that, the Kuchar oeuvre is also an archeology of the banal, the budget of each film being the price of the VHS cassette tape it was shot on (and, often, the fast food and snacks we watch the filmmaker consume on camera).

Contrary to his critics' objections, Kuchar's move to video was very much a deliberate one, motivated by a range of aesthetic and personal factors—which, for Kuchar, were always one and the same. In a prolonged meditation on the differences between film and video, Kuchar explained how these considerations informed his decision. "I got attracted to video because it was a despised a medium, and because film got to be too puffed up financially for me." When he was working in film, the financial constraints often affected not only the production, but the final output. Kuchar was thus forced to evolve a cinematic language that he described as "shorthand":

> Film, I tried to squeeze the essence out of each scene because each
> scene was expensive. I don't really know if that was on my mind while

I was making it, but I did know I had a certain language in film. And that was like, do away with extraneous scenes like coming and going out of doors and telling people where you were and who these people were. Just have them go around doing their business, and their business, while you're photographing, should be very high key, at that moment. Emotional peaks. So that became my movie style.

While his turn to VHS might have shocked critics and fellow film-makers, Kuchar saw little essential difference between the two media:

I look at it as—you know, it's stock, and, ah, you slip it into your cassette player and it gets thrown onto a screen, and the screen's a hell of a lot smaller, but, it's fine with me. I will always enjoy going to the movies. [...] And I enjoy making movies ... But ... you see, I made a lot of movies and I don't really know how I made them. I don't know how I put all that effort into making them. And I've been sidetracked so often, I've been hit with such terrible vices ... that I don't know how I managed to pull off the pictures. But, for some reason, maybe in order to overcome my vices, or, maybe that movie-making was a vice on my part, I was able to turn out these things and go through all the steps that you have to go through making a movie ... And then you go into the lab, you bring it in, you get your movie and there's the premiere and people look at it and ... of course it's like, how did this horror ever get made? So ... making movies is a very peculiar thing. But if I have difficulty ... am paying $600 or $700 for a 20-minute movie, you know, that gets shown on a screen and gets pooh-poohed because it's either not "politically correct" or for some other reason. And I could make something that's even more offensive for $6 or $8, and that's so offensive it would even offend the filmmakers—because I'm workin' in video. I would option for the more offensive medium.

Thus, the reduced content of Kuchar's video works purposefully sets out to match the medium's inherent constraints. Despite the title, in

the *Weather Diaries*, much of the footage is centered on Kuchar's motel room: a collage of banal narratives ultimately veering into the grotesque (as we are constantly informed of the artist's canned-meat and fast-food diet—and its gastrointestinal consequences) interspersed with weather reports from television and radio, as well as "action" shots of the (impending) storms outside the window. Occasionally, he ventures out for strained interactions with the locals: In *Weather Diary 5*, we accompany Kuchar to the empty beauty salon, where the proprietress gives us an in-depth tour of all the hair products. In *Weather Diary 3* (1988), he befriends a student storm chaser staying in the room next door. His romantic infatuation with the young man is rooted more in Kuchar's own awe of the meteorology student's bravery than a straightforward sexual attraction—not to mention the artist's boredom.

After all, what becomes immediately apparent, in *Weather Diary 1* (1986), the first and—at seventy-five minutes—longest tape in the series, is the inherent boringness of the endeavor. For a lifelong city resident like Kuchar, his three-to-four-week stints in El Reno each year can be excruciating, forcing him, as they do, to confront the existential muck of life that one is otherwise able to ignore in more lively environments. The irony of weather, of course, is that it is really only interesting when it is severe. The raw facts of meteorology—as Kenneth Goldsmith's 2005 tome, *The Weather*, a transcription of a year's worth of hourly weather bulletins on a New York radio station, makes clear—are boring. "Not much goes on in this town," Kuchar notes in *Weather Diary 1* over a montage of scenes from the El Reno town center, with its limited range of remaining Old West historical relics. "Whatever did happen, came and went."

Weather's other main quality is its unpredictability. One never knows when or where the storm will manifest. In yet another of his many nostalgic ruminations on his childhood storm obsession, Kuchar notes,

Yeah, I did like storms, and *twisters*, tornadoes. I don't know why. I think in the '50s a big one had gone through Worcester, Massachusetts. And I guess there was talk about it in New York, and it was in the news, and for some reason it excited me. The great storm smashing up towns, and blowing into people's lives, and changing it. Not so much that I was interested in the carnage, but the fact of … whirling clouds and big winds and stuff like that. It was weather on the rampage, it was nature unleashed, nature loosed. It was dramatic. From all descriptions the sky is a weird color, the clouds are *boiling*, and etc., etc. It struck my fancy. And I think most people that are interested in meteorology are fascinated by that particular character in meteorology, the tornado.

Inevitably—and perhaps fortunately, for Kuchar's well-being—the tornado never hits El Reno, but nearby towns in Oklahoma. Thus, he spends a considerable amount of time filming local TV news footage in his hotel room.

What else is there to do? He watches *Godzilla* on television. He spies on his neighbors from the window—denizens of the trailer park across the street and the few other guests of the motel; he gossips and speculates about the motel owners' personal lives. He becomes fixated on Gloria, the absent daughter of Ruth, the establishment's elderly matron. At sporadic moments when boredom threatens to overcome him, he intones her name. Near the end of the video, which is crammed with a sudden burst of social activity—as though the light of immediate departure has filled our cinematic guide with the sudden desire to spend as much time as possible interacting with those around him, all the freaks and unknowable human detritus of white-trash small-town Americana, whom he previously dreaded encountering—we learn from Ruth that Gloria's husband has recently left her after she caught him in bed with another woman down in Houston, where the couple had been living. Kuchar's sole companion is a stray dog, Runt, who follows him around on his nature strolls around the motel, and who, according to Kuchar, "smells terrible"; in

one of many scenes of grotesquerie, Kuchar refuses to allow the dog into his room because he has been "rolling around in dead animals."

Rather than interacting with others, Kuchar turns his focus constantly back to his own body and its lower functions—particularly the flatulence and state of his bowel movements resulting from a pure junk-food diet and total absence of fruits and vegetables. As Margaret Morse wryly notes, "The tape ultimately addresses all the big questions—death, origin and family, religion—as well as the small discomforts of the body, only to reverse their order of importance."

At the same time, we begin to understand Kuchar's horror of those around him when he manages to get himself invited to Ruth's Bible study meeting near the end of the tape. "I like Ruth and Roy," Kuchar narrates. "They're decent people. Decent enough to try and convert me to the Cult of the Christianities! Of course, I went when I heard that refreshments were going to be served." Surrounded by Great Plains church ladies of a certain age, Kuchar begins to feel the absurdity of his presence in El Reno. When queried on his religious predilections by Ruth, he responds, "I was a Catholic. I became a hedonistic sinner."

"What's that?" Ruth asks.

"Well, I was a Catholic. I would go to church all the time, but I would pray for the wrong things. And unfortunately, I got them."

The clash of values signals it's time to go back to the safe confines of the city. Until next year …

Just as Kuchar has a love-hate relationship with El Reno, his relationship with mainstream cinema has always been one of give-and-take. While there's nothing here resembling a conventional plot, the action is always fast-moving, with most shots in the Hollywood three-and-a-half-to-five-second range, thus refuting the strategic slowness on which oppositional strategists of "art cinema" so often rely. Kuchar, then, can be thought of as *anti*-anti; his art is the deployment of a deliberate artlessness. With its wandering gaze, lo-fi effects, and obsessive need to document and find meaning in the unspectacular,

Kuchar's vision remains, in spite of itself, one of the most endearing in American cinema.

Weather Diary 1 is the longest video in the series. By the time *Weather Diary 3* rolls around, Kuchar has reduced the films to the episodic temporal structures of television. The video opens with a shot of water boiling in a pot on a hot plate in Kuchar's motel room. Cut to a close-up of Kuchar's face with a serious expression, an expression that can be read as somewhat psychotic, as it is accompanied by stabbing music à la Hitchcock's *Psycho* (1960).

"I ruined my welcome," Kuchar laments, as he spills hot water from his teacup onto the "Welcome" paper towel beneath it. For that, the gods seem to be punishing him: the video cuts to a weather shot of a pristine sunny day. There are thick white clouds on the horizon, true, but they hardly look threatening. Rather, they are fluffy—much like the paper towels obsessed over in the opening shots.

Kuchar walks down the railroad tracks toward downtown. With a large hole in the knee of his pants, he looks something like a hobo. He cannot buy pants in town, he informs us, because all the clothing for sale here is made out of itchy polyester. Shots of small-town Americana, scenes that appear quaint and idyllic at the outset, until one considers the possibility of living there and is immediately reminded of the sinister horror of eternal boredom that such places inevitably deliver. Kuchar has never learned to drive, and thus is always quite stuck on these annual sojourns to Tornado Alley. This is why, as he tells someone later on in the video, he has never been able to become a storm chaser; rather, he identifies as a storm squatter.

In town, Kuchar picks up the photographs he had dropped off to get developed. They are mementos of his recent trip to Ohio for a film festival in the town of Athens, which he shows us. Interspersed with them are photos of his cat back in San Francisco, as well as his brother.

Directly outside his room, two Chihuahuas in a wire cage bark ceaselessly, much to the artist's annoyance. For diversion, he wanders about with his camera, spying on shirtless young men playing football

and swimming at a nearby pool. A medium close-up shows Kuchar licking his lips. "Hot," he says—referring more to the sight of the young men's bodies than the weather, of course.

The "heat"—in the double sense of the term—of the previous scenes is then relieved. We are subjected to an extreme close-up of what at first appears to be torrential rains, but then reveals itself to be the shower in Kuchar's motel room, where the artist is subsequently shot masturbating.

Meanwhile, the dogs outside continue barking. Standing outside amid the barking animals and a group of neighborhood children, who smile and stare into the camera shyly, Kuchar states in a graven voice, "Those things wake the devil in me. All fury and caged lust. I know exactly how they feel. The dogs ..." Cut to a close-up of the uncooked hot dogs that appear to be Kuchar's sole means of sustenance these days. The sequence is concluded with a montage of close-ups of the hot dogs in boiling water on the hot plate and Kuchar's erect penis as he masturbates in the shower. To conclude the string of visual metaphors that much of the video has consisted of thus far, we see shots of a local baseball game. "It's a paradise of balls and bats," Kuchar's voice deadpans over the scene.

Nearly ten minutes into the video, the entire tone of the work changes abruptly with the arrival of Mike, a twenty-one-year-old storm chaser staying in a room next door. Although he is not identified as being a prior acquaintance in the video, Kuchar later explained in his Harvard Film Archive text, "He was someone I met in Wisconsin at a screening of my films/videos a few years before. This was his first visit to Oklahoma to chase tornadoes, but the storm season proved to be a dry one. His presence lubricated me on a more personal level, and our friendship helped to sweeten the sourness that happens when nature doesn't 'put out.'"

Indeed, Mike becomes the focus of the rest of the video—much as he becomes the (secret) focus of Kuchar's lust. The two while away their time hanging out in El Reno, eating junk food, talking in their

motel rooms, and walking through the town together. "Oh, wow!" exclaims Kuchar on one of these walks. "Look at all the good stuff in Walmart!" Quick cut to the toilet bowel in Kuchar's room, where a bunch of the artist's turds are floating …

Kuchar's and Mike's hatred of El Reno is shared, but both are temporarily stuck in a sort of *No Exit* game—Kuchar in his self-imposed exile, Mike as he awaits the bad weather that will bring with it the National Storm Laboratory's truck that he has been granted permission to ride in.

Finally, Mike arranges to have a friend with a truck come rescue him from the state of perpetual ennui that is El Reno, Oklahoma. "I'll be sad to see you go," says Kuchar as they await the friend's arrival.

"Yeah, these past few days have been a lot of fun, but this place is killing my soul," replies Mike.

The friend finally arrives. The truck is seen pulling out of the motel's empty parking lot, leaving Kuchar alone as he was at the beginning, in Dead Soulsville. In the closing sequence, we see him wandering shirtless through an empty field—no friends in sight, no bad weather on the horizon—just the brutality of the early summer sun. He entertains himself with the reading material brought on this trip: male physique mags, *Fangoria*, UFO books and magazines, and a copy of *The Abominable Snowman*. The show must go on, after all, and the camera keeps rolling, until the video fizzles out into its anticlimax.

Each *Weather Diary* entry proceeds according to its own situational and formal logic. For instance, *Weather Diary 6*, shot in 1990, is more about portraying Oklahoma as a bizarre danger zone among the bucolic banality of the Great Plains states; in the absence of bad weather, after all, one has to improvise. Unlike previous tapes in the series, the entirety of the tape was edited to include a soundtrack of music. Since they were children, the Kuchars obsessively collected

vinyl recordings of film scores, which they plagiarize gratuitously in their own films—often to very comic effect. In fact—hardly a usual obsession for cine-buffs—Kuchar even became obsessed with certain cinematic composers such as Bernard Herrmann, Franz Waxman, and Alex North. As a teenager, his choice of what film to go see would often be determined by which composer had scored it.

Weather Diary 6 is a good example of how music is utilized as one of the pivotal components of Kuchar's frameless, cinematic writing. The video opens with a shot of a vintage postcard reading "Hay from Oklahoma!" and featuring a photograph of a farmyard with bales of hay and a rainbow in the distance. The following intertitle, painted in Kuchar's own flashy cursive, reads "Scenes from a Vacation." Quaint symphonic music plays as a montage of images of ducks on Lake El Reno going about their business on a sunny day unfurls. Kuchar is seen in his motel room, seated on the bed and reading a book called *Confrontations: A Scientist's Search for Alien Contact.* (Kuchar's sporadic encounters with UFOs throughout the 1970s, a subject of numerous films and videos, give his obsession with the sky a further significance.) This is followed by shots of the sky in various phases of temporal and climatic conditions.

There is considerably less of Kuchar in *Weather Diary 6* than in previous entries to the series (barring, of course, *Wild Night in El Reno*, in which he does not appear at all). While his voice chirping animatedly from behind the camera is a fixture of nearly all his diaristic video work—and film work, stretching back to at least *Hold Me while I'm Naked*—no other sounds except for music can be heard in *Weather Diary 5* (save for a short segment near the end, when a local weather report on a severe tornado is recorded from his motel room's television set). As a visit, this one is clearly a bit of a disappointment for Kuchar; the sky constantly veers into near-disaster, with vintage horror music accompanying each dive, but then always returns back to idyllic sunniness. (In this sense, the visit is similar to that recorded in *Weather Diary 3*, which is

largely a recording of Kuchar's encounter with a storm chaser.) Indeed, one of the most attractive features of the weather for Kuchar is its inherent unpredictability; nature is something that simply, by definition, cannot be controlled. As his brother Mike pointed out, this indicates one of the key differences between the two brothers' aesthetic approaches to making films: "My brother's latest films are a sort of diary or interpretation of the world around him. Me, I'm sort of a control freak. My brother, he goes to visit and whatever happens, happens. His are sort of unpredictable. With mine, I kind of direct more."

With regard to the question of directing, the *Weather Diaries* in particular takes on a more documentary approach—the few scenes that do seem staged have an improvisational feel, and are often the contrivances and depictions of Kuchar alone—and most of the "directing" thus takes place in the editing room, with the addition of sound effects, music, and extraneous narration. (It should be noted, however, that with other projects, namely, the student films, Kuchar continued to "direct" in a conventional narrative cinema fashion.)

Then again, directionlessness—or the seeming state of directionlessness—is very much Kuchar's direction—his "line of flight," to put it in Deleuzo-Guattarian terms. Like Ryan Trecartin's work, Kuchar's videos can be seen as yet another example of writing outside the frame. And that which moves this particular method of writing is a wandering agency, as opposed to a static agency.

Writing, in fact, is everywhere in Kuchar's work. One could say he is just as much a writer as he is a filmmaker—if not more so. In the book he coauthored with his brother, *Reflections from a Cinematic Cesspool*, George wrote the majority of the text, which serves as a showcase for his outrageously florid prose:

> Realism only comes to the screen when the film jams in the projector
> and the image begins to bubble. An instinctual fear of the dark manifests
> when the projection light fails ... heightened by the little furry things

with long tails that scamper beneath the seats. The electrical nature of sex becomes apparent as the hair on your neck bristles when that pervert to your left makes knee contact. In these moments of truth, cinema reveals her face of realism. But she is a two-faced creature; the other countenance being a rainbow palette of dyed coiffures, pancake makeup and pancake-bloated guts crammed into costumes designed by cock-eyed midgets for superstars who beat their children with wire coat hangers and then peddle soft drinks potent enough to rot their dentures.

Writing, for Kuchar, is a sort of machine, one in a state of constant generation—which is why, in a sense, he can never shut up in most of his videos. For that would cause the entire machine to break down. Kuchar is an automaticist.

What is automaticism, anyway? It is a particular way of working that we find in a lot of the artists engaged in making Bad art—or at least what we are calling Bad art here. It is rooted in the awareness that creation is not merely a mental process, but a physical, bodily one, as well. No Cartesian splits acknowledged by the automaticist, by the Bad artist. Instead, the principle of extension rules: wherein mind is but an extension of body and vice versa. Do not let that "vice versa" confuse you, however: for the automaticist, the body always comes first in the equation. We can thus conceive of the automaticist being as a body-mind machine. As a machine, what automaticism essentially means is you program yourself. For the automaticist does not merely conceive of herself as a mere machine, but as a particular kind of machine—one that defies the staticity that harnesses most human beings to a particular mode or frame of existence. The automaticist is constantly trying to evade the frame, to go outside the territorial entrapments of the socius. For that reason, it is best that we call the machine what it is: a vehicle. For vehicles are defined by motion.

The Bad artist, then, is the self-contained machine whose sole purpose is movement, motion. The *work* produced is Bad, because it is but the by-product, the *exhaust*, of the process. This is why, as is so

often the case, what we find is a triumph of *quantity* over supposed *quality*—the latter is annihilated in the explosion of the former.

Kuchar's vehicularity was most pronounced in his switch to video—anything necessary to keep the vehicle in constant motion, without slowing down—despite the resistance he met with among fans and colleagues. Those voices, Kuchar realized, did not belong to the people expressing their disapproval: they belonged, in actuality, to the law.

"From the point of view of a supposed transcendence of the law," write Deleuze and Guattari in their book on Kafka,

> there must be a certain necessary connection of the law with guilt, with the unknowable, with the sentence or the utterance. Guilt must in fact be the a priori that corresponds to transcendence, for each person or for everyone, guilty or innocent. Having no object and being only pure form, the law cannot be a domain of knowledge but is exclusively the domain of an absolute practical necessity: the priest in the cathedral explains that "it is not necessary to accept everything as true, one must only accept it as necessary." Finally, because it has no object of knowledge, the law is operative only in being stated and is stated only in the act of punishment: a statement directly inscribed on the real, on the body and the flesh; a practical statement opposed to any sort of speculative proposition.

If the law is pure form—the empty frame—what content is it meant to contain? What is the law's non-object, as mentioned by Deleuze and Guattari above? The answer: bodies.

For many Bad artists working from the wandering stance of body-mind vehicularity, the "badness" of their project seems to imply an exaggerated assertion of body over mind. This is articulated quite well by Kuchar throughout the *Weather Diaries*, particularly with regard to his own body and its base functions.

Kuchar views his body and its functions with a mixture of shame, disgust, and degradation, yet he can never, ever resist turning away

from it—it might even be said that the artist's body is the sole focus of the work. Even when the camera's gaze is focused elsewhere, the sky, it enters into the scene through reference in one of Kuchar's breathless, eternally punning monologues. Kuchar's obsessions, one might say, are perverted, though one must also keep in mind that perverts are the sole creation of the socius—that is to say, the law. In Kuchar's particular case, as is made perfectly clear in the closing segments of *Weather Diary 1*, the law that created this particular pervert was the Catholic Church. Some perverts are eternally stigmatized, unable to live with the burden imposed upon them, while others gladly revel in the delights of this burden, going so far as to impose them upon others—whether through their art, their activism, their quest for "community," for mutual indulgence ...

These represent two different ways of dealing with, confronting the law that has created you, the Pervert. Either recognize the sovereignty of the law and submit to it: live a life of shame. Or, the alternative, what we might call the Pervert's Recognition: *The law was created for the sole purpose of being broken.* As Deleuze and Guattari state, the law has no content, no truth—it is but empty utterance, devoid of meaning beyond its own assertion of governing presence. Before the law existed in this hovering ghost state, it was not possible to break it; thus, there was no perversion. Normality is, in fact, an effect of regulation. Program your vehicle to substitute your own law for the Law: to make your content overflow the governing form, the frame. This is akin to Deleuze and Guattari's conception of a minor literature, which can only exist in relation, in constant opposition, to a major literature.

We might go even further here and brand Kuchar an invert. Not just a homosexual, but one whose sexuality is turned *in*ward. To himself, his own body-mind vehicle, his own functions and processes. He is, of course, obsessed with the bodies of others, but those other bodies appear so distant and foreign to him, the closest thing he can grab is always his own—and he does so, repeatedly. His sexuality is

not antisocial, but against the socius. (For the pervert, the invert, recognition of the socius yields a distrust of the entire species; a negation of the perceived— because *imposed*—value system of the collective whole.)

Catholicism, the socius: both law. Another form of the law, however, is the Hollywood system: the major literature to Kuchar's minor. While enthralled with Hollywood melodramas in his youth, Kuchar never attempted to break into that mold of filmmaking, never tried to infiltrate the system with his vision—or, rather, allow his vision to conform to that law's dictates. Moviemaking in Hollywood, Kuchar sensed, "seemed too much like a job," as he stated in a filmed interview. The body-mind vehicle doesn't *work*; it just goes. But it is not as though Kuchar simply ignored it as a model. Rather, he inflected it through his own work: through his movies, through his writing. Kuchar's Hollywood:

> Aging women take endless enemas so as not to wind up in horror films and virile he-men doomed to an excruciating regimen of exercises keep their sodomized posteriors picture-perfect. EST trained actresses show the world what it is like to be liberated and free of cellulite. Alcoholic celebrities barf up their past in book form so that all can marvel at the hideous mess that has been cleaned up by a Christian re-birth. Harpies with herpes rip apart, in print, plump fornicators whose every performance they slander with type-set juju curses. Innocent children sing and dance down the yellow brick road to drug addiction and toxic box office poison. This is the other face of cinema ... the side that sells tabloids and makes legends; a trillion dollar heritage of human refuse devoured by a cyclopean eye designed to entertain, to titillate with tit, to teach. THE art form of the 20th century.

The difficult entry point for many to appreciating Kuchar's *Weather Diaries*—and, indeed, the vast majority of his video works—besides their content, and its oppositional stance to the Hollywood model—

is their personal, diaristic nature. Other writers have noted the prob-
lematics of the diaristic mode in contemporary art-making practices.
Chris Kraus: "I teach a diary-writing class in an MFA Studio Art
program. Here, diary-keeping is not a popular art. It sounds too much
like something girls do. *Theories* of subjectivity sounds sexier and more
important. Since diary-writing is subjective practice, it's more fragile,
looser, messier. As a transcription of live thought, diary-writing's des-
tined for confusion because *the mind does not stay still for very long*. As
an art-making practice, it's *incoherent* and therefore essentially *flawed*."

Part of the "problem" of the diary mode is that, by definition,
it is not intended for an audience. Address yourself to an audience
of zero, which is to say: to yourself. What does it mean, then, to go
and publish that diary, to present yourself unedited, as a work of
art, to the harsh, uncomprehending masses? Kuchar long had an
aversion to theory, refuted identity politics, wanted his work—when
he wasn't sarcastically denigrating it—to be viewed on its absolute
own terms; he would rather have it disappear than appear under the
scrutiny of someone else's "theory of subjectivity."

We could go even further and say that the fact of filmmaking
here is accidental—that Kuchar's art is his roving personality, which
just happens to be captured on film. The extension principle once
again: the camera becomes an extension of the artist's body-mind
vehicle—much like his voice. Like Ryan Trecartin, Kuchar offers
an example of a *total writing*—a record of pure mind. Thus: total
flawed incoherency.

The Everything Artist

What is an Everything Artist? Difficult to say, though perhaps the best example to date would be Dieter Roth, who worked his way virtuosically—or else recklessly—through every medium, who produced his work in excess—in the same manner that he lived his life—and therefore eroded all distinctions between his life and his art; indeed, the latter became much more than a mere extension of the former. How did he manage? It seems as though his filters were simply turned off. That, or else the filtering process was so mysterious that no one really understood the mechanics except for Roth himself. Filter/frame: every type of material, organic and synthetic, was allowed into his universe. It is perhaps fitting that much of his work is now undergoing the sort of processes that the human body endures once life has vacated it. For Roth, art and the body were one and the same: a dying, rotting, but above all living, enduring material. Born under a reign of fascism—1930s Germany—he took up the cause of formlessness as a means of revolt against a certain world that would lay in ruins by the time he reached adolescence.

As a vehicle, despite his amazing productivity, the astounding, inestimable amount of exhaust produced as he moved across the European landscape throughout his life, Dieter Roth was fueled by doubt and uncertainty from early on. While his devotion to art emerged at an early age—his brother recounts how, as a teenager, he would go off in to the forest alone for hours, only to reemerge with

beautiful paintings under his arm—by the time he reached twenty, he had decided upon poetry as his true vocation. He cofounded a literary review with two friends, yet when he brought his own poems to the table, they were rejected by his coeditors. Although he would never quite turn his back completely on writing—it permeates his entire oeuvre, and up to his death, whenever he met people who were unaware of his "true" vocation, he would always tell them he was a writer—one might surmise that the devastation of this early rejection sparked an implosion that effectively kick-started his vehicle.

Before he reached this frenzied phase of vehicularity, however, he would have to pass through another roadblock, one of fixedness and rigidity: one rooted in the geometric utopias of Constructivism. From the failure of literature, the young Roth needed a solid, preestablished language in which to ground his position in the world. The resulting paintings, sculptural work, and furniture were predictably academic, by and large. The American art critic Donald Kuspit credits an encounter with Jean Tinguely as the breaking point between Roth's early and mature styles.

The key work here is Tinguely's *Fragment from Homage to New York*, a machine that was forged out of junk and refuse and designed to self-destruct, which it did in the garden of New York's Museum of Modern Art in a performance that lasted less than a half hour. Nevertheless, the spectacle would play an influential role on the development of Roth's art in the subsequent decade, and established Tinguely as something of a post-Duchampian agent provocateur. *Homage to New York* was comprised, among other rubble, of "wheels, motors, bikes, baby carriages, and assorted gizmos"; an antique Addressograph machine; and a contraption forged by Robert Rauschenberg that would fling silver dollars into the audience. The machine was shaped like (and contained) a piano, and over it was suspended an enormous balloon. Part of the spectacle of the performance was its near failure; indeed, it almost didn't happen. On the evening of

March 17, 1960, a massive crowd turned out for the well-publicized event, including such luminaries as Governor Nelson Rockefeller, as well as reporters from around the world. The audience was kept waiting for several hours as technical glitches were sorted out. When the machinery finally did get rolling, in the words of Jed Perl, "the piano barely played, Tinguely's self-drawing machine barely drew, and other parts of the meta-matic turned or twisted in ways that the audience couldn't see. There were tons of smoke; a radio went on but was barely heard, and through it all Tinguely walked around, delighted by everything that was happening." However, the disaster of the performance and the media spectacle it provoked have become inscribed within its legend. As the research scientist Billy Klüver, who would assist Tinguely and Rauschenberg on projects throughout the 1960s, reflected, *Fragment from Homage to New York* was a work that emerged "out of the chaos of the dump and back again."

It is easy to understand the excitement the young Dieter Roth must have felt at this first encounter with Jean Tinguely's contraption. Here was a machine that completely serviced the doubt that had been welling up in Roth his entire life: a machine that declaimed its status as art, only to end up in ruins, which the audience then descended upon and swept up in their pockets and purses to take home as souvenirs of the spectacle. Art as self-destroying machine. At the same time, that machine was designed by a maker with the built-in intention of suiciding. What implications could such a model have for the Romantic deitous notion of the artist as creator-of-worlds? What happens to the sense of value that is meant to be attributed to the creative endeavor? Art's eternal endurance throughout the duresses of time?

Some critics accused Tinguely of reducing expression to mere spectacle, thus ridding the artistic gesture of any real potency. "This is what social protest has fallen to in our day—a garden party," bemoaned a critic from *The Nation*. But was Tinguely's *Homage* really a gesture of social protest, a statement of the ultimate futility of all art?

Instead, I would like to suggest that it is perhaps more useful—and, indeed, less lazy—to look for something positive in this negative gesture: namely, the beginnings of a theory of authorship, from whence we might understand the dramatic turn that Roth would take in his subsequent work. Even before we have the death of the author (for Barthes's famous essay would not be published until 1967), Tinguely gives us the death of the object. And, with the accompanying spectacle, the spectacle that would launch Tinguely into the newly emerged orbit of art stardom, what we have here overseeing the object's destruction is certainly not a dead author; if anything, Tinguely assumed the role of uberauthor. Certainly, we find in Tinguely's self-destroying object the visual equivalent to what Barthes identified as a cacophonous array of voices and styles united within the messy "singularity" of the thing. In a visual sense, once the object is liberated from the author, the visual referents composing the thing are imbued with a total autonomy; viewed from this zero-degree perspective, Tinguely's *Homage* is all visual anarchy, an asemic assemblage whose *death*, then, makes total sense. What is at stake here, of course, is meaning, and how it gets assigned and formed. Barthes put the task in the hands of the reader; as he famously concluded, "We know that to restore writing its future, we must reverse its myth: the birth of the reader must be ransomed by the death of the Author." Barthes was right, to an extent; what he failed to take into account was the power structure inherent in the economy of reception—that is, reading is, for many, yet another form of writing, and certain readers and the readings they produce come to be seen as definitive for the rest of the readers, who play a smaller role in the system in which dominant and lesser meanings are produced, packaged, and sold. Having a major spotlight on the vast stage of the critical enterprise, Barthes conveniently overlooked his own position of authorship in formulating his quasi-populistic theory. Barthes fell victim to the Marxist ideologies in vogue at the time, and his failure in this instance was a failure of the imagination: he was unable to

see what a total collapse of capitalism might look like for artistic practice. As implied by anarchist Hakim Bey's notions of immediatism and "temporary autonomous zones," a veritable dispersion of authorship would imply the becoming-artist of every human being on the planet.

We are too realistic to imagine such a thing happening in our lifetime, though one may always dream. Besides dreaming, we might also take the time to revise Barthes's spurious notion of authorship via Tinguely's machine. Let us speculate that Dieter Roth was looking not at Tinguely the artist, per se, but at Tinguely's *Homage* as a new model for becoming-artist. "When I was young I wanted to become a real artist," Roth once stated. "Then I started doing something I felt wasn't real art, and it was through this that I became a well-known artist."

Destruction as creation and, naturally, vice versa. But even more so when we investigate the chief impulse behind Tinguely's machine, the cause of its near failure, that is, its programming. Here, we find the key to Roth's vehicularity: the artist as machine, programmed to create, programmed to destroy—both at once. Such a stance must depart from the notion of the uberauthor, which contains within its conceptual sphere the Barthesian notion of the author as multiple, the author as shamanistic medium through which all these varied discordant languages are dispersed. Yet it does not get rid of the author, as Barthes mistakenly implores us to do, as though this mere gesture would suddenly do away with the power structure through which knowledge and expression are conceived and received. Rather, the uberauthor is the vehicular synthesizer of this doubt, which is why destruction must necessarily enter into the equation each and every time—even as the artist's constant movement across the plain implies a ceaseless productivity: onward, toward the horizon, until we become one with the horizon.

We can see the change in Roth's attitude toward art-making in examining the transitional period from the late 1950s to the mid-1960s.

Early experiments with screen printing, such as *Untitled*—with its zebra lines of diamonds bleeding into each other in order to create a mild daze in the viewer—see Roth experimenting with the visual language that would come to be known as Op art.[11] By the time 1965 rolls around, Roth has gone messy, using food in his works. A fecal self-portrait features a round, turd-like mound of chocolate and emulsion on cardboard mounted on hardboard, surrounded by a colorless brown-yellow concoction of oil paint. *Fruits of a Crash for G + J* consists of rotting food and dishes stuck between sheets of glass in an iron frame hinged on a wooden plank.

Tinguely allowed Roth to become that maniac whose incessant need to reconcile his own vices to the rhythm of the world's disordering sent him on a nomadic quest through reality's detritus. Everywhere he looked, he found—stuff. *Stuff* is what he called his output. For him, the process of making art was akin to pissing, shitting.

The key to understanding the new direction found in Roth's messy Everything Art lies in a comprehension of the profound doubt that Tinguely's self-destructing machine suggests. For Roth's was a truly grand skepticism, a skepticism of grandeur that would serve as the pavement for all of his constant and indecisive peregrinations back and forth. When asked by an interviewer later in life how he got to be an artist, Roth replied, "I don't know if or how." It would be a mistake to suppose that the doubt was centered on his own capabilities; *a skepticism of grandeur* would naturally have to apply to the entire endeavor of art-making and aesthetics in general. "Do you think there are any eternal values in art?" the same interviewer would ask. "I don't see any," Roth replied. It could be that art, in the way it is seen, in its normative dimensions, was beside the point; one could scarcely see Roth endeavoring toward any one particular masterpiece, and the point where one work stops and another begins is always blurred, nearly impossible to decipher. What we are ultimately left

[11] Though the term "Op art" was not introduced until 1964 in *Time*, works by artists like John McHale, Victor Vasarely, and, in this case, Roth, predate and can be considered proto–Op art.

with, when considering the Dieter Roth model, is a philosophical conundrum: What is a life for, but to do, to make, to run, to be? What does it mean to collapse all these actions into a single verb? What do we call it? What are the dimensional implications or eliminating that boundary between art and life?

The Importance of Being Iceland

Dieter Roth was described by those close to him, like his friend Laszlo Glozer, as being constantly on the go, a tireless nomad:

> Up to the end the artist was a living example of a nomadic existence for the public surrounding him. He was notoriously on the road. In the specially sewn extra-large pockets of the suits he carried with him writing materials, painting utensils and notebooks. The complete outfit, not overly conspicuous and also featuring a little suitcase with a combination lock, was practical, but at the same time it was also a tangible sign of homelessness. The indivisible union between personal lifestyle and deliberately embodied, readily proclaimed free and independent artistic genius—this was Roth's trademark. And "arriving to depart" [...] was his motto.

A further motto might be: no self, no world, no god. Instead, perhaps: selves, worlds, gods.

Every vehicle, it is true, needs its garage, its gas station—a place to temporarily turn off the transmission and refuel—and for Roth, that spot was the island country of Iceland. Much could be said about its geographic peculiarities—at once a part of Europe and yet not—a floating ship in a vast, uncomprehending sea. For many years, Reykjavík was a major transport hub—indeed, nearly all flights from North America would land at its airport, forcing travelers to spend at least a few hours there before boarding their planes for much

more exalted destinations on the continent. Visitors who have spent a bit more time in the Icelandic capital often remark upon its architectural quaintness. The furthest thing from the big city clichés that those of us reared in the "civilized" West have come to conjure, Reykjavík appears as a maze of brightly painted houses fashioned simply out of wood and scattered across a flat plain, with the sea and snowcapped mountains forming the backdrop.

It was love that first brought Roth to Iceland in the 1950s. He met his first wife, Sigríður Björnsdóttir, while working in Copenhagen, and would eventually follow her when she returned to her home country. The couple had three children together, including Björn Roth, who would go on to become his father's collaborator, to the extent that he has continued Dieter's legacy after his death.

While Roth's marriage to Björnsdóttir was not destined to last, his infatuation with Iceland would become an enduring part of his life's work, and his studios in Reykjavík and Seyðisfjörður, on the country's east coast, have been woven into his artistic legend.

According to his son, his initial impression of the mysterious island was one of terror; upon arriving, he felt like he had reached the end of the world. Eventually, however, he warmed to the idea of the Icelandic capital and began to see the beauty of his new home. *Reykjavik Slides (31,035) Every View of a City* is but one example of Roth's phenomenal interest and engagement with every aspect of the world around him. With the help of his sons and several assistants, Roth set out to photograph every building in Reykjavík beginning shortly after his move to Iceland in 1957 and continuing until 1998. (Though excluded from the title, the project also includes photographs of the town of Seyðisfjörður.) In their most recent major exhibition in 2011 at the London branch of Hauser & Wirth, the *Reykjavik Slides* were displayed on hundreds of slide projectors scattered across the room. Given the brisk slideshow format, the spectator is unable to contemplate any one capture of the city for long. Rather, the city's quaint and colorful boxlike architectural curiosities seem to melt

into a singular impression in the mind's eye, much like the stuff that makes up any one of Roth's messier sculptures: shapes colliding into one another, leaving an abstract imprint of forms and colors on the mindscape: this bluntly becomes "Iceland" for the viewer.

A travelogue without people; as Donald Kuspit has observed, "No human being is in sight, the houses are anonymously geometrical, and the Warhol-like repetitive inertia of the series has a deadening effect, suggesting Roth's depression, or at least his loss of appetite for life."[12] Kuspit implies that the absence of human presence somehow signifies death. First of all, Kuspit's initial impression must be corrected: there is, on occasion, a human being caught in one of the slides (a pedestrian in blue jeans and a leather jacket casually strides by a white house), while in others, the shadow of the photographer (likely Björn or one of Roth's other assistants) can be made out in the foreground. While it is quite possible that Roth instructed his assistants to avoid getting any humans in the shot, this was more likely an attempt to preserve allegiance to the project's titular aims, rather than evidence of some misanthropic melancholia that Kuspit wishes to read into it.

Kuspit got it half-right. While Roth's bouts with depression and alcoholism are well known and certainly enter into specific terrains of his work, I would suggest that the very ambition of the *Reykjavik Slides*—the very impossibility of the project, photographing more than thirty thousand buildings—represents a defiant strain of vitality in the face of the deadening forces of depression and lethargy. As Björn later relays, in explicating why the project bears two dates, Roth

[12] Kuspit: "The basic problem was that Roth had no secure sense of himself, as *Double Self-Portrait* (1973)—an optical hollow man—suggests. It is a self without a core—without a stabilizing center. The series *Interfaces* (1977–78), made with Richard Hamilton, confirms the point: their identities blur into one confusion, thus reducing Rimbaud's 'I am an other' to absurdity. Roth's art became a Sisyphean search for a self—an obsessive attempt at self-creation, with the self always elusive and protean—that led to ironic posturing, climaxing in the self-portrait of *Large Tapestry* (1984–86), which looks like a mocking reprise of Rembrandt's majestic 1658 *Self-Portrait*. Roth's work looks somewhat tarnished and trashy in comparison, suggesting the distance downward art has come. Roth's picture seems like a devolution of Rembrandt's—a fall from the heights of art and the self. Serene pride has been replaced by vacuous arrogance, interiority by exteriority, integrity by exhibitionism. Compared to the self-possessed, dignified Rembrandt, Roth looks like a ham actor, even an imposter—a pretender to the throne of art."

was discouraged by the initial results when he realized that there was sunlight in nearly every photo. He had had his assistants carry the project out during the summertime, perhaps as a practical measure. In evaluating the results, however, he realized that this was somehow not the "real" Iceland that his mind conjured up, and ordered the project to be reshot in the wintertime. It took some fifteen years to get around to it, and another eight to carry the full project out, as the Icelandic capital had grown significantly in the intervening years. Rather than dump the initial photos, he kept them in the project, merely adding the new ones in. The resulting works thus offer a view of Iceland at two discordant moments in the late twentieth century.

Kuspit was not the only critic to take issue with the *Reykjavik Slides*. In reviewing "Roth Time," the artist's largest posthumous retrospective to date, Eric Gelber failed to see any positive qualities whatsoever in the series, characterizing it as a product of the artist's neuroses: "More obsessive/compulsive energy is on display in the 'Reykjavik Slides,' (1973–75/1990–1998). 30,000 continuously projected slides of all of the houses or dwellings in Reykjavik, Iceland are meant to impress through the sheer uselessness of the task the artist set before himself. You have to wonder what the point of the monotony is. The images of house exteriors and the lack of interior shots emphasize the alienated or misanthropic feelings of the photographer. But again, we are impressed more by quantity than quality." Here, we must contend with one of those factors that we seem to find in nearly every Bad artist we have looked at so far (such as Gertrude Stein and George Kuchar): that is, an apparent obsession with quantity over quality. In some ways, it comes down to a question of editing. Usually, when we hear the word "edit," we tend to think of the term in its redactive sense: chiseling away at a mess to excavate that which might be valuable, lasting. In composing his masterwork *À la recherche du temps perdu*, however, Marcel Proust took an additive approach. Only rarely did he take anything out; instead, he would go back and put more in, thus the novel's astounding length. It is as

though everywhere he looked, he saw holes. Indeed, this approach to editing—fattening up rather than slimming down—became woven into the very universe of the novel. Wherever there is something *wrong*, it must be because something is *missing*. Never a wrong turn: it is just that something needs to be fleshed out, added on to. And, in much the same expansive way, the city of Reykjavík continued to be built up throughout the intervening years. Why not acknowledge that expansion in Roth's own novel of images?

But, of course, there had to have been something more to it than that. Proust was very much aware that he was building a tower: the daunting size of the thing was precognized. In a sense, it infers a sort of sickness: the neurotic sense that something is *nearly always* missing. You look across a vast, empty landscape, and where others are able to remark upon the tundra and the foliage, all you are able to notice are the gaps dovetailing into the earth. You don't wonder where they lead to; you just have an impulsive need to fill them. Is it rooted in depression and a loss of appetite for life? On the contrary. For us to reach the diagnosis of depression, the vehicle would have had to shut down. Instead, the Proust and Roth vehicles revved up their engines, ruthlessly went ahead. Both were unable to get rid of the flaws. For Proust, the latter half of his novel is marred with contradictory scenes, unresolved tensions, as it essentially remained incomplete at the time of his death. Roth's series is also essentially marked by terrible inconsistencies, the cheapness and disposability that lies at the heart of the serial ambition.

The extension principle (of the body-mind machine we call a vehicle) here again comes into play when we come to realize the true ambition behind Roth's project, which comes to us as we stand in a room absorbing these slides and the title of the project suddenly flashes across our minds: *Reykjavik Slides (31,035) Every View of a City*. The words that matter most in that title are "every" and "view." The project is not that of a visual artist, but of a collector: I happen to own every view of the city of Reykjavík. The multiplicitous

nature of being—in this specific instance, being-Roth—extends to the perspectival agency that "contains" each "view." An energo-intensive pathway is etched through the landscape; the eruptive framing of each single perspective defines the whole's seriality. Nature spits views, meanings at us. The photos fly past us rapidly, mimicking the pace at which they were snapped. Kuspit's way of viewing is only one of the extreme ways: the spectatorial gaze deadened to the energo-intensity, the speed of the project. In this way, the images fly past us, bounce off our skin, but do not touch our core—no meaning is allowed to be formed. Another extreme, however, is to jump upon the vehicle, much as the artist arguably did in this project of becoming-landscape, becoming-building, becoming-Iceland—to go along for the ride, temporarily abandoning our own territories, and thus extending our own territories, invading and shattering the frame.

Early on in the history of contemporary photography, Susan Sontag intuited that the desire to acquire a sort of ownership over an image of an existing scape is one of photography's primal essences:

> Photography is acquisition in several forms. In its simplest form, we have in a photograph surrogate possession of a cherished person or thing, a possession which gives photographs some of the character of unique objects. Through photographs, we also have a consumer's relation to events, both to events which are part of our experience and to those which are not—a distinction between types of experience that such habit-forming consumership blurs. A third form of acquisition is that, through image-making and image-duplicating machines, we can acquire something as information (rather than experience). Indeed, the importance of photographic images as the medium through which more and more events enter our experience is, finally, only a by-product of their effectiveness in furnishing knowledge dissociated from and independent of experience.

Sontag felt that the third and final form of acquisition was the most inclusive, as it allowed a photograph to enter into a systematic flow of information, and thus leave the orbit of "mere" art. It is here that the photograph attains what we might term a supra-autonomy, in that it truly leaves the hands of the author, its meaning to be forged in the hands of the receiver/reader (in true Barthesian fashion). (This is particularly relevant for the included slides of Seyðisfjörður, as the example recounted below will sufficiently demonstrate.) In what Sontag deems the mode of possession of the photographic event by the "consumer," a distancing effect is created between the original, captured image of the subject/event before us, and its actuality: the tension between the referent and the act itself. This makes the whole project all the more interesting when one considers that Roth likely only took a few of the photographs included in the *Reykjavik Slides*. Thus, he himself experienced the distancing effect in a way that effectively eludes the authorial model proposed by Sontag; although he is likely familiar with most of the buildings included in the series, he is, in fact, just as distant as the spectator from the experience of the original.

Of course, Sontag's first and primal notion of the photographic project of possession (what she deems "surrogate" possession) coincides with our earlier elucidation of the collector's impulse overriding the classic authorial impulse within the project. For the primal drive behind photography is the desire to record. We might suggest, then, that Roth, in tackling the project from the odd position of collector and spectator, wanted to reach and exceed his own limitations as an artist.

Kuspit's comments are useful, however, in that they unwittingly point to one of the underlying themes of the *Reykjavik Slides*, that is, the exhaustion of spectatorship. The fatigue of looking. And, indeed, part of this fatigue lies in the transference of vehicularity from artist to spectator, the way in which the artist-landscape slides into—*extends into*—the spectator-landscape. Such a transfer inevitably provokes an

alterance: one can never look at those buildings in Reykjavík the same way again. As a matter of fact, when slides of Seyðisfjörður were first exhibited to that tiny town's citizens during a time when local consensus implied the need to destroy many local buildings and begin an ambitious rebuilding project, the tone of the conversation shifted: suddenly, after encountering Roth's slides, the citizens saw the importance of their homes and local landmarks, and began to propose ways of preserving and conserving their built environment.

It is no strange coincidence that a vehicular force—that is, an entity whose machinery was composed so as to defy stasis—was the one that brought them this gift. Nor is it strange that one of the great philosophers of movement—Gilles Deleuze, with his concepts of nomadism and deterritorialization—was not fond of travel. Björn Roth later tried to articulate his father's penchant for vehicularity in relation to the Icelandic scape; he conceived it in terms of a *drift*. As he stated in Edith Jud's documentary film *Dieter Roth*: "He didn't actually like cars or driving itself. It was somehow … this drift. The feeling it gave him was a similar feeling to sailing—this *drifting* through the landscape somehow." In drifting across the land, one is able to sublimate oneself within that scape, to become one with it. This is the secret that the ancient Chinese landscape poets and painters knew: the real landscape always lies within. What we see outside is but a reflection of that inner landscape. In Roth's case, it was a landscape that he was not content to merely provide a picture of. He was also compelled to perform constant excavations.

The Diarist

Perhaps another way to further untangle this web is to turn our attention toward the diary form. Like George Kuchar, Roth was an avid diarist. But perhaps the directional flow was reversed, for Kuchar seems to have come to the diary form later in life, while for Roth, it

was arguably the root of everything he would do from at least the early 1960s onward, after his encounter with Tinguely's machine. Not only did Roth keep diaries, in the "traditional" written form—he, in a sense, exploded them: everything, the entire space around him, all the spaces he came to occupy, Dieter Roth's World, became his diary.

Still, every diarist has his own strict system of organization. In a 1979 interview with Irmelin Lebeer-Hossmann, Roth described the three-pronged nature of his written diaries and the way they fed in to his overall practice:

> DR: One book is simply what I want to do, what I have to do, and what I believe that I have to do. Appointments, a calendar, or what do you call it—a notebook. And then the second form is where I write down what happened on particular days, where I've been and what I saw, which people I met, which books I've read, etc. And then comes the third, in which I ... for example, I write in one book: "Simenon— Le Train" and then I say no more about what I thought. But in the third book I always wanted to register what I think of Simenon, or what I experience when I read it. And, needless to say, that's a rather extensive madness: you can do it quite badly. I've only described a couple of days this year so extensively.
>
> IL-H: And the rest of the time, that hangs over you? You think: now I have to do that, but you don't get round to it.
>
> DR: Yes. For me, it's ... it's like a cancerous tumor, it's basically an illness. An illness that I have. Now.
>
> IL-H: This compulsion to represent your entire life.
>
> DR: Yes. That's my terminal illness. It'll probably be the cause of my death.

We can venture that the inherent impossibility of the tripartite structure established by Roth is very much the point. Set yourself an impossible task, and then despair at the prospect of ever fulfilling it: this is called *fuel*. Without it, a goal is never a goal. The impossibility of such goals comes to be the waking, dreaming motive for every

Bad artist; the defiance of realism in one's expectations is, indeed, not the proper, sane way to behave, as conceived by the socius.

As such, the diaries can be properly thought of as a failed project. Though, unlike other failures, who attempt to hide away their shameful attempts, Roth put his on display repeatedly: much like the products of George Kuchar's bowel movements, focused in on his small screens, Roth had nothing to offer up except for that which is excessive: the processes of living itself.

On occasion, Roth was forced to answer to the charges of vanity and narcissism among his critics. This is rooted, I believe, in a misreading of his work—and perhaps of the entire diaristic form in general. Here, we have to contend with the strange fact that the diary, as a form, is not autobiography. Whereas the autobiographical endeavor infers completion, finality, a *definitive state*, the diaristic is inherently rough, unfinished, non-definitive, *fragmented*. Autobiography is, above, all, a project—that is, something done with a specific end in mind, the end being entrance into a circulatory flow of reading and meaning formation by outside forces. The diaristic, on the other hand, is a process. Its force is its own engagement with becoming, it resists the incorporation that is autobiography's chief impulse and ultimate aim, and it therefore has no need to attain any semblance of perfection—it is quite satisfied in its flawed, perennially first-draft condition. It resists meaning formation by outside forces, content with its incomplete product of uberauthorship.

What is it that makes Dieter Roth's work not vain? In a word: its apparent artlessness. An artlessness that could only be manufactured at the hands of an uberauthor. Jan Voss, a close friend of Roth's, once described him as "the broken Superman who has become a clown." The Superman here, of course, being Nietzsche's. That is, a *fallen* Superman. The world, as a solid entity, does not in fact exist; it is but a container for our individual exertions and the circulatory flow of our energies. The eye and nature of abandonment by the god force we have experienced is the annihilation of staticity by the

millennia. What once merely *floated*—silent in its hostile stance toward self-mobility—now propels itself unceasingly in vibratory multiplicities, in defiance of all possible schemes of directional logic. What the Bad artist, the uberauthor, does, it cannot be qualified because of its excessive and chaotic relationality, as encompassed in the abundance of quantitative flows. How do you go about assessing something that cannot even be measured?

While the diaristic mode pervades much of Roth's output, particularly in the second half of his life, there are two works in particular in which it serves as the overriding motif: the *Flat Files* and the *Solo Scenes*.

Flat Files was a project undertaken in 1975 and 1976—immediately after the first round of *Reykjavik Slides* was shot. Today, the work officially consists of "flat materials in transparent sheets in 623 binders, 5 wooden shelves, 7 bookrests, [and] 4 ceiling lamps between every shelf." The task was rooted in "the quantitative act of collecting things that were no more than two or three sixteenths of an inch thick [ranging from] bottle labels, envelopes, slips of paper, or prospectuses to handkerchiefs, packaging, and leftover bits of food." The resulting diary consists of plastic sleeves in binders (the pages and books, respectively) housing a chronological array of detritus from the artist's travels, including matchbooks, receipts from bars and restaurants, hotel stationary, and snotty tissues from Berlin, Stuttgart, Hamburg, Düsseldorf, London, and Reykjavík.

As Roth would later remark about the project, "Every day sings a little song, there are themes in a way, of cities, and then you see the trips, by airplane, you can see—well at least I can see all of that when I leaf through the binders."

Or, to put it bluntly, in the words of a longtime Roth friend, Pétur Kristjánsson, "It's the truth: what didn't really matter today."

As with the food-based works, it could be that tactility is the key to all this messy objectity. With Roth, one must speak not of the dematerialized object, but of the dematerializing object—as his art is not only process-based, but so many of his objects continue to en-

dure a process, even long after the artist-vehicle's demise. This lends his work a scientific air.[13] If, as Barry Curtis has noted, all houses are in some sense haunted, we could extend this even further to all objects. And, once we begin to speak of hauntings, of ghosts, what we are in fact speaking of is a certain tension between presence and absence. That is to say, an anxiety surrounding the issue of touch, of contact. The *Flat Files* allow us to get close to touching these "originals," and yet they are "protected" behind the thinnest veneer of plastic. Inviting us in, challenging us to come as close to the dirt and filth of his life, yet refusing full access, Roth shows us one way to expand the language of the diary form to include the most banal of objects utilized in our quotidian motions.

The *Solo Scenes* and Uberauthorship

What about Roth's relations with others—namely, his audience? While much has been written about Roth's supposed misanthropic nature, he was also an avid collaborator—and, judging by the self-centered/ self-exploded nature of much of his output, an exhibitionist. The exhibitionist, of course, requires an audience, and the relationship is not necessarily abusive—one might say that it is, at least on occasion and in specific contexts, a relationality defined by an empathetic exchange between two vehicles.

"I believe the diaries are primarily an attempt to register a complaint," Roth asserted, "a shrill howl of complaint. As loud and as penetrating as possible to invoke crying, you know; that people bawl and cry when they read it. For me, it's about empathy, about this lament."

One of the more shocking claims made by one of Roth's harshest critics—again, Kuspit—is that the artist had no sure sense of himself. Perhaps this is because of spurious claims Roth periodically

[13] Gilles Deleuze: "Science or theory is an inquiry, which is to say, a practice: a practice of the seemingly fictive world that empiricism describes; a study of the conditions of legitimacy of practices in this empirical world that is in fact our own. The result is a great conversion of theory to practice."

made to interviewers, with whom he liked to toy a bit, throughout his life.[14] Roth's notion of identity, of selfhood, certainly defied the essentialist notion of a cohesive self to which Kuspit and other critics of a conservative bent subscribe. Rather, Roth had a remarkably fine-tuned sense of his *selves*. This awareness of the inherently multiplicitous nature of his existence is, in fact, what enabled him to function as a vehicle, as the uberartist that he was constantly in the process of becoming. In order to doubt so deeply and profoundly, as Roth, the empiricist par excellence, ultimately did, one must have an exceptionally strong sense of one's (many) selfhoods.

Here, when considering the projective aspect of Roth's work, it is useful to consider Deleuze and Guattari's notion of "conceptual personae" in philosophy:

> The conceptual persona is not the philosopher's representative but, rather, the reverse: the philosopher is only the envelope of his principal conceptual persona and of all the other personae who are the intercessors [*intercesseurs*], the real subjects of his philosophy. Conceptual personae are the philosopher's "heteronyms," and the philosopher's name is the simple pseudonym of his personae. I am no longer myself but thought's aptitude for finding itself and spreading across a plane that passes through me at several places. The philosopher is the idiosyncrasy of his conceptual personae. The destiny of the philosopher is to become his conceptual persona or personae, at the same time that these personae themselves become something other than what they are historically, mythologically, or commonly (the Socrates of Plato, the Dionysus of Nietzsche, the Idiot of Nicholas of Cusa). The conceptual persona is the becoming or the subject of a philosophy, on a par with the philosopher so that Nicholas of Cusa, or even Descartes, should have signed themselves "the Idiot," just as Nietzsche signed himself

[14] "Asked how he would like to be remembered after his death, Mr. Roth said, 'Here lies the carcass of a man who didn't know who he was and where he was heading.'" Perhaps this was, in fact, how Roth would have liked to be remembered; this does not necessarily imply, however, that this is how Roth actually was or how he really thought of himself.

"the Antichrist" or "Dionysus crucified." In everyday life speech-acts refer back to psychosocial types who actually attest to a subjacent third person: "I decree mobilization as President of the Republic," "I speak to you as father," and so on. In the same way, the philosophical shifter is a speech-act in the third person where it is always a conceptual persona who says "I": "I think as Idiot," "I will as Zarathustra," "I dance as Dionysus," "I claim as Lover." Even Bergsonian duration has need of a runner. In philosophical enunciations we do not do something by saying it but produce movement by thinking it, through the intermediary of a conceptual persona. Conceptual personae are also the true agents of enunciation. "Who is 'I'?" It is always a third person.

For Kuspit, Roth's failure is lodged in his inability to conceptualize himself in the singular: the Great Male Artist of the Western canon. Curious, as the process of this conceptual disruption had already begun years earlier with Marcel Duchamp and his numerous pseudonyms. One might say that it is the artist's natural domain to enter into divergent zones of being each time she sets out to create another instance of particularity, another work. A signature, in this sense, can never be anything more than a parody of the type of assignable "secure selfhood" apparently coveted by Kuspit. Once again, perceiving, collecting, and creating are all collapsed in the force of a singular gesture, a gesture's singularity: "As in science fiction," Deleuze writes, "one has the impression of a fictive, foreign world, seen by other creatures, but also the presentiment that this world is already ours, and those creatures, ourselves." The foreignness of the world that belonged to him was naturally and essentially tied to Roth's vehicularity.

In this sense, Roth can only be understood as a radical empiricist. This is not mere conjecture, but has been confirmed by his closest friends and collaborators, including Richard Hamilton, who once accompanied Roth on a journey to purchase six volumes of the complete letters of David Hume, that arch empiricist philos-

opher par excellence, in an Oxford bookshop. Like Deleuze, Roth disparaged the work of Wittgenstein and his followers, with their "language games," as Deleuze called them in a filmed interview with Claire Parnet. No Teutonic idealism for Roth, either; he turned Hegel's complete works into sausages.[15] Deleuze might as well have been thinking of Roth's work when he wrote, "The real empiricist world is thereby laid out for the first time to the fullest: it is a world of exteriority, a world in which thought itself exists in a fundamental relationship with the Outside, a world in which terms are veritable atoms and relations veritable external passages; a world in which the conjunction 'and' dethrones the interiority of the verb 'is'; a harlequin world of multicolored patterns and non-totalizable fragments where communication takes place through external relations." What is indeed futile is to search for any form of metaphysical truth in the exhaust produced by the Dieter Roth vehicle. His vulgarity lay in his extreme physicality; his epistemology was a lived empiricism, the pollution he left behind a trace of that legacy.

Basel. An elderly Dieter Roth talks on the phone, pen in hand. Putters around his homemade, handmade studio. There is a table in the corner that, according to Björn, was made just for reading mail. Another strictly for dining. Each object has its restricted use: even those whose use is to assist the artist in creating more excess. The space around him, his office, became a sculpture. Dieter sits, a large fat man at a desk, and writes poems. If he liked a pair of pants, he'd buy fifty pairs and send them to his various studios, dotted around Europe. A bed was erected next to each of his main working desks,

[15] I refer here to Roth's *Literaturwurst*, in which Roth utilized traditional sausage recipes, only replacing the meat with a shredded book or magazine. The series culminated in 1974 with *Georg Wilhelm Friedrich Hegel: Werke in 20 Bänden* (*Georg Wilhelm Friedrich Hegel: Works in 20 Volumes*), a work that was actually made by the collector Hanns Sohm according to Roth's instructions.

in case he needed to take a quick nap while working. Everything around him was set up to support the running of the vehicle.

Like Kuchar, Roth turned to the VHS format toward the end of his life for its simultaneous accessibility and disposability. The monumental work here is *Solo Scenes*, comprising 131 VHS cassettes: footage of Roth in his Swiss studio but also (and mostly) his Iceland studio, where he had retreated once again from the continent, this time as a means of quitting drinking, during the last year of his life, 1998. Standing before these dozens of monitors, one is moved by this blunt display of the artist at work. In between, one spots, for instance, the sludge of Iceland, as filmed from the window. Everywhere you look: landscape rot, as in one of Roth's messier food paintings. Catching this bit of the *Solo Scenes*—it is probably impossible to watch all of them—is to realize that Roth effectively went from representing the landscape to doing, being the thing. Roth wanders over to a table, where he sits down and writes. On another monitor, he walks into the bathroom, removes his robe to reveal an obese flabby vehicle, climbs into the shower.

Or: sitting at a desk, staring vacantly. Looking out the window. Doing nothing, yet the camera is there, turned on, and so: constantly making.

Hamilton, who collaborated with Roth on occasion, describes the incessant need to do, to make, to go, *to ride*: "I would have qualms about the quality of what we were doing because it was so speedy, I wouldn't have time to stop and think—I would just have to do something."

Unlike Kuchar's video films, Roth's videos appear to lack any editorial agency. While they share the commonality of the artist's constant presence, in the case of the *Solo Scenes*, the work is more a monitoring of the artist at work, at rest, distracted, sleeping, bathing. It is, for many, an exercise in banality, tough to watch, and yet also impossible to watch, in that the way it is exhibited, much like the *Reykjavik Slides*, is an exercise in overdisplay, where all the works are shown simultaneously on rows of monitors. One can, in a sense, only see the

Solo Scenes in/as excerpts. Indeed, this is how they were meant to be taken in. In this sense, the spectator forges her own edit of the work.

Roth in bed, taking his socks off. Illuminated by a thin light from the lamp. He stares. Roth seated at a desk, at night; lamp; staring. He picks up a diary, opens it. Takes a Polaroid of the camera sitting on the tripod across from him. From inside the Seyðisfjörður studio, the camera pans over again to the autumnal Icelandic landscape—the bay across the way. A cut to the interior of one of Dieter's other studios, where the artist can be seen working, drinking. Roth emerges in these works as something of a Beckettian character. Indeed, for those familiar with his jolly, vital being in earlier works, seeing him in these tapes—a withered, sad, disgruntled old man, clearly at the end of his life—can be a depressing experience. For sure, Roth himself was aware that the fade had begun. Still, he kept running—continuing to project himself and forge new alliances between life and art. "The broken Superman who has become a clown"—a Nietzschean characterization, to be sure, though in becoming a clown, Roth manages to attain a moral superiority over most beings. Many of us have, at one point or another, reached a low point, a crash in our journey; few of us, however, would willingly put it on display. To do so is beyond humbling—it is to cross a line into demoralization, which is to say, equalization with the object.

Indeed, for Roth, the ride never really stopped. "He's not a person who led a very active social life. He worked and worked and worked and worked," says Emmett Williams, a longtime friend and artistic collaborator. Williams describes how the two of them would be together in someone's kitchen drinking wine and talking, while Roth, drunk, would be making two-handed drawings.

Hamilton, in Jud's film: "One of the intentions of the collaboration was the idea that we could produce bad art. And so we discussed a lot this idea of bad art and what was bad, why was it bad. He would be rather pleased if we got something so awful that neither of us liked it." And yet, at the same time, the option of

flight was always kept open; one begins to conceive of his various studios around Europe as escape hatches. "The master of 'running away' did his share to encourage [obscurity]," writes Glozer. "He constantly evaded incorporation, even in cases where he initiated the game. He often abruptly packed his bags and left, prompted by an instinct sharpened through profound distrust: the scheme might succeed (far too easily)."

Roth at his night table. Removes a page from his address book; draws on it. Roth sits down at a piano. Plays a beautiful, aharmonic tune. Roth as an old man, hiccupping before two microphones. He flips the top on a keyboard and plays another beautiful melody.

Roth in another studio, removing bits of stray plastic from the floor, putting old paper boxes in the trash. Roth talking to himself, drunk, trying to tidy, failing all the while. "Hey, what is all this? Hey, what's all this? This tragic shit. What's that mess you're making there? Now, what are you doing? That's a mess!" Puts the work garbage down, takes another drink. A stack of books on his desk. Breathing heavily. "What is this, asshole?"—referring to himself. There is no one else in the room. It was a question that would never be answered satisfactorily. And yet the ride continues—even within this apparent stasis.

Beyond Mortality: *Garden Sculpture*

"The fantastic thing about this sculpture is that we don't know what it is," says Björn Roth with a smile. Begun in 1968 and originally taking the form of a self-portrait forged out of chocolate and birdseed standing on a table, *Garden Sculpture* has gradually expanded over the years as more stuff was added on and more collaborators became involved.

Here is where the Everything comes together: the Work (noun) and its ceaseless evolution, the work (verb) and its constant demise. What is life but a struggle to retain life? Currently housed in a large hall of the Hamburger Bahnhof in Berlin, the long horizontal wooden

contraption known as *Garden Sculpture* resembles, as of this writing, a sort of fucked-up pirate ship. We might suggest that it's the closest Roth ever got to Tinguely's self-destroying sculpture: a massive contraption of junk and detritus, though expanded to include a workshop (off to the side), so that the entire room resembles a massive construction site. Attached to the sculpture at various strategic points are television monitors with VCRs displaying footage of the work in various phases of construction—though not only. One video—played on one of those now near-extinct TV-VCR combines and installed beneath a green cage stuffed with toy bunnies, cans of acrylic paint dumped unceremoniously over their heads—features footage of a large, calm body of flowing water—likely the sea outside Roth's Seyðisfjörður studio—where, occasionally, a boat can be made out on the horizon.

Currently, the sculpture itself is divided into two main parts, with the front end comprised of a zigzag of rickety stairs and ladders leading up to the captain's quarters, a makeshift office for starry-eyed Ahab. (The sculpture's references to *Moby-Dick* cannot be ignored: we come to realize, in regarding it from afar, that a ship almost always resembles a whale, and vice versa. Again, construction/destruction: that which is built which is never complete; that thing that gnaws at you from within like a neurotic illness, that propels you forward, toward the gulf of unexplored blind death and the immortality of completion.) A handmade (like nearly everything else here) desk fashioned out of wooden boxes, chair with a paint-splattered jacket on the back, and two transparent, paint-splashed Plexiglas canvases in the place of the absent uberauthor. Behind the desk, a bookshelf where, among other titles, *The New Cosmology* and a biography of Buster Keaton can be made out—testament not only to Roth's omnivorous appetite, but also perhaps twin poles of his created persona: where the supernal meets the absurd. Beneath the stairs on shelves, various jars have been installed. They contain foul liquids, each labeled with a Polaroid photograph and the name of the city and date, documenting the

process of collecting condensation, via huge vats and funnels, from each place where *Garden Sculpture* was worked on/displayed.

The second, rear part of the sculpture is fronted with a "sail," composed of a jumble of flat, wooden animalistic shapes, projected skyward. This rear sculpture also contains plant life—a bunch of potted plants in various phases of life and death—as well as the majority of the videos depicting the construction of the sculpture beneath the mast, each displayed on a cheap, dirty television set. Also included is a smashed TV set (in Jud's documentary on the artist, we see the elderly Roth himself joyfully smashing it with a thick block of wood as his son and assistants watch bemusedly), a paint-splattered photograph of *Garden Sculpture* in progress stuck inside. Nothing stays clean for very long in Roth's universe. On one of the videos, we listen to Björn's voice laughing and chirping cheerily in Icelandic to his colleagues, enthralled to be hard at work at nothing, drilling a hole into a piece of wood for some unseeable continuation of the sculpture. Dieter is absent, but the work continues: the artist dies, and yet the vehicle never comes to a halt. "He thought of it as a train," Björn would later explain. "And he asked us … when he went off the train, if we'd be ready to continue the ride." Thus, the sculpture has no end date, no completion: it continues onward into infinity. Parked at the rear of the sculpture, a giant empty watering can. And at the very rear: a trunk opened to reveal a vast barrage of junk, stationed above a TV set showing yet more grainy VHS footage of the same trunk, with voices and work heard in the background. A typical Roth joke: endless reflection of the same thing, over and over again. The thing's thingness thus amplified. And there is so much junk in this trunk, so much junk in Roth's world, how do we even begin to parse it, to assess its significance, when its excess objectity encourages nothing higher than denigration? Is anything with paint poured on it then christened "art"?

So we walk around to remember what we saw when we first entered the room—because by now the process of immersion has taken us to quite a different place. We are greeted with the head of the ship, the

face of the whale: another television set, this one with a live video feed, showing ourselves, our friends, our fellow museumgoers moving past the vast parked thingness that is the *Garden Sculpture*. This thing, its constant evolution, even beyond the death of its maker: this is the key to the puzzle of Dieter Roth's voracious vehicularity.

Taking up about a third of the room—the rear corner—is the workshop, indelibly a part of the sculpture. The workshop contains a long table with eight chairs around it, old coffee cans containing various pencils and pens, paper, some shelves on top with scattered papers, binders, CDs … One is nervous around it, never sure whether, as a spectator, one is allowed to sit down and contribute to the scribbles one sees all over the table, or if it is strictly for display. Around the work area, a typical "dude dorm"/construction-site atmosphere. A fridge. Bottles of beer, water, wine, many of them empty. A coffee-maker. The rest: slabs of wood, much of it sloppily spray-painted. Tools. Paint cans, electrical wires …

In the connecting corridor, a window reveals that behind the museum, various plotted plants have been set out to be exposed to the elements. Also, the distillation process (as displayed in the Polaroid photographs on the front sculpture) has been set out, as rain and condensation are in the process of being transmitted into jars: so even in the absence of any authorial presence whatsoever, the sculpture continues to be "made."

Environmental art without a real ecological message? Perhaps. Yet the sculpture continues to "grow," like a plant, even when no humans are available to work on it. One might say that Everything Art represents, in a sense, a total ecology: Everything Art means Everyone and Everything become a part of it, whether each entity, human or otherwise, is aware of its contribution or not. And the spectator? Those vehicles who pass by the thing, observing it without directly contributing, are immediately let in on the joke, and thus become a part of it. The joke of art; the joke of life.

The Anatomy of Melancholy

Still Life

As Rainer Maria Rilke once noted, when writing of Rodin, the artist eventually comes to the realization that he is limited by the surface just as the writer must ultimately grapple with language's intrinsic failures to adequately convey the essence of a thing. Surfaces, surfacing: Isn't the melancholic realization of the painter identical to that of the obsessive, the lover: that you can never truly *know* another person? For what is there but the surface that prevents us from crawling into the skin of another, thinking their thoughts and feeling their feelings with them, inside them, discarding our own physiological realities in a gelatinous act of *becoming* another, preexistent being? Couldn't we propose that nearly all art that addresses, nay, idealizes the human figure, is an act of reconciliation on behalf of the artist who wishes to do just that?

These are the thoughts that flood my brain when I consider a painting by Christian Schoeler. It is because Schoeler clearly works out of inner necessity, impelled by something like love, though I don't think it's quite as simple as that. His quest for capturing and rendering beauty in his male portraits certainly has its historical precedents—it is loudly part of a tradition, it announces itself as such—but without the self-referencing that positions the artist on a higher, godlike plateau of being above his subjects. God is not Christian Schoeler—God is the boys he depicts.

At the same time, most of these *are* studio pictures. In that they take on the difficult task of attempting to capture "natural" beauty within a frame, or a *framed* situation that is going to reveal at least some vestiges of its artificiality. Thereby, the medium makes reference to itself, often in the form of the models' explicit outward gaze at the viewer or the staginess of their pose. The visual is allowed to be truly and totally visual.

Like Larry Clark, an artist he admires, Schoeler's primary concern is with boy-men situated on the edge of becoming—that vulnerable situation/moment in life, that state of being stranded between boyhood and manhood fraught with existential inevitabilities. "Most of the decisions are made on an emotional basis," Schoeler insists. Emotion, as opposed to formal or conceptual concerns, we may presume—a bold admission in an era when art is moving away from the purely visual and further into the conceptual, almost as though in reaction to the broader, increasingly image-based culture. This is where the Clark comparison comes to an end: for Clark, who assumes what could be called a similar faux-naive melancholic stance toward his subjects, his subjects' engagement with the wider cultural milieu—and that milieu's representation of the teenage male body and its sexual prowess—is a constant presence in the work; one need look no further than *The Perfect Childhood*, a book that combines Clark's own photos with news clippings, handwritten letters, movie stills, and teen-celebrity posters, among other forms of trash/sex culture memorabilia, forming a complex psychosexual art object that simultaneously serves as a manifesto for the artist's obsessions. Schoeler, on the other hand, ignores culture altogether, transmitting his obsessions purely through the paintings—even the settings are often obscured to the point of illegibility in order to focus solely on the subjects themselves, typically depicted singly or in pairs, to the extent that the pictures attain an air of timelessness reminiscent of Rainer Fetting's portraits. Furthermore, the paintings showcase a Hegelian impulse for capturing a precise state of affairs, linking the concrete with the ideal. In the case of Schoeler, it is a concretion rooted in a semantics of melancholia.

From an interview with Francesca Gavin: "The true antagonism lies within the difference between ethics and aesthetics. [...] In my mind there is a certain melancholy, a degree of light in concert with a degree of darkness, a sad finesse, which is directly connected to gay sexuality."

In his 1917 essay "Mourning and Melancholia," Freud elucidates the structure of melancholia. It is, of course, rooted in loss. When you lose someone you love, according to Freud, you subsume that person into the structure of your ego. You take on attributes of that person; in doing so, you are able to sustain them, you are able to sustain your love for them.

Because time moves too fast for us, there is a reason for preserving and idealizing certain forms. We don't know what Schoeler's personal relationship is with his models; we don't need to know. Love occurs on several layers: in the human realm of relationships, in the aesthetic realm of beauty and idealized form. It is the latter form of love that Schoeler prefers to talk about when asked by an interviewer whether he is currently in love, referring to the work of fellow artists with whom he feels an affinity.

Whether you choose to view the male figures in Schoeler's paintings as projections of the artist's past-present self on the vulnerable precipice of becoming, or as literal representations of models with whom he may or may not have a more intimate relationship, the same *othering* device is at work. Contrary to classical psychoanalytic definitions of melancholia, however, this is a form of love-loss projected externally through the creative act, rather than subsumed within the artist's ego. I would even go so far as to argue that this is a tactic of ego-destruction, which aligns Schoeler with a number of (namely, literary) explorers of extreme states of being, from Rimbaud to Kathy Acker.

An act of melancholy—for example, a painting—is then a method of preserving something that will otherwise, inevitably, be lost. And Schoeler is correct in linking this to homosexuality. Via Lacan and Hegel, Judith Butler has identified traditional Western conceptions of gender as equating "having" and "being" with "masculine" and

"feminine," respectively, with regard to the phallus. Such divisions have been naturalized through the stringent laws of heterosexual discourse that dictate societal norms. Women (and, I would argue, "feminine" boys such as those typically found in Schoeler's paintings) must cope with the ludicrous expectation of having to "be" the phallus while having to conceal their lack of the phallus; this compromise is conceived as "appearing," or masquerade. Butler writes:

> The mask has a double function which is the double function of melancholy. The mask is taken on through the process of incorporation which is a way of inscribing and then wearing a melancholic identification in and on the body; in effect, it is the signification of the body in the mold of the Other who has been refused. Dominated through appropriation, every refusal fails, and the refuser becomes part of the very identity of the refused, indeed, becomes the psychic refuse of the refused. The loss of the object is never absolute because it is redistributed within a psychic/corporeal boundary that expands to incorporate that loss. This locates the process of gender incorporation within the wider orbit of melancholy.

This returns us to that curious statement of Schoeler's regarding the tension between ethics and aesthetics. With his subjects lost in an orbit of desire, stranded between their own private sexual battles and their position as potential sexual objects, Schoeler recognizes that their essence is their vulnerability—something a more sinister artist might try to exploit or desensitize. Furthermore, I would have to add that there is a sense of shame in desiring—to love, to become, to subsume— another, a shame that is intrinsic to gay identity formation. What we have is the classic vision of homosexual-as-outsider, a melancholic refusal to cope by feigning gain; a celebration, really, of loss and the humanizing beauty of suffering through memory, nostalgia, and hope.

Of course, in suggesting this, I risk suggesting that Schoeler is a wispy person deluded by dreams, unable to act but through art.

To clarify, I have to propose that Schoeler, on the contrary, is an artist who understands that dreams are, in fact, the stuff of real life. Further, he is able to intuit that pain is the *being* of "being well."

In the end, we give in to the desire to see Schoeler's boys as characters or totems in the formation of a future epic. An elimination, a denial of the meta, brings us back once again to a joyous affirmation of the surface. A surface that is, perhaps, not sexual or even tactile—a distancing effect is used to fog these subjects in the dreamlight of a parallel universe. Youth will fade, the twinks will become something else—kings or else tyrants, fools—we cannot know, a picture tells no stories—art is not life, but a dream, a moment captured. Time's formidable absence from the cause of being elevates these snatches of becoming into relics of affirmation, providing the illusion of a living continuity of beauty. Chaste and refined, Schoeler's paintings are still lifes with living beings.

Trash, the Body, an Accident

But enough about corporeality—we are dealing in two dimensions here. Is this a problem? If so, how to articulate this challenge, how to articulate it in a way that it may be overcome?

Argument: there is, in fact, a sensuality that takes place when no bodies are present.

The sensuality of solitude is closely related to the act of creation. I'm not talking about a masturbatory process that is linked to ego fulfillment, but rather the depths of a field that transcends the confines of the self, the gulf of selves that is our inevitability, as each one of us *is not one*—is, in fact, a collective entity. That is why each time we are painted, a completely different figure emerges. Just as a landscape never stays the same, the body, the inner being that it reflects, is a constantly shifting and evolving field of perplexities.

To find this sensuality, we must look beyond the figures, at the backgrounds. What do we find there? Total abstraction, most of the time. No, for the *totality* is in fact always a merger between those blotted-out forms that articulate *nature* for us and the human body structures that are struggling to find their expression. There is a competition between the two forms of life here, one that is not necessarily resolved in, by the painting. Painting, an *unnatural act*, can make anything come alive. This is its animating paradox. And, when it is successful, the apparent formlessness of nature is just as important as the (mostly precise) human forms inserted into the landscapes.

Doing "bad painting" is easy, Schoeler asserts, when the question of German Neo-Expressionist enfants terribles like Georg Baselitz and Albert Oehlen comes up. There's no challenge in that. It's a generational thing; Schoeler is not part of that generation that feels the need to break *those* rules. This points to a shift in the cyclical notions of badness in art. Now it's more risqué to try and paint beauty.

Is Schoeler painting beauty in the classical sense? If so, he worries, then maybe what he is doing is kitsch. It's a subject that comes up a lot in my conversations with the artist. Am I doing kitsch, he asks, and if so, is doing kitsch a bad thing? Sometimes he says that he's proud to be painting kitsch, that he's engaging in a dialogue with it. That to make a beautiful painting in the twenty-first century is something like penning Romantic poetry, an endeavor that no serious contemporary artist or critic would accept anyway. (Clement Greenberg actually sources the roots of kitsch in Romanticism at one point, in its identificatory impulse toward the *effect* of poetry on the poet. Great art, avant-garde art, always identifies itself with cause rather than effect, argues Greenberg.)

Artists like Schoeler seriously trouble the old Greenbergian dialectic. Writing in 1939, Greenberg identified then still emergent abstract art as the forefront of the avant-garde, as it was the first time in history wherein artists had begun to imitate the processes of art itself (rather than, say, nature, presumably). At the same time, as the result

of rapid industrialization and improved living standards, a state of sup-posed universal literacy was attained as the masses began flooding into the city from the countryside. With this new enlightenment and work schedule that allowed for amounts of free time hitherto unknown, the masses met with boredom for the first time, and thus required their own form of culture—though they could only tolerate one sit-uated on their "lower" level, lacking the refinements of the master classes. "Kitsch is mechanical and operates by formulas," Greenberg insisted. Chez Greenberg, kitsch is incendiary, deceptive—some-thing that one must always be on *guard* (avant-garde) against; hence, he invents a role for the critic while simultaneously identifying the moral stance of the avant-garde artist, whose duty of upholding the standards of good art is rooted in a natural instinct; the avant-garde artist "has an organic sense of what is good and what is bad for art."

If abstract painting represented the heroic avant-garde of good taste, then outside of popular culture, within the art historical canon, Romanticism was enunciated as the enemy, veering dangerously close to kitsch in its attempts to dissolve the barrier of the medium that is the dividing force between the *emotions* of the painter and the spectator. And, insofar as he *flatters* the spectator, Schoeler could be said to be performing a feat of kitsch romanticism. The dichotomy, however, is not that simple, because according to Greenberg, the artist who flatters cannot simultaneously enlighten. Schoeler shows that it is possible to do both.

Schoeler feels forced to identify his practice as engaging in kitsch because, in the eyes of the art status quo that believes its duty is to uphold these categories, what he is doing is somehow too physical, intimate, dirty, present. In short, it is a sort of anti-conceptualism. What makes it so is the central presence of the body. Body becomes an expression, an extension, of being. For expression is extension: a point that Greenberg misses in his bitter dismissal of Romanticism. How can one truly separate feeling from thought in the authorial *or* spectatorial experience of the work of art? The main problem with Greenberg is

that he never managed to throw Descartes in the trash where he belongs. In such discourses, mind *always* perseveres over body. What's left for the body? It becomes a thing only women and gay men need concern themselves with: this burden of being and not-having.

But a warring and combative physicalist viewpoint proposes that mind is but an extension of body, so why isolate one from the other? The idea of *extension* is infinitely productive, enabling thousands of tiny universes to appear. We are all, to an extent, victims of the era we live in. Intoxicated by the endless whirl of technological "progress," it hardly ever occurs to us that the most essential questions may, in fact, be the most primitive ones. By confining these questions—to which no easy answers have ever been found—to the toilet bowl, by trashing history in our arrogant obsession with contemporaneity, we are only accelerating the process of universal destruction. It is with this knowledge, this supraphysicalist perspective, that Schoeler moves forward. He very well might be asking the same questions as Rembrandt and El Greco before him, but it is not done in willful ignorance of the world he is living in. He knows this place is a world of ugly accidents, of brutalism, ignorance, and danger. It is a radical gesture to deal openly and directly with beauty in times like this. Schoeler is a radical traditionalist, a neo-Romantic.

There is a boy, he is naked, he stands on the precipice, the edge of a body of water. The water is green, which means it is not completely clean. Not necessarily dirty, but polluted by foliage, by the efflorescence of its surroundings. He takes one step forward, into it, to test it. He does not know if he can trust it, whatever it is. It is a moving forward: that is all, seems so simple, and yet it scares him. Scares us. So many of us. For us many, those of us who are scared, it is much better, safer, to stay put, avoid the uncertainty of the future unknowable.

On the other hand, how silly this fear seems. Look over there, you can see the other side, it is not so far away.

He wants to be always walking. But he cannot go where there is no surface to be seen.

It could also be a field, of course, not water at all. But in this version of things, it is a lake, a sea, a body of water. It may be vague, but it is still liquid, that much is certain. Maybe it is different for you.

Total immersion entails, more than entails, is *akin* to loss. We must move forward to make new discoveries, but we're giving up control by doing so. Uncertainty is a tall order. We turn our back on past experiences, reject the sentimentality of nostalgia. But the longer we ignore that gulf of lack that forms the center of our selves, that multiple being that each of us is, the more it widens, threatening to drown the you that has to live this life, that must stay afloat, live and love and hate and die.

Schoeler manages expression without a face. And yet not. There is a reversal of orders going on here. The boy has his back to us; we cannot see his actual face. His face is turned toward the landscape, the same thing we are facing. And yet what looks back at us. Faciality—screens, surfaces, images—a hylozoic force that not only receives our gaze but projects one of its own back in our direction. We are looking, the boy is looking. Looking, looking. What looks back? The answer is simple. *The face is the landscape.* What does this face-landscape consist of?

The question of flatness is an interesting one. Ultimately, it is something that Schoeler totally rejects in his painting. This greatly troubled his professors at the Academy of Fine Arts in Munich, ardent Color Fieldists, who wished that Schoeler would leave out the figures and simply allow his backgrounds to compose the whole. A lot has happened since Color Field painting. Ever the bad student—like a lot of great artists, a dropout, a reject—Schoeler not only persisted in his loyalty to the figure, he sought to disrupt the "pure" painterly qualities of his backgrounds by making them, by and large, accidental. He would take a photograph of a spot of dirt on the studio floor, enlarging it to make a full, distorted, splotched landscape, then fucking with it in the post-processing, adding various layering effects, to get it to the right degree of blurriness, contrast—*a troubled*

surface. While the illusion of depth is always the most classical effect, the surfaces of his figures—not only their skin, but their clothing, the objects they hold in their hands—remember, we are dealing with *extension* here on a grand, endless scale—are similarly tortured, usually by the strange way the light inevitably violates their bodies. For this is a violence being done to them—a subtle violence, maybe— but it is violence nonetheless and it is the violence of vision, the violence of this world that we were brought into without choosing and must now make our way through.

Being: always a lack. Awareness of one's sensitivity to a living field does nothing to lessen or deplete it. For this is what the body becomes: a landscape. The living organism a confluence of forms. He works at and on the surfaces to lessen the affects, diminish the sharpness, a field of being. A protective shield against the violence that the eye is capable of. Or not. For what is often mistaken as a softening of forms, of the overall image, might also be seen as a brutal assertion of something.

So when Schoeler has an accident in the studio—when a mess is made, when a field becomes tarnished, a plane polluted—then it is always a lucky accident. A piece of trash is photographed, becomes a landscape, or perhaps even the surface of the skin—one of many surfaces. For, ultimately, the body is the landscape, vice versa. Being a part of something is being apart, the networked indulgence of a total sensuality that does not need to be zoned in on in order to siphon out its definitionality, all liquid and pure. True, the painter is the architect of visual meaning. But the store by which he sets up his practice can also get sucked in. You are in the way, you piece of filth, and thus, you become a part of this wider mess, even as it is transformed into beauty. There is nothing "soft" about these images, beautiful as they may seem. This is Schoeler's crowning achievement, this rendering of a *hard beauty*, something very coarse and rough, the body in its blurred causality. The sum of all the conditions that led it to get to that point, the interpretative state it is in when it is projected on the canvas or on the paper.

Memorialization

Memorialization—something that takes place within the doctrine of safekeeping. I am haunted by a memory, and so I wrap it up in protective layers, the folds of an image, I externalize it, it is then there, outer, projected into space, it is something I can look upon, a safety latch. The colors of my memory crackle in the thinness of the daylight. I retreat into a permanent darkness—the only place I can be truly alone with these thoughts. Ever mindful of the interactions going on around me, I remain silent, untranslated. What escapes me—certain things that might have happened in the past, certain things I might have been. All those selves that once trespassed me, so many of them have died now. So many of them gone into the silence. A wry new day. A dull light that shudders. Now I have grown my hair long. It falls down way past my shoulders, I smoke a cigarette, I am pretending to be. Pretending in the half-light, that glow that signals late afternoon, hour of all permanence. Mood affects every movement I make, even the tiniest gesture, I am one of those guys. I have that glint. Don't worry, it signals no violence. I am tired of having thoughts. I only want to be depicted. I don't wanna be surrounded. Look, my shoulder, it looks so messy. When I grow my hair long, I become an example: primitive man. There are no shadows on the wall behind me, he's been sure to block those out. No one wants to distract from this facade.

Though maybe in the background, it is true, you can make out traces of a ghost. Or an image removed, something that has been erased to make way for this focus. You could conjecture that it is smoke from the cigarette he is holding that forms this specter. The way that smoke begets a separate image, separate from what you think you are actually seeing.

I am not a fag and I do not want to be seduced. I do not have a sexual orientation and I am the answer to this mayhem. I am my own definition of maleness, I am what can never be believed. The family has fallen away, the individual can be re-heroicized. Schoeler

does not work within the confines of any "community" in the normative sense. We're not fighting any of those old wars anymore. The battle within and among the selves takes precedence over the old political identity dichotomies: male/female, straight/gay …

Memorialization can be thought of as the process of creating out of loss, the substitutive recovery of a lack. Sometimes that process manifests itself in physical form, as in a painting. But that doesn't mean that the painting is capturing an (auto)biographical memory. A memory can also be forged, the end product of a forgery that is embedded within the creative act. I risk suggesting here that there is something dishonest about the creative act by noting that forgery is inevitably involved. Here we go again, another contradiction that this type of painting reveals: within forgery, the production of a truth takes place. (In China, we were confronted with another version of truth. Everyone knows that China is the global capital of the simulacrum, the fake. Capitalists and intellectual copyright obsessives paint the Chinese as a race of pirates, out to destroy our precious legal-financial system in the West that says that ideas and artworks belong to individuals—not all of mankind. And by stealing my work, by replicating it so that you can profit from it yourself, you are stealing my identity, you are stealing *my truth*. In China, people fail to see this Western wrongness that is behind, nay, *thrust on* what they are doing. "Their" tradition is not "ours." In Taoism and Buddhism, chanting— ritualized repetition—presents an alternate model of truth-forging, wherein the more you repeat something, the greater the degree of truth and potency it assumes.)

Boy in the forest squatting naked rests his hands upon his knees. I knew him as I was painting him; that was our moment together. I could not know him after the fact, it wasn't allowed. He was so full of life then, the dead expression on his face, I caught him believing in something. That's what's poignant about youth, especially the cynical ones, for no matter how bleak the outlook, belief—that which keeps them going—always shines through. When I catch him

believing, when I depict it, I know I am depicting my own belief. That foreshadow of a future world that will blacken out all of this world's failings. I'm not talking about heaven, ideality. The boy wears red sneakers, he is still rooted in this world, he looks to another.

It is in the forest that so many memories get made. You can look at this shelter in two different ways: as being generative of life or else the advent of decay. Both are the same thing, really. It is possible to look at the forest and only see decay. Because from decay springs life. What's important isn't so much the fact of the forest itself but of the things that happen inside that lend themselves toward the forging of the truth, the forged truth that is the memory. It can be so simple— you just being there naked. Another boy stands behind a tree, looking. Next to the tree, he sort of competes with it. You think about it later when you are in the studio, painting another picture, and then process closes in on itself: you paint another one, a boy, and this time, his torso becomes a trunk. His arms raised above his head, the truth of his bone-thin anatomy is concealed when you use the brush to go *down down down*, from his armpit down to his pelvic bone, where the frame interrupts and the image abruptly cuts off. He was there—that is the substance of the memory—though the real thing that's going on cannot be seen, for it is the thoughts that are being thought inside his mind, the thoughts I am thinking as I paint his picture.

Painting and Writing

Painting is a language, as well, but it is one that can be very hard to read. You have to look hard for the signs, and even if you manage to find them, there is no guarantee that you will be right. Painting is the language of metaphor: it is true and yet not. It does not always present us with something we want to see.

I am standing in front of an image, it is a figure, male, he is naked, he has his face hidden by his arm, his genitals with his left leg, arched

upright, he is splayed out on the floor, his right leg providing support, it is a stressed, not entirely comfortable position, it is a being-thought-of. Today is more like yesterday. It is a dark image, what's happening here with the light is very strange. Schoeler has chosen to accentuate the softness of the light by restricting its expression to a grayish, earthy blue—the dirt beneath your fingernails as a child's after a full day at play. It is also a blue of exhaustion, a blue that says that night has come and so the normal, expected thing to do is fall asleep. This man cannot fall asleep, though, the distress is evident in his body. He is interrupting the darkness; it is cruel to be awake. His eyes all splotched out in the rendering by the shadows, one of these shadows forms a black, burned-out star. The image spells hesitancy, a not-giving-in to sublimation—that is what insomnia is all about also. Look at the blue, the man is being raped by the light, it is not at all clear where it is coming from. The background neither. I imagine it is an attic, for attics are spaces that generally have no windows, and the light cannot be coming from the moon, it is artificial. The only thing that's bright, white, is that arched leg ... He is cowering, because he is somehow mortified by the light, by what it might bring, the consolation. His body forms a constellation. He is a sort of moon and I am the planet when I am looking at him.

To be displayed.

There is a ghost inside that shadow, most of them. That ghost has a name; it is called absence. One can fill that absence, inhabit the ghost, with words. But this tactic presents its own set of problems. Narrative implies movement. To impose any sort of narrative on to a static image is, then, inevitably—whether we like it or not—an act of trespassing. My day-to-day thus varies a great deal from Schoeler's, although necessarily there is a lot of movement in each of our actions. But the ultimate destination is very different for each of us. The role that invention plays ... Don't get me wrong, we're both filling up empty spaces, we're both spilling something down and then ordering it up. There is a loneliness in doing all of that. But

we're not talking about the psychology of the process here. What's interesting is the two different forms, purposes of movement.

Describing versus inhabiting. The image does something that the words can fill? No, that's like a bubble. A thought came to me today while I was writing something else that the words can somehow fill out, inhabit the scenario that the image introduces. But that's somehow unfair to the image. When I say image, it doesn't have to be something physical; an image can occur in, occupy memory. Sometimes that type of image is more powerful than a painting.

Sometimes the two have a very strained relationship. Gertrude Stein saw what Picasso was doing, said "I can do that," and picked up her pen. Wonderful things happened, even though it wasn't really Cubism, as some have strained to explain. But then one day, when Picasso started to write poetry and (briefly) decided to give up painting altogether, Gertie wasn't all too happy about that. He wasn't sticking to his role: she was the genius writer, he needed to remain the genius painter.

It is perhaps best to view the two abstractly—that is to say, from a very far distance. That is to say: to see their similarities more than their differences. Magnify those similarities, to the extent that we can view a novel as a painting and read a painting as a novel. Get rid of all narrative, conceptual, pictorial prejudices. Perception is the last frontier. It is the gateway to everything else, the entire politico-cognitive superverse. Liberating ourselves from the prison of our categorical prejudices, we are able to see, for instance, the body as landscape and the landscape as body.

The difficulty then becomes considering writing as an act of seeing. This is the challenge posed by the new art writing. Will it overtake what is busy being there in another form? But writing has a materiality to it, as well, let us not forget. The base form of its materiality is sonic, a fact that all poets intuitively get. Writing should have a rhythm to it just as each painting has its own rhythm. Participating in a synesthesia of circumstances, we arrive at leveled ground, a new sense of order.

Frankenstein Figuration

1.

With all the recent art-critical chatter about "zombie formalism," Winston Chmielinski returns us to a time when painting was exciting and genuinely upsetting because it had so much to say. Yet that "return" needs to be qualified, because it could infer that his project is somehow nostalgic; in fact, his paintings are bold and new, without boasting mere novelty; really, it is a *return* meant in the cyclical yet eruptive sense of Nietzsche's conception of time. It doesn't really matter whether we categorize Chmielinski's paintings as abstract or figurative. Such categories quickly become obsolete, or else they shift from painting to painting; in the end, Chmielinski's ultimate commitment is to the image. His practice is one of transubstantiation, rather than appropriation. This reflects a specific relationship with nature, the image world. Nature is abstract; nature is abstraction and thus, the primitive source of all "abstract painting" (a problematic term, for sure). The Abstract Expressionists wanted to *be* nature, to embody it, and gave such primacy to the gesture that composition became accidental. In Chmielinski's painting, the work forms around those little accidents that arise through his imagistic collisions. His experiments, then, are buried in the strokes, the layers, the bright and interplanetary shades, the unruly and unsummarizable shapes, until some feasibility is arrived at, a sentence offered to the world; the world becomes enlivened by gesture. Gesture can never be reduced to

a unitary signifying device; Chmielinski is the antithesis of the Abstract Expressionist heroic solitary gesture. He posits the One as the Many, inspired by a Shintoist conception of nature, in which every living thing is its own god or else possesses its own unique brand of energy.

2.

His most recent works can largely be thought of as scapes. To call them *landscapes* would be going too far into territories of typology; they are too nebulous for that, they resist formulizable conclusion, and anyway, *land* infers that they belong to some recognizable plateau, when very often, they are otherworldly. Their nebulosity is what gives them autonomy as living objects. A siren screeches through the night; what we arrive at is a glare. A scape can just as easily encompass internal, deeply private impressions of the outer world; a collation of senses; it might also be speculative, a putting-forth of what *should be*; or else/and also a reductive yet combinatory analysis of competing color-shapes, fields, diluted into a zone that is private and primal.

3.

There is the saying and then there is what gets done about it, with it. There is narrative and then there is myth. Each painting an utterance that is open; the language is one of skin.

Chmielinski's engagement with images is one of adoration, and adoration naturally gives birth to mistrust. The parable must be obscured in order to be conveyed. He doesn't want specific narratives from his source material coming through. If other narratives emerge, he is fine with that. He knows exactly what his images are concealing and what he produces is a phantom vision.

4.

His concentration is a sublimation of distractions. The floor of his studio littered with printouts of images he has collected in his computer over the years—his source material. Adrift in a sea of his own

devising. It's not like we can fight it, this world we live in. *Ghost Where the Image Folds*: the title a figural imagining that reveals something of his process—taking two or more images often quite disparate, and "finding" his painting in the fold between the two.

Instinct is everything. An illustrative dwelling in the muck of circumstance. A boylike figure seated or else suspended in space, but only for a very brief moment—he is being propelled forward. His shape is spelled out all blobbish and undynamited, while the specter that pursues is armful, predatory, and preteriterary. The boy is pink and unethnicitated, the monster behind him that only he can see, awash in dark turbulent grays and flesh tones. As often happens when a figure is so articulated in Chmielinski's paintings (rarer these days), the boylike being is defined by not just his bodily position, but his motion (hardly ever a static pose): this one a lurch. His eyes are two aqua-green spheres, he could be blind; as Chmielinski explained in a recent interview, he can't do eyes anymore because it involves lines; now he only wants to paint shapes, swaths—not lines. One of his legs is the color of flesh, the other a pale blue, inferring gangrene or the manifestation of a phantom limb. The ghost behind him has no face. An upturned cartoonish bubble-claw for a head. The rest of it is all arms: above the claw-head, extended arm with hand attached about to come crashing down on the boylike being lurching through his own nightfield ...

Clusterfuck existentialism.

5.

The antidecorative ethos of Chmielinski's pictures demands we dive into them, even if it entails the risk of drowning. Scurrying mousishly into the space marked *Wholes around Openings*, the festivities of divisionlessness awaken us. These are colors that neither compete nor complement: a leaky marine blue in the center, hedges of plant-life greens, tropical-fruit pinks, withered joyous flesh, electrical pink, inferences of shit brown and the tentative urges of black violet. It

is rather like an overgrown garden where the rocks and flowers have agreed to trade substance for a temporary eternity, and the sublime process of melting resultantly endures. If one stares hard enough, discernible shapes might also emerge—I found a hand on the right side of the canvas near the edge, as though it were one of the things holding the painting up. Ultimately, the triple invocation of the mineral, the vegetable, and the human—with no favoring of any of the three—bespeaks a hylozoic activism in a potential world called nether.

6.

His initial inclination was toward the figure. Often—but not always—that figure bore some likeness to himself—but it could also be some random androgyne, femme fatale, or bear daddy clipped from one of his combings of the internet. Even when he was focusing on the figure, it could never be classed as straightforward *portraiture*. The figure, too, became a scape, as in *High Tide*, a painting from 2011— to take but one obvious example, wherein the torso of the reclining nude figure has been violently and shamelessly "erased" in considered swaths of orange and pink formlessness, while the background rhythmically breaks down into zebra print and pale, noncommittal sky blues. These are decisions made by the hand-brain without any anxiety. The dominant impulse is to mask or transform the violence done to his figurescapes with the flesh-savvy flashiness of a bright palette.

As Chmielinski moves increasingly into the scape and away from the figure, it is not as though he has abandoned the figure. Precisely the opposite: what Chmielinski attempts—and pulls off—is a figuration of the unfigurable. His painterly eye refuses to discern between "living" beings, nature, and inanimate objects; all are infused with the restlessness of life. If you need a name for it, call it Frankenstein figuration, wherein even inanimate objects or blotches of landscape are invigorated with a life force.

7.

Yes, the face has a great future, but only if it is destroyed, dismantled.

On the road to the asignifying and asubjective.

—Gilles Deleuze and Félix Guattari

His battles evolve all the time. *When Talismans Saved My House from Burning Down* had four different beginnings—one can discern in the chaos of the completed painting an array of different scenes; the final image was only arrived at via personal mythology—Chmielinski's revisitation of his childhood, when a fortune teller's predictions caused his family's life to be uprooted on numerous occasions. *Notes on Paradise* started off as a portrait of a woman holding a branch. In the middle of painting, Chmielinski began to doubt the subject—he began to fear it was turning into some pointless formalist exercise—and turned his attention to a photograph of an island. Thin washes of floral trees then plastered themselves across the canvas against the tropicality of reds, light greens, the blue of a pristine sea. Finally, what gives the painting its distinctly Chmielinskian rhythm are three white elicitations of folds, based on photographs of crumpled paper taken by the artist.

In *Hardest Water*, the canvas is unevenly divided across a horizon. The top is relatively uncrowded, with a piercing marine-blue background supporting three inferences of shapes. The bottom, which takes up most of the canvas, is a scene of inclement weather and blind graspings played out against an anemic pink wall. Originally there was a giant white indefinable artifact in the middle of the canvas. After looking at a photograph of a field of flowers in order to distance and distract himself, to *distrance* himself, things started to move around, shift. Substance is an ever-changing element. He reached a point with the painting where everything felt too safe. He wanted to feel there were pitfalls in the image, so he inserted a series of dark spots. Another annoyance—to give an idea of the severe degree of layering that goes on in a Chmielinski painting—was a proliferation of faces

that uncontrollably appeared, the ghost in the machine. He had to erase them. What we get are arms instead of faces. An illustration of that primal act. Extension: brain to arm to canvas. Armbrains. Says Chmielinski: "I don't want to be a clown face painter."

8.

"That oscillation between frenetic gesturing and really controlled painting is what keeps it exciting for me, and I think it's one of the intrinsic (and unique) characteristics of painting, that even though I always find myself fighting with representation, if I were to forsake it then I would be forsaking the magic of painting, and the fact that not every gesture has to be heroic, some can be the most minute shifts in perspective and they have the most profound effect."

9.

Chmielinski shares many of the poet's inclinations. He never studied painting formally. It is not an accident that his initial vocational calling was to literature and philosophy—particularly philosophers like Gilles Deleuze, who considered philosophy as a vehicle for creation, rather than mere reflection. While he continues to write, his ultimate linguistic idiom has become the image, rather than the word. Yet the word continues to play an important part in his paintings, in their elaborate and poetic yet exacting titles; as he himself admits, at times he labors more over the titles of his paintings than the paintings themselves. And, as those with an intimate knowledge of Chmielinski's process can attest, he proceeds much like a poet, according to mystical and very private associations rather than rigid conceptualist strictures.

He also proceeds according to the indefatigable compulsions of the autodidact. He looks at the world and perceives in each object a quivering around the edges; the aliveness of the inanimate. Each painting becomes its own thing, a synthesis of gestures and lush, exuberant imbalances. A mop that absorbs motion, then distills it into color, shape—yielding a solid and endlessly placeable permanence.

Trance Cinema

1.

For the rare few who have braved reading it, Gertrude Stein's 1925 novel *The Making of Americans* posits a kind of endlessness, an infinitude in its endless stacks of paragraphs comprised of long, winding, repetitive sentences with short, simple words, fomenting a singsong rhythmicality that puts the reader into a sort of trance. And a similar trance poetics is effected in the films of James Benning who, like Stein, achieves a temporalization of space, a spatialization of time. Both artists find in the American landscape a rich depository of meaning in both its beauty and instances of ugliness. With its inferences of boundlessness, it serves as the primal locale for the poet's vehicular wanderings, the fertile soil for the implantation of the impossible dream of freedom, of divorce from the strictures of the supernal and the unpleasantness of history, of a real all the more remarkable for being spread right before us, blinding us with its encoded morality tale of everlasting life.

For the landscape, like all objects, whether big or small, contains an inner life that we may come to appreciate only by knowing it. And this knowledge is an impossible task, made all the more vital because of its inherent impossibility. The only way we might come close is by going there, treading upon it and across it, diffusing ourselves among its spread. This, we might fathom, is one of the underlying intentions behind "Looking and Listening," the class Benning has taught at

CalArts for the past thirty years, which is organized around a simple pretense: that these two isolated senses, when combined, yield at least the wondrous possibility of a dissolution between self and object.

In the class, Benning says, "I'd take ten or twelve students some place (an oil field in the Central Valley, the homeless area near downtown Los Angeles, a kilometer-long hand-dug tunnel in the Mojave foothills, etc.) where they would head out on their own and practice paying attention. I never required a paper, or a work of art, or led a discussion. If there was an assignment, it was to become better observers. And that they did: afterward their art grew in a far more subtle direction." The only rule was that students were not allowed to talk when in the field, so as to pour all their energies into the task at hand, nor were they allowed to bring with them any devices with which they could record (including pen and paper).

Given the increasing mediation by which nearly every aspect of our lives now comes to be dictated by technology, and the resultant diminishing of attention spans, the mere exercise of our raw senses seems almost radical: a veritable "total minimal situation," as Ryan Trecartin would have it. But it is looking and listening that have formed the core of Benning's filmmaking practice since he began in 1971. Typically considered the task of the viewer in the cinematic scenario, Benning challenges this convention, showing us how looking and listening can serve to defy the stasis of passivity: how looking and listening can, in fact, serve as vehicles, much like the motorcycle on which the filmmaker has made countless journeys across the American landscape.

Where does the vehicle get to when it finally arrives?

13 Lakes contains static shots, each totaling around ten minutes in length, of thirteen different lakes in North America. *10 Skies*, the same with skies. *Two Cabins* is two cabins, fifteen minutes each. Seems so simple, so boring in its simplicity and in what we are meant to endure by sitting there, looking and listening, and, in defiance of cinema's dominant coding, nothing happening. Yet once we get to that place where we are able to *really* look and listen, this *nothing happening*

turns out to be a lie. Our senses come alive to the subtlety of detail contained within the frame, forming a whole. Look at Lower Red Lake, the seventh of *13 Lakes*. We enter into what seems the middle of it (the day), though we can't tell what time, or what season—the clouds are too thick. There is but a thin sliver of land, a dash in the right of the screen, whatever it turns into is out of sight. The horizon line is perfectly bisected in the shot, with the sky taking up the entirety of the upper half, the lake the lower. The clouds have grown so heavy that they can't help but synesthetically over-take the sound of the light lapping of the waves, the placidity of the waters they shield. It seems as though they could break at any moment, add yet more water to our water that is so calm we don't want any more of it—still, we wait for it to happen. But in vain. Clouds move so slowly, so gallantly from right to left. Suddenly, a light thunder crumbles over the scene, a thunder that seems to signify our time is almost over. The deep, dark blue that masks the horizon's vanishing point: that must be where the planet comes to an end. Don't steer your ship over there, it'll fall off. When the earth was flat, the people who came from the other side were aliens. We are aliens among ourselves whenever we travel. Birds chirping but unseen. Wandering toward the bottom of the screen, shore begins to surface: the layers of orange underneath. Pregnant soil that will soon give birth … to what? A new species of storm? What will we name the first one? For that is our job, as humans: to name things. Our big accomplishment. The flowing water reminds us of lava. Water moves like clouds: the cloud-hills. Water moves faster than the clouds. Nothing stands still. Nature moves fast, like our gaze. This slows it down. Darting between within and without … Stuff happens all the time. You can't stop it, you can't control it—and why would you want to? Give yourself over to the movement of nonbeing—this nature, the joy of its static dancings. I had a dream once: the sky. And everything that happened after was but a reminder of this numinous affirmation.

Wandering thoughts: one of the consequences of this type of cinema is that the viewer's agency becomes part of the final product, which is not the film itself, but the experience of watching the film. Whereas narrative cinema based on the Hollywood model (what I call dominant cinema)[16] attempts to control the viewer's thoughts and feelings throughout the duration—if your mind wanders, the film has failed, because it has lost your attention, you have *grown bored*—with Benning's films, you are allowed and even encouraged to turn inwards, melding your agency with the body-mind vehicle that is James Benning. So if while watching *13 Lakes* your mind wanders and you suddenly think, "I should do the laundry when I get home tonight," that thought becomes a part of the film's fabric.[17]

Over time—even if the time that passes is but a "mere" ten minutes—so much changes. In the first scene of *13 Lakes*, depicting Jackson Lake, the mountains in the background are shrouded in a purple-gray hue. We get to watch as the day becomes new. The mountains perform a striptease with the rising light of morning: the darkness slowly moves down their height, until, at the end of the scene, they stand before us naked, their craggy skin shimmering in the brightness of the day's sheen.

In Benning's films, landscape is considered as a function of time and all the changes that are impelled thereby. To film *Casting a Glance*, Benning visited the site of Robert Smithson's *Spiral Jetty* in Utah's Great Salt Lake sixteen times between May 2005 and January 2007. A landmark of Land art, *Spiral Jetty* is vulnerable, shifting its appearance constantly as a result of the climate and the weather, the rise and fall of the water levels—at times, it is nearly invisible. Its effect upon the viewer changes according to the time of year, the season, and whether one views it from the air or the ground. Very few have seen it; only the most dedicated have truly experienced it.

[16] While most critics regard Benning's films as nonnarrative, Benning has asserted that they are, in fact, narrative films. Dominant cinema is thus a useful means of regarding the sort of mainstream narrative cinema that Benning is opposed to, for both formal and political reasons.

[17] Benning is quite fond of this laundry example, which he has repeated in several interviews.

"In order to experience the *Jetty*," says Benning, "one must go often. It is a barometer for both daily and yearly cycles. From morning to night its allusive, shifting appearance (radical or subtle) may be the result of a passing weather system or simply the changing angle of the sun. The water may appear blue, red, purple, green, brown, silver, or gold. The sound may come from a navy jet, passing geese, converging thunderstorms, a few crickets, or be a silence so still you can hear the blood moving through the veins in your ears." In *Casting a Glance*, Benning captures this experience, condensed to eighty minutes. Yet even as the film, in its essence-seeking, brings us to a place in a more visceral sense than still photographic documentation enables, it simultaneously problematizes cinema's purported claims to give us an authentic experience of a place. It thus illuminates the inherent failure of an object-oriented approach to another work of art (the *Jetty*), while simultaneously asserting the usefulness, the right to be of such failures. This built-in critique of the medium—and of presence in a more general sense—is very much a part of Benning's cinema. "I think *Casting a Glance* does it best; it tells you that even if you go there you won't be there, because if you go there again it won't be like that, it's constantly changing, and the *Jetty* is this kind of barometer to measure change. That's true with all place, right? Time is always working and entropy happens, things collapse and are rebuilt. Reality is never static, it's always moving. What I'm trying to do with films is provide a metaphor for being there, but also the idea that this is just one view, and that many other completely different views exist."

2.

For effectively disrupting our normative means of perception when we enter the cinematic scenario, Benning earns the distinction of Bad filmmaker. It is a title he covets. "I don't want to make another good film," he tells one interviewer, "there are too many of them. I want to make radical work that adds to a discourse." Benning's films

aren't radical merely for their aesthetics, but for their politics—both in terms of formal matters, the oppositionality of their form, and for their encoded references to social, political, and economic subjects. The latter might be more difficult to perceive, as they are bereft of the sort of Brechtian didacticism one typically associates with overtly political art. In Benning, the landscape is always more than a mere landscape, it's the scene of a crime. Put another way, his films ask, what does it mean, in the American tradition, to withdraw from society, to purposely exclude oneself from the mainstream of discourse, to enter not merely a *room* of one's own, but *into* an insertion in the landscape, cementing one's isolation from the noisy business of the human sphere by a permanent communion with nature—those very forces that society aims to tame and control, rather than embrace?

In 2012, Benning released a "remake" of *Easy Rider*, Dennis Hopper's 1969 film that is considered a classic of hippie counterculture. Benning drove across the United States, shooting landscapes from the original locations of Hopper's film, devoid of human actors. Instead, the landscapes, often mutated or altered by the ravages of time, take center stage, overlaid with selected excerpts of dialogue from the original film. While the remake, as a genre, tends to manifest at least in part as an authorial homage to the original, Benning's *Easy Rider* is actually highly critical of the lifestyle politics celebrated in Hopper's classic. In Benning's view, the "rebels" depicted by Hopper and Peter Fonda are very conventional in their yearnings and desires, revealing a failure of American counterculture to fully divorce itself from the values of dominant culture. In attempting to fulfill the neo-Romantic quest to live on the road, Hopper and Fonda can manage only the most superficial engagements with the locales they pass through and the humans who have put down roots there. Despite their long hair, motorcycles, and rock 'n' roll, their ultimate desire, expressed at one point in the film, is to retire in Florida and enjoy the good life—perhaps the most conventional of American dreams—with the money they have earned in a lucrative drug deal. (On the subject of intoxicants, Benning is fond of

repeating Malcolm X's assertion that drugs are counterrevolutionary.) As Benning observed, the word "Vietnam" is not uttered once in the film—a shocking omission for a counterculture film shot at the height of the war, when protests were tearing the country apart. The protagonists' interactions with the people they encounter are similarly selfish, superficial, and scornful; the minute these people are able to satisfy Hopper and Fonda's needs, they are discarded and forgotten about. Here, one can't help but be reminded of one of Benning's earlier road-trip films, *North on Evers*, whose textual narrative, which is Benning's handwritten diary kept on this particular road trip detailing his interactions with the friends, family, and strangers he met along the way, is a moving and powerful counterexample.

In returning to sites of the original filming, Benning observes a contemporary Middle America that lies in ruins—the film is filled with dilapidated storefronts, scenic victims of recession and financial trauma: Main Street USA is long dead. Several shots in Benning's film linger on structures built by the Anasazi, a tribe that predated the Pueblo Indians, whereas the protagonists' engagement with indigenous Americans in the original film is desultory at best. The thirty-seventh shot in Benning's film shows a mansion on a Southern plantation, giving rise to a prolonged meditation on the origins of Black America, slavery, and the unrepaired race relations that persist to this day.

The vehicularity of Benning is premised upon a deep engagement with all of the locales he passes—he becomes *absorbed* by the landscape, and part of this absorption is a mindfulness of the historical truths they contain. This is where looking and listening gives rise to something greater—a *will to know* that is a politicization of both consciousness and perception.

3.

Often misread as a structuralist filmmaker, Benning is really more of a landscape poet. His work reflects a complete surrender to the mired totality of the natural world, yet it is ever mindful of humankind's

tinkerings and contaminations. In recent years, Benning's work has extended beyond cinema—without, thankfully, completely neglecting it. His 2011 *Two Cabins* project was inspired by a perceived affinity between two philosopher-seekers of the American "back to nature" dream, Henry David Thoreau and Ted "Unabomber" Kaczynski. On his own property in the Sierra mountains of Southern California, Benning meticulously reconstructed the cabins of both men based on details left behind in their writings, as well as, in Kaczynski's case, FBI photos: not so much an appropriation as a living (and lived-in) homage to the mystique of the self-styled outsider. This project formed the basis of *Two Cabins by JB*, Benning's 2011 book with Julie Ault, the short film *Two Cabins*, and the 2012 feature-length *Stemple Pass*. More recently, within those cabins, Benning has hung his own remakes of paintings by eight of his favorite "outsider" artists. It was these paintings that were the focus of a 2014 exhibition at neugerriemschneider in Berlin, as well as one quilt, *After Pettway*, which was installed across from a fake Mondrian as a means of calling attention to the shared aesthetic affinities between the great European master and Missouri Pettway, the self-taught daughter of a former slave.

Here, in *After Darger*, are the Vivian Girls being strangled in a vast field by soldiers in unionesque navy-blue uniforms. "BRAIN,' WARSHE-R. YES,' BRAIN WASHER," screams *After Howard*, a hand-painted sign that is also a poem, a three-fingered hand pointing at the final "BRAIN" like a conductor fanning rhythm out of all that cacophonous punctuation. *After Ramírez* shows a deer standing on a stage fashioned out of white piano keys framed by frilly curtains, staring quizzically, its head and torso caringly patterned with lines that are an echo to those forming the curtains. Are we to evaluate these homages in comparison to the originals? The artist's very working method implies that there is no easy answer. In the second room of the gallery were eight framed digital prints, photographs of art books opened to reproductions of one or two works by the artists cited in the other room. Though none show any of the first room's

paintings, this was a reminder of the unsurprising fact that Benning worked from reproductions, rather than originals.

Benning's act of autistic copying becomes itself a folk craft—down to his painstaking attempts to use the same materials as his predecessors. In an art market obsessed with authenticity—especially in the case of outsider art, where it becomes an object of fetishization—Benning puts forth the "dangerous" proposition that what matters is not originality but feeling.

The exhibition concluded with a silk-screened quotation, penned in Thoreau's own beautiful leaning cursive script, in which the writer extols the yearning for an uncorrupted form of pure seeing, and began with a wall drawing of a grid of numbers illegible to the math-challenged like myself—a code employed by Kaczynski in writing his diaries. The two men transposed the very American puritanism of their forebears into their own personal extremities of relating to the external world, and both ultimately failed in their attempts to turn an ideal into a lifestyle; Kaczynski, after all, ended up behind bars, while Thoreau spent considerably less time at Walden Pond than is commonly believed and later regarded his total immersion into nature as little more than a brief experiment. There is something poignant in these very human failures, Benning implies, and perhaps even something worth preserving.

Forever Okay

Jimmy DeSana believed that the human body was every bit an object as, say, a toilet or a chair. Blend together, mix up the legs of a table, the legs of chairs, the bare legs of a person and see what you get. A person is no longer a whole, but known by her/his=its parts: head is a suitcase, brain a lightbulb, penis a shoe. Maybe become an entity with four legs instead of two arms and two legs. It's all the same world, isn't it?

There are those of us afraid of what we see. A world of interior objects we keep so that we can ignore other things—namely, the world out there. Furniture is static existence. DeSana's work says something about domesticity. What does it mean to be a person and to disappear. There are no warnings, no announcement is ever made. Objects are kept around us to avoid the sense of disappearing. To imply permanency. Railing: a railing against the sure swallow of the big fat void whose rim some of us dance around.

DeSana's gesture is a violence against disappearing. He committed suicide constantly in his work. He had to do that as a way of living in the world. Suicide salvation: the black-and-white photo that made him famous was him hanging from a noose naked with a hard-on. Or else he lies under a car, again naked, forever naked, wearing a mask with a tube connected directly to the exhaust pipe. Inhaling the car. Is he really killing himself there? I don't think so. As with all of his photos, it's more of a becoming-object than a becoming-dead.

An extension of the car, that's all. If you look at it as a body, then of course it's going to die, but Jimmy DeSana did not want to die and his photos are not about death. Inanimate objects never die; you can't get rid of them, no matter the state of decay. They're never really alive, either, are they; they just are. Forever okay. A being that is a freedom in not-being.

For a gay person who has suffered violence directly, there is a fluffy comfort in becoming-object that few others may comprehend. It seems so hard. DeSana's aesthetic *looks* hard, but I would say it's just the opposite. Wooden boxes, pool chairs, torsos; the arch of a body running the length of a room, head in the toilet, an extension of the toilet; heads, faces almost never to be seen in these photos, to heighten the sense of disappearance, of desubjectification; the light always soft; no more self to contend with, no such thing as death to confront. Jimmy DeSana is soft-core, if the core we're talking about is being, safe from the trenchant torpor of navigation.

This was among the least apparently glamorous approaches one could take in the '80s, which DeSana characterized, in an interview with Laurie Simmons, as a decade of death and money. The art market exploded, everyone dancing as dollar-bill confetti floated through the air, meanwhile guys were walking around with lesions, dropping dead all around you. It's wrong to read these photos as documentary evidence of a gay S&M subculture that DeSana was never really a part of. Mapplethorpean scenes from a Manhattan night. Others have more aptly identified surrealism as the operative force, the fuel in DeSana's vehicle. As an adjective, *surreal* is too vague and overused, and anyway, it is the artist's duty to carve their own reality out of this messy consensual one—that impulse comes out of a disbelief in messy consensus reality. It's too easy to say that *the world*, as it is, is surreal on its own. Forty-year-olds dropping dead for no real reason is surreal—becoming an object is pretty much okay, in a permanent sort of way.

There is, after all, a glamour, certainly a sexiness, in immortalizing yourself or some other selves in this manner. *Don't treat me like a sex object*, screams the liberationist who, in doing so, believes they are on their way toward attaining autonomy. But for the corporealist, sex is just another utility; come here, let me touch you where it matters least. Jimmy DeSana knew things about bodies that we're only now, in the twenty-first century, beginning to figure out. In this way, his photos can be seen less as a relic of a past moment and more as a blueprint for our present-future selves.

walden

There is a whole other history of cinema out of which Jonas Mekas falls—kicking and screaming, alive and elastic to the necessities and vicissitudes of this thing we call life. One has to be thoroughly drenched in it to attain such a position as Mekas's, and for evidence, one doesn't have to look further than the films themselves, which capture a politics of the banal and everyday despite their author's frequent assurances that he has no overarching plan, no real understanding of what it is he is doing. The films are political precisely because Mekas allows experience to serve as his sole structuring device. His cinematic submersion into total presence has been at the root of all his activities from the beginning—for he knew no other way. This not-knowing is what Mekas might term "beauty"; for the viewer, it is the spiritual impetus that compels us to go along for the ride.

It makes total sense that Mekas, a displaced person, would end up making films from a positionless position. It is also not coincidental that Mekas, after surviving Central Europe's attempts at civilizational suicide in the Second World War, would wind up a resident of his century's capital of displacement: New York. Once there, he and his brother Adolfas procured a Bolex camera and immediately began filming their lives in this baffling new world, to which they would both make a massive contribution as artists. Jonas Mekas would soon find himself at the very center of New York's downtown underground filmmaking scene.

Just as the Abstract Expressionists required a dose of the old world, which came in the form of the great German painter and teacher Hans Hofmann, in order to come into being as artists, it is hard to imagine how their cinematic counterparts on the Lower East Side in the 1950s and '60s would have turned out without Mekas's contribution. The roots of Mekas's sensibility, more "Russian" than "European," can be traced back to Soviet filmmaker and film theorist Dziga Vertov. Thanks in no small part to Mekas's influence, as well as that of Maya Deren before him, one could read the New York scene as Vertovian in many of its aesthetic ambitions.

In *Man with a Movie Camera* and his voluminous writings on cinema, Vertov articulated his principle of the "kino-eye," which considered the cinematic apparatus as a means for revealing the true nature of reality and thus liberating the masses from the bondage of servitude to capital. "From the viewpoint of the ordinary eye," writes Vertov, "you see untruth. From the viewpoint of the cinematic eye (aided by special cinematic means, in this case, accelerated shooting) you see the truth. If it's a question of reading someone's thoughts at a distance (and often what matters to us is not to hear a person's words but to read his thoughts), then you have that opportunity right here. It has been revealed by the kino-eye." While Vertov took as his grand subject the building of socialism in the USSR, Mekas, beginning his work at a later date, had already seen the tragic failures that such utopian schemes often descend into and the human expense that results. Here is where Mekas's "kino-eye" departs from Vertov's. From *Walden*, Mekas's first major accomplishment, onward, his concerns were immediately diaristic, and yet political, albeit in a more subtle way than Vertov's could ever be. Mekas's camera became an extension of his being, constantly on hand to record the peregrinations of a Baudelairean flaneur. In fact, it is probably not much of an overstatement to characterize Mekas as the Charles Baudelaire of New York City. Just as the poet's wanderings through the capital of the nineteenth century, Paris, formed the basis of his oeuvre, so did Mekas merge with the

camera to become a moving machine, generating audiovisual poems of city life almost as a by-product.

The camera as an extension of the eye, of one's being. All those who traveled along such a path—among them Stan Brakhage, Jack Smith, and Bruce Conner, to name but a few of Mekas's fellow travelers—felt it within themselves that film, the vehicle to which they had dedicated themselves, and with which they had merged as they became artist-machines, had the power to do more than merely tell stories. Or else, it compelled them to tell stories in truly *different* ways, outside of the narrow conceptions of Hollywood. The underground filmmakers were far away—geographically, aesthetically, and spiritually—from that model, in which the neurotic fears and banal desires of the middle class are spotlighted and attention spans are capitalized upon in order to generate an endless stream of copies. Instead they assumed the possibility of an entirely different means of cinematic transmission and representation, unthinkable to the mid-century mainstream, which was largely complicit with McCarthy's witch hunts that had only just recently ravaged American society. Each of these filmmakers had his (or, admittedly less often, her) own individual style, with Mekas's being the diaristic—which, in cinematic terms, is the home movie.

How, for instance, does one begin to make sense of the first major diary-film, the 180-minute-long *Walden*, described by its author simply as "materials from the years 1965–69, strung together in chronological order," interspersed with random reflections, philosophizing, and bursts of music? The film is of course a major archival landmark of the decade, capturing as it does a number of the era's luminaries, including Andy Warhol, Yoko Ono, John Lennon, and Allen Ginsberg. Besides that, as its title suggests, it serves as Mekas's own version of *Walden*, the famous tome by the nineteenth-century Transcendentalist Henry David Thoreau.

So here we have a Lithuanian poet-filmmaker standing between Thoreau and Vertov—two unlikely figures, the American Transcendentalist and the Soviet revolutionary. Two radically disparate visions of reality. But are they, really? And is Mekas's stance between them

really so uncanny? What more suitable position could one adapt as an immigrant in New York from a country behind the Iron Curtain? "We loved you, world, but you did lousy things to us," Mekas reflects in *Reminiscences of a Journey to Lithuania*. Mekas's quest has been to locate his own mystical Walden, realizing, unlike Thoreau in his idealization of nature or Vertov in his eulogy to the city, that this Edenic realm is not likely to be found anywhere on earth, but in the people that surround you and the experiences shared.

The diaristic mode is, from the standpoint of consumption, rife with problems for the viewer. The key to Mekas's films, perhaps, is not to *watch* them, but to attempt to *drift* into them. His films are what those of a conventional bent call "experimental," because they refuse to do our thinking for us. "This is a political film." The message flashes across the screen several times, and yet his films are political in no obvious way other than their form, which is often rooted in the seeming senselessness of the collage principle, the anarchy of the chance technique.

Adapting the diaristic mode to cinema has allowed Mekas to be at work virtually all the time, bringing his camera with him everywhere, and thus annihilate the divisions between art and life. One is, in a sense, always at work while never working—just *being*. His 2001 epic, *As I Was Moving Ahead Occasionally I Saw Brief Glimpses of Beauty*, consists of 320 minutes of film made throughout his life, randomly spliced together and featuring occasional voice-over ruminations from the author. At some point Mekas announces, "By now, you must have realized I am not a *filmmaker*. I am a *filmer*." Mekas takes on the role of the amateur, the Sunday painter, not to demean his product, but to assert the viability of a cinematic vehicle that is markedly other in design. He has no other choice; this is the language he has forged out of compromise with the world he was thrust into. "But while we are confined to books," writes Thoreau,

though the most select and classic, and read only particular written languages, which are themselves but dialects and provincial, we are in danger of forgetting the language which all things and events speak without metaphor, which alone is copious and standard. Much is published, but little printed. The rays which stream through the shutter will be no longer remembered when the shutter is wholly removed. No method or discipline can supersede the necessity of being forever on the alert. What is a course of history, or philosophy, or poetry, no matter how well selected, or the best society, or the most admirable routine of life, compared with the discipline of looking always at what is to be seen? Will you be a reader, a student merely, or a seer? Read your fate, see what is before you, and walk on into futurity.

Jonas Mekas made that choice a long time ago. Walking alongside him, we are reminded that vision, an active agent, is nothing less than the life force itself.

Goddess in the Machine

The object—in its autonomy, its detachment from a larger system—has been a philosophical fetish-item in recent times, whereas earlier, it was the nature of the system—its peregrinations, its sinister machinations—that held us captive. Arguably, not much has changed except for the directional flow of the analysis: many artists and thinkers retain the concern with the omniscient "outer" frame and its embeddedness in our lives. But with technology playing a bigger role than ever before in mediating our quotidian transactions and affections, a bottom-up analysis has come to the fore: simultaneously considering the object qua object *and* (consequently) as a means through which to critique its relations, or the systems to which it contributes.

The point of such critique is, naturally, to catalyze some change in the structural flows of such systems. But is *critique* enough? Does it necessarily act as a catalyst in an era when, owing to technology's omniscience and the so-called global forum, everyone has a voice; when, now more than ever before, the old adage "Opinions are like assholes …" rings accurate? Indeed, under such conditions, critique often seems like little more than necessary filler.

A third, activist approach might be located in the work of Holly Herndon. Herndon is a musician whose recent output has focused on the considerable deployments of one particular object, the laptop: an item whose overloaded instrumentality nearly precludes—or at least, makes ridiculous—any notion of objectile autonomy. Through

her ideas of embodiment, technology as extension of self, and an anti-escapist ethos, Herndon seeks ways for her laptop-produced music to "direct the conversation," as she put it recently.

Herndon cannot be considered a "pure" musician—in the sense of being a composing and recording artist who also performs live concerts. To consider her in this traditional sense would be to exclude her academic activities, what one might call the research side of her practice, which have entailed a rigorous interrogation of the ontology of her chosen medium; it would also be a mistake to overlook the frequency and nature of her collaborations, which often extend her work beyond music's traditional confines. Just as difficult is any attempt at considering her music "purely," for it straddles the demarcation between "experimental" music or sound art and the marketized machinery of pop. Herndon's music, as well as the model of the artist she puts forth, is a new machine, representing a challenging means of looking at and interacting with the world—a means that is very much rooted in the perambulations of the "now."

"I'm not interested in retro fetishism," Herndon says. In popular music, the integration of retro elements—or, worse, full reliance upon them—is viewed with suspicion as a means of escapism, entailing a denial or refusal to deal with the problems posed by the present. Here, Herndon has acknowledged the influence of Suhail Malik's notion of the need for an "exit," rather than an "escape," from the contemporary in art. For Malik, contemporary art's entrenchment in indeterminacy prevents such an exit from occurring; he proposes, somewhat vaguely, the need for a deeper engagement with the real and the conditions of the present.

What "now" sounds like, according to Herndon: fast cuts and splices; multiple browser windows broadcasting conflicting strands of competing frequencies, each carrying their own ideologically loaded brand of "truth"; an equal playing field—with all inequalities equally represented. Yet "representation," now becomes erasure, the pessimist might say: All these screens blaring information, all of it

manipulated to serve some agenda, all of it simultaneous, a barrage of noise. A permanent state of exhaustion is frequently the result of a contemporary way of life that requires one to constantly and endlessly read between the lines. Escapism, then, is a major temptation; what we often seek, when we turn on music, is a release from the myriad anxieties of contemporary being.

Herndon's work seems to suggest that the exit must be not through evasion, but through a total immersion in the machinery of the present. This entails locating what is human—emotion and expressive capabilities, to name but two examples—within the technology to turn the machinery against its political and corporate creators.

Embodying the Machine

Herndon has indulged in her own fair share of escapist longings. She spent five years in Berlin in the late 1990s and early 2000s, frequenting and working in the city's famously hedonistic club scene. This must have been an exciting, stimulating, and dangerous-seeming world for a person reared in the US Bible Belt, where Herndon learned to read and perform music singing in the local church choir. While her years in Berlin's club and underground music scenes undoubtedly played a formative role in the evolution of her communitarian ethos, Herndon eventually came to realize that something was missing, that there was a floundering sense of lack in her own artistic development, prompting a return to the US and to a more formalized mode of education.

Mills College is situated in the historically hippie-centric Bay Area of Northern California. It is an unusual mix of an institution: its curriculum is generally deeply reflective of the "lefty" situation of its environs; its undergraduate student body is all-female; its graduate programs are mixed. Among those programs is one of the most famous in the country for experimental music. Steve Reich,

Morton Subotnick, John Cage, Joanna Newsom, Laurie Anderson, Meredith Monk, and David Behrman have all passed through the doors of the college's Center for Contemporary Music, where Herndon set out to pursue a master's degree in electronic music and recording media.

Herndon credits her encounter with computer-music pioneer John Bischoff for opening her mind: "It was an aha moment, seeing that the laptop could be a musical instrument—a *concert* instrument! Prior to that, I had never encountered that. To see him perform in these beautiful concert halls on a laptop, seeing everyone take that so seriously … It was nice to see that as an option." Herndon also studied improvisation with Fred Frith, spending a term in the college's improvisation ensemble, where she was forced outside of her comfort zone by being required to compose on her laptop on the spot; under Maggi Payne, Herndon undertook training in programming and theory.

It is of equal importance to note that Herndon's formal studies of music, her foray into the laptop-as-instrument, took place against the backdrop of revelations by WikiLeaks and Edward Snowden of worldwide, systematic spying on private individuals by government agencies via technological apparatuses. For Herndon, this was the definitive and most consequential political event of her generation—one that has continued to influence her aesthetics and her thinking about music's position in the world and its potentialities as a vehicle for change. While on a more general level, one might assign Herndon's propensity for collaboration—often with artists not directly working in the medium of music—to the expanded consciousness and anti-individualism of post-Occupy thinking, a more fundamental engagement is with the notion of embodiment, which was the subject of her master's thesis.

A frequent complaint leveled against computer-based music, particularly when it is performed in a live setting, is that it is *disembodied*, thoroughly detached from the human factor. This has profound and

problematic implications. One might trace this line of thinking to the Cartesian body/mind divide, which is a paradigm that Herndon, alongside a number of contemporary thinkers, explicitly rejects in favor of a physicalist position. This is where the notion of *extension* enters the equation. Whereas Descartes assumed that the mind held supremacy over the body, for artists like Herndon, the mind is but an extension of the body's vast machinery; the latter cannot be held subordinate to the former as such. To do so is to deny the "logic of sensation," as Gilles Deleuze deemed it, in what is essentially a concise definition of expressionist art practice. The body, the physical manifestation of ourselves in the world, speaks its own language, and to deny that language's inflections would be a futile, and anyway impossible, task; it is the sensory and conducting rod for flows of intensities pertinent for the creation of the art object.

To take it further, the laptop, whether it is used as a musical instrument or for more quotidian purposes, emerges as an extension of one's body-mind being—a force of projection rather than a disembodied shell devoid of human agency (and, to take the implication even further, a potential vehicle of exit from the "merely" human). As the computer, whether in the form of a laptop or even smaller mobile device, is increasingly the mediator for most forms of communication between humans, why should art be absent from this equation?

Many of Herndon's early performances were staged collaborations between human and machine: besides the laptop, Herndon's main instrument is her own voice. A primal instrument, and perhaps the *most* human, her voice was projected into a microphone, to be subsequently processed through an array of effects via her laptop. Raw vocal emissions were transformed into sounds both otherworldly and utterly familiar, packed as they were with a range of referents to the contemporary technosphere. *Solo Voice*, a 2012 performance at an interdenominational church on the campus of Stanford University in Northern California, was one of the more salient demonstrations of this, and a good entry point for fathoming the fundamentals of what

Herndon does. Beginning with a single tone sung into the microphone, she almost instantly cuts it off, syncopates it, then loops it through her machine, turning her voice into bouncing balls of sound. She uses the machine to vary and shift the pitch, adding new arrhythmic syncopated tones on top of the original sounds. Midway through, she contributes further sustained notes with her voice to the composition, forming a harmonious underscore for the bouncing tones: a truly vox organ.

Performed as part of Herndon's master's thesis, *195* is a fifteen-minute piece that further addresses the disembodiment of the human voice via electronics. The performance, which took place in March 2010 at Mills, featured six female singers and was conducted by Herndon, who simultaneously "played" her laptop, processing the vocals and using extended vocal techniques to create a variety of sounds from synthesis and feedback. Her use of the laptop was kept rather minimal compared to her later developments, as though she were purposefully restraining its instrumentality so as not to draw too much attention to it. Fair enough—she was, after all, attempting to prove a thesis. At times noisy, at other times lush and choral, *195* made no effort to deny its incompatible aspects; but even at those moments the capacity for inflection—of one instrument's affective transformation of the other—ran high. *195* demonstrated the richness and complementarity of two instruments that are still often polarized—the human voice and the machine.

Net Concrète

Since completing her master's at Mills, Herndon has continued to work in academia, and is now pursuing a PhD in the music program at Stanford University, where she also teaches a class called "Aesthetics of Experimental Electronic Music, 1980 to Today." In 2012, she released her debut full-length album, *Movement*, to wide acclaim, expanding

her audience beyond the comparatively hermetic worlds of the academy and the experimental music scene. While it can't rightly be categorized as a pop record, *Movement* effectively created a bridge between the rigors of research- and theory-intensive institutionality and the dance clubs where Herndon spent her adolescence and young adulthood.

Importantly, it represents a progression of the idea of techno-embodiment that has been the artist's driving concern. "Fade" and the title track, for instance, are cinematic and danceable in equal measure, built on the repetition of techno beats and samples of Herndon's singing, blended into harmonies, synthesized with ethereal effects, and occasionally distorted. Such songs would seem to clash with a less beat-driven track like "Breathe," but Herndon manages to give the entire album an underlying unity and sense of progression. "Breathe" begins with a heavy sound of inhalation; this is followed by a pause of more than twenty seconds before the next sound, the exhale, resounds. The track lasts for about six minutes in total, with samples of the artist's inhalations and exhalations in various tonal registers, heavily distorted, electronically sustained and mutated, then layered with a cacophonous array of throat-based ejaculations, *tzzz* sounds, and unarticulated exclamations: the lung in the machine. It retains the cinematic and ethereal feel of her more danceable numbers, but "Breathe" is a soundscape that rejects the sustenance of rhythm in finding its unity; rather, it affirms the higher significance of gesturality, which a machine cannot manage on its own—it is defined by the human presence at its root.

In this, Herndon asserts her attachment to one of the earliest forms of experimental electronic music, musique concrète, the first form of music to utilize recorded samples as the core of its methodology. Sampling is, of course, widespread in electronic dance music today, and long ago breached into commercial pop as well. Similar to other media that underwent major technical evolutions through modernism (one thinks here of poetry after T. S. Eliot and Ezra Pound), the frag-

ment is today an a priori building block for almost all forms of music produced via digital means.

Herndon's practice of sampling is indicative of her more general resistance to replicating preexisting structures and techniques. Her sources tend to be recordings of her own vocals, as well as the sounds produced by her laptop—both the noises it emits as a physical object, in its daily operations, and the noises that result from her interactions with it, such as her online viewing habits and even Skype conversations. She views her laptop as more than just a musical instrument; it is an "amplitude envelope." Using induction microphones, which are typically employed to pick up electrical signals, she sonically maps her laptop in order to give it a voice, enabling her to "play" it in live concerts with a swiping motion (in this sense, some have compared it to a theremin). This gesture allows her to improvise and transform a track on-site, often resulting in a markedly different sound than the song in its recorded form.

A further instrumental technique, developed by her husband and frequent collaborator, Mathew Dryhurst, enables Herndon to record her web-browsing habits and transform that data into sound, which is further used for sampling in both live situations and the recording studio, giving rise to what Dryhurst and Herndon call "net concrète."

This mediated use of the fragment through gesture completes the process of the laptop becoming an extension of the self, which, for Herndon, is as much a political technique as an aesthetic approach to music. When discussing the process of concept formation that goes into her music, Herndon often makes reference not only to the revelations of Snowden and WikiLeaks but also to a distrust of mainstream social media platforms. A half-true, half-paranoid nightmare has it that we are well on our way toward becoming machines; that is, that nefarious forces—be they governments or the warlords of capitalism—make opportune use of the fact that technology is developing faster than our capacity to understand it, and that we are so seduced by the gadgetry that it has effectively contaminated us, robbing us of our agency. Such

thinking has, of course, been around for a while. Herndon has mentioned the influence of Donna J. Haraway, who, in her 1985 "Cyborg Manifesto," voiced what has become a common concern of the twenty-first century: "Late twentieth-century machines have made thoroughly ambiguous the difference between natural and artificial, mind and body, self-developing and externally designed, and many other distinctions that used to apply to organisms and machines. Our machines are disturbingly lively, and we ourselves frighteningly inert."

Herndon's modus operandi is to "take technology back" from the powers that be by reversing the contamination, by going inside the machine rather than allowing the technological apparatus to infest us, rendering us trackable, docile beings and consumer-bots. While she retains Haraway's critical stance toward the tech-industrial complex, she proclaims herself to be an optimist when it comes to the exploration and utilization of technology's potentials.

This position entails not just an openness toward collaboration, but the necessity of engaging with like-minded individuals and organizations, many of whom work in nonmusic-related fields. One might fathom that the title of her album *Platform* (2015) indicates collaboration's potential for building something much larger than the ambitions typically represented by a pop album. That's because in contrast to traditional practices of collaboration in popular music, which are typically limited to cowriting or else contributing vocals or instrumentation to a track, Herndon engages with her collaborators on a conceptual level. Herndon tasked Metahaven, the Dutch design agency that places the aestheticization of politics at the core of their practice, with designing the album's visuals, which arguably assume equal importance to the music itself. For the video for "Home," they transformed PowerPoint graphics used by the National Security Administration of the US Federal government (as revealed by Snowden), into patterns of emoji raining down on Herndon as she sings; the visual overload unclothes the mundane yet still-frightening signifieds of digital iconography.

Another collaboration for *Platform* makes "an attempt to obscure the boundaries of the real space and virtual space using the screen": Akihiko Taniguchi, an artist and software designer based in Tokyo, created a piece of software that is "played" live by Dryhurst on backdrop screens at Herndon's concerts. The software is deployed in the video Taniguichi directed for "Chorus"; woven in and cut to the rhythm of the music are collaged images of Herndon at home speaking with Taniguchi on Skype, virtual-reality re-creations of Herndon at work, and images of twenty-first century home/work spaces where Apple laptops are surrounded by soda cans, cables, and external hard drives, captured by a floating lens, magnified and distorted. The banality of the quotidian is transformed into a dystopian, hallucinogenic, hyper-computerized netherworld, mirroring the splintered and stuttering fragmentation of the music.

At the same time, one might question the utopian ethos of such models of collaboration, which can be readily co-opted and adapted by the very nefarious forces that such an "activist" approach aims to pursue. Given the conceptual flexibility and scope of her practice, Herndon herself has been contracted to work for corporate and other organizations—unsurprising, given her success in the model of the twenty-first-century freelance economy. Recently, she has been working with global automotive and technology company Semcon to develop potential soundscapes for electric vehicles, because they pose a safety risk for pedestrians owing to their soundlessness. Rather than merely replicating the sound of gas-fueled car engines, Herndon has been developing processual software that takes in the sounds of the surrounding area that the car is driving through, remixes them, and spits them back out again. In this exercise in urban sound planning, the car itself becomes an instrument. An apt project for Herndon, whose first official release was a double-sided cassette tape, *Car*, a nearly hour-long sound collage meant to be listened to while driving.

But is this really indicative of the exit that Malik proposes, the sort of neo-utopianism of the present that informs Herndon's aesthetics?

Certainly, it seems to represent the sort of gateway into the real that Malik argues contemporary art is lacking; but in the end, it is also merely indicative of art's ready and willing co-optation as a utility by business; and, despite its eagerness to "problem-solve" in this instance, it makes no effort to respond to the larger, systemic problems that the electric car only treats on a micro level (i.e., the root causes of climate change remain untouched).

Where Herndon has proved to be most effective is in her propensity for sublimation, for giving us a concrete model of the potentials of the cyborg in the twenty-first century. In reality, escape versus exit is a false binary; both are impossible to achieve fully. The projective pathways of escape aren't so nefarious, and can even be quite productive, in that they represent tiny steps that, once they coalesce, will work to destabilize the Main Event, whatever it might be.

What will be interesting to see develop are the steps that will be taken in the direction of extension, of becoming-machine, that Herndon represents. Like the laptop, the vehicle is a machine that gains operative meaning once the human gets inside it. More than just a handy metaphor for an artistic practice, vehicularity represents a new way of interacting with and being in the world. Of course Descartes got it wrong: the mind is not separate from the body. Nor is it superior to the body. Rather, the mind is but an extension of the body, which can be programmed to do all sorts of things, including create and destroy. Herndon shows us the expressive potentials of what becoming a machine can make possible in the twenty-first century: a vehicle whose exhaust might yet transform the atmospheric conditions that otherwise endanger our autonomy and our very agency.

SPla✗

Scriptophiliac

The vehicle in a state of constant movement—across the canvas, across the floor. Across the continent. Jerking and swaying. Shivering and ejaculating. Cold sweat, hot sperm. Fueled by chemicals and paranoia, selves splattering themselves across surfaces already densely layered with previous splatterings, prior images covered over with brand new eruptions, tarnished and preserved, preserved through their tarnishment—the scriptophiliac splatter holds sway over any possible articulated Apollonian meaning. This is what it is to write with the body.

Emotions can be extreme things when you have no real desire to control them. "[Bjarne] Melgaard's art comes across as something much closer to need itself," writes Jerry Saltz, "something maniacally important he's trying to get at—even if he knows that in our oversaturated, defensively cynical moment that this is almost impossible … [the result is] death drive and life force in collision." Sex and death: both aims driven by desire. United in a vehicularity, a *drive* that, like every Bad art object should, desiccates the frame, giving rise to a froth that resists containment.

Melgaard is the sort of artist that the art world hates to love. And in return, he hates them right back; as he writes in his 2012 novel, titled bluntly *A New Novel*: "In New York, the social etiquette is

lying. Nowhere do you see this more clearly than in the art world. You never have to worry about what stupid sentences came out of your mouth the previous night, 'cause everybody is so self-involved that they never even remember what you said. Never is a story told twice the same way, 'cause everybody is entrenched in lies they read as truthful only 'cause they're so transparent." Like Dieter Roth, the Everything Artist for whom the supposed boundaries between disciplines was something to be violated rather than revered, Melgaard is responsible for thousands upon thousands of works of art, paintings and drawings and pieces of furniture, often installed on top of one another, each impossible to discern from the next.

According to various biographies and critical writings on his work, Melgaard has also authored dozens of novels—though his employment of the term reflects Gertrude Stein's refusal to respect categories, as some of these "novels" were in fact exhibitions of complicated installations where text and image met, only to devour one another in the space. As Ina Blom, a Norwegian art historian who has written extensively about Melgaard, comments: "The novel, here, is not a dignified cultural format and not a token for the benefits of reading. It is a name that stands for the resurrection of a specific functional site—a site where bad ideas are allowed to proliferate freely, where thinking and attention follow the wacky logic of what actually takes place rather than what should ideally happen. [...] For this reason it is also one of the few places where it is possible to articulate not just the abjection but also the strange and expensive resources of the body in pain." Like another Bad artist, George Kuchar, Melgaard's textual work has a deceptive concern with the diaristic. Deceptive, in that Melgaard has stated he is not interested in autobiography, but with autofiction: the vehicular *proliferation* and *perpetuation* of self-mythologies across a space, whether that space be virtual or real.

At the core of his motives is an excavation of abnormality in all its ugly abscesses. He rejects the political correctness, the "progressivist" stance of mainstream neoliberal society's "enlightened" stance toward

queer politics in favor of what we might deem exceptionalism, which seeks out the extremities that such discourse willfully overlooks in putting forth its agenda. "Yes," he stated in a recent interview, "it has been very important for me to explore the places where abnormality exists in society. For me it has to do with being homosexual. In many ways I don't think there has been any real homosexual liberation, because this fight for freedom has in some strange way excluded what is different and divergent. The struggle to marry and have children has a reverse side, which shoves everything that doesn't fit into the heteronormative category into the dark." Melgaard goes into that darkness; the darkness facilitates the eruptions of his vehicle. The eruptions, his splatterments, serve as an allegory, not just of homosexuality, but of a larger society in decay.

Norway, Melgaard's native country, seems to breed aesthetic extremities, disruptive forms of expression that often intrude upon the real in the most violent of ways. Throughout the 1990s, the Norwegian black metal scene made international headlines, not so much for the extremity of its music—with its high-pitch murderous screaming espousing Satanism, backed by repetitive droning guitars and drums—as for the sensational murders committed by some of its long-haired, corpse-painted musicians. Melgaard was fascinated by both for a period, to the extent that he even collaborated with some of the musicians/convicted murderers in the scene, in addition to independently producing several paintings and drawings depicting anonymous black metalists. "DEAD GUYS GET HARDONS TOO ..." screams the text in one of these paintings. The text is inscribed in black marker on the left side of the painting, the words dripping cartoon drops of sperm, while on the right side, one black metal musician is on his knees sucking the cock of another. In another of Melgaard's black metal paintings, with a blood-red background, the text declares, "CUT OFF MY COCK TO PLEASE MY DARK LORD," and we see that the Viking metal dude has done just that with a large butcher knife. The details, however, are

nearly obscured by the thick black wavy lines painted wildly, uncon-
trollably, inferring spurts of blood and semen that overwhelm the
pictorial plane. Throughout Melgaard's oeuvre, one finds evidence
of a pronounced scriptophilia, defined by Patricia G. Berman as "the
love of the line, or gesture, of excess." Or, to put it another way, we
encounter the irruption of a frameless writing, the elucidation of a
new syntax marked by the breakdown between line, image, word—
but also dimensionality, as Melgaard's flat surfaces erupt seemingly
spontaneously in exhibition contexts, where the dense layering of
the installations becomes an artwork in itself.

Despite the initial reciprocal interest between Melgaard and the
Norwegian black metal scene—Melgaard was even featured as the
sole visual artist in the 2008 black metal documentary *Until the
Light Takes Us*—many of the musicians soon came to reject Melgaard
owing to his integration of gay pornography in these works, even
sending him homophobic death threats. This was but one of the
many conflicts that Melgaard would have with his native country
because of the nature of his work.

Contingent Vehicularities: Munch, Melgaard

One of the wealthiest countries in Europe, Norway, is also arguably the
most nationalistic. As any visitor or resident can readily observe, the
national flag is woven here more often than any other country besides,
perhaps, the United States of America and/or North Korea. As a
Danish friend remarked prior to my first visit to the country, "You
won't meet a Norwegian person who's not proud of being Norwegian."

Although Melgaard hasn't lived in Norway for more than a decade,
he is still often referred to in the press as the most famous Norwegian
artist since Edvard Munch. In January 2015, this notion was cemented
when Melgaard was invited to show at the Munch Museum in Oslo.
The resulting furor surrounding the exhibition provides a tough

challenge for those who believe that art no longer has the power to shock and outrage, suggesting that the romantic conception of the avant-garde still has at least one flame-bearer.

"Melgaard + Munch" was the first in a series of exhibitions intended to establish a dialogue between the Norwegian Expressionist painter and other modern and contemporary artists.[18] In the weeks following the exhibition's opening, it was featured nightly on television news broadcasts and in front page editorials throughout Norway, garnering calls from critics, art historians, and a hostile public for the exhibition to be shut down. The show was even subject to a police investigation for its inclusion of Melgaard's 1999 video *All Gym Queens Deserve to Die*; in one scene, a man sucks on the arm of a baby suggestively, leading someone to contact the authorities with the accusation that this constituted child pornography. (The police concluded otherwise, and the exhibition remained open for its planned duration.) Somewhat surprisingly, another work in the exhibition, a blown-up photograph of a naked boy taken from a North American Man/Boy Love Association newsletter, evaded the authorities' investigation.[19]

The dominant outcry, however, voiced by one conservative art historian, was that Melgaard's overly sexualized work stepped over the line, morally, performing a sort of assault upon the viewer while tarnishing the oeuvre of Munch, a national hero. Such claims are historically naive, however, in their forgetting to recall that Munch's work also generated substantial scandal in his own day. His 1892 exhibition at the Verein Berliner Künstler was shut down as a result of outrage over the artist's seemingly unfinished canvases and hasty approach to form. (When sitting for portraits, Munch's subjects were frequently astonished that the artist would complete a painting in less than twenty minutes. Such speed no doubt contributed to the pro-

[18] Subsequent exhibitions paired Munch up with Vincent van Gogh, Gustav Vigeland, Robert Mapplethorpe, Jasper Johns, and Asger Jorn.

[19] The North American Man/Boy Love Association is a grassroots organization of pedophiles that seeks to legalize sexual relations between adult men and adolescent boys.

lificacy of his output; speed, in perhaps another sense of the term, could be said to account for Melgaard's.) Munch scholar Berman states that "such a 'lack' provided some of the terms of a 'material-based' modernism in which the visible traces of accidents, the rapidity of execution, and a lack of anticipated academic finish, signaled authenticity, the bodily traces that give form to intuition." Munch's friend Rolf Stenersen could similarly have been writing about Melgaard when he identified Munch's "quest for a non-existent happiness, [which] was nothing but turmoil and need, sex, sorrow, and anguish." Sex and need over form and polish: indeed, this is one of the identifying characteristics of both artists' modi operandi, as Melgaard himself averred: "[Munch] worked hard to make things unfinished, he worked quickly and very sketchily. It was important for me. Being able to let things remain unfinished, leave areas of canvas unfinished by paint." As it surfaces in the work of Munch, this "sketchiness" and unfinishedness is related to ideas regarding morbid and failed masculinity, according to Berman. It also chides with obsolete notions of homosexuality as being revelatory of a failed, incomplete masculinity. Before Munch another oft-ridiculed Bad artist named Paul Cézanne—regarded by Picasso and Matisse as the father of modernist painting—also exhibited his canvases unfinished, suggesting this as an originary motif of modernist painting. Ultimately, as art historian Øystein Sjåstad reminds us, the conception of queerness has a lot more to do with just mere sex: "To be *queer* was to criticize the establishment through one's life, the equivalent of being avant-garde." In addition to the scriptophilia that both artists share, in the fluidity of their lines and shapes, the essential queerness of the avant-garde tradition unites the work of Munch and Melgaard.

Sickness unto Death

> You've got a very advanced case of AIDS. You've got Hepatitis A, B, C, and D, you have gonorrhoea in your anus and mouth and hair, and you have syphilis and crabs.
> —Bjarne Melgaard, *A New Novel*

Melgaard shows us an example of how the vehicle might continue to operate when it is infected, fueled by sickness in both body and mind. Contrary to liberationist rhetoric, Melgaard insists upon homosexuality as an abnormality, a sickness.

> I feel that certain aspects of the homosexual culture, which continue to be oppressed, are important. They represent an opportunity or space to explore what is negative in our culture. That which is difficult, painful, and possibly without language. One can say that in a way I have been preoccupied with depicting homosexuality as a state of illness, which says something about human beings. For instance my pictures from the exhibition in Herford, where a homosexual male in a sex scene cuts off his own nipple and then takes a drill and bores it into the wound afterwards. Of course it is extreme, but it is also a sick form of sexuality. It's not that I think all homosexuality is that extreme, but I think it is interesting to explore homosexuality as an illness.

This runs counter to the language of political correctness and the fascistic ways in which it has been insisted upon in the dominant discourse of the neoliberal economy. Much like gangsta rap's deployment of the N-word was a subversive means of overidentification with the ugliest of stereotypes, Melgaard's work force-feeds us a language of faggotry that, though wildly fantastic, perhaps brings us closer to the real than many would wish to acknowledge.

His poetics are a writing of the body—much like the late American author Kathy Acker—only unlike Acker, Melgaard's vehicularity

merges with infection as a means of aesthetically "spreading" disease and decay, in order to show where the border separating sickness from sexual pleasure breaks down: a subject particularly relevant for gay men, in whose culture this literally manifests via sexual promiscuity and HIV. In Melgaard's art, these sentiments erupt in such virulent texts scrawled across the canvas as "JUST WANT TO GET YOUR BLACK INFECTED COCK UP MY WHITE ASS AND BE A USELESS WHITE WHORE."

Counter to the critics prone to dismiss his work as the deployment of mere shock tactics, Melgaard's Bad, sick objects conceal sophisticated and profound ideas about gender and sexuality. "Why can't gay men accept that they are not men?" asks the narrator of *A New Novel*. "That they're a third sex and that 98% of them just wanna have a cock as deep and hard as possible up their asses? That the more you act like a man being homosexual, the more you turn into a woman?" Could such a profound "diagnosis" of gay culture, resonating with considerations of third-genderism in many different cultures and throughout history, be merely the "symptom" of a diseased mind?

Indeed, the trope of mental illness is channeled by Melgaard throughout his work—though at the same time, it is not a mere act. There is an intentionality encoded within his vehicularity that teeters purposefully on the edge of self-control. Recorded sessions with his therapist have been edited into his video work, and he has spoken openly of his use and abuse of hard drugs in fueling the madness of his vehicle—particularly crystal meth, a drug that keeps one awake for days, often inducing a state of psychosis, and further deepening Melgaard's infatuation with the death drive. "I don't understand why people in the art world are so against crystal meth," he told me once in conversation. "I have no interest in taking any drug if there's no possibility that it might kill me." The dissolution of the border between life and art that we observe in so many Bad artists is further intensified when the production of such work entails significant risks.

But, as Melgaard has elsewhere noted, it is one of the many risks that gay men take that goes safely unobserved by the "pink-washing" of mainstream media and politics. "Gay men have trust in strangers, and you can see this very clearly, for instance, in the way that dark-rooms work. Since you never have a clue who you're having sex with or what they might do, it's conceivable that somebody could kill you there without anyone noticing."

It would be so boring to be dead, and probably even more boring to live in a world where there's no Bjarne Melgaard. On a superficial level, he might be Norway's most famous artist since Munch, but he is also the most prominent living artist to show the world a side of reality that very few wish to look at, acknowledge, or are frankly able to stomach. That's the real miracle of Melgaard's Bad art and writing—that, and what I regard as its ejaculatory integrity. It hits you right in the face. Which is exactly where you want it, you dirty art whore.

III.

FiCtoCriticisms III.
FiC.

III. III.

III.
FiCtoCriticisms
FiCtoCriticisms

III ·

FiC*t*oC*riti*Cim

*riti*Cim

III·

FiC*t*oC*riti*Cim

Reading Capital in Venice

1.

It is the spring of dead bodies washing up on European shores, the end of a season in hell in America that saw a spate of killings of unarmed black men by white police officers. The spring in which a white, tenured so-called Conceptual poet gave a reading of one of those victims' autopsy reports as a "found poem" at an Ivy League university to a presumably majority-white audience, the spring when yet another white so-called Conceptual poet, uncoincidentally also poor in talent and rich in capital, would, in the spirit of competition, attempt to draw even more negative attention to herself by tweeting the most blatantly racist passages from Margaret Mitchell's *Gone with the Wind* as a so-called art project. The year that, as long as anyone could remember, the Venice Biennale would break with its tradition by opening in spring instead of summer, and the first time in history that the Biennale's curation would be given over to a black man, one of a handful that have managed to attain success in the art world (perhaps made a bit easier because he came from a wealthy Nigerian family), who would build his central thesis on the issue of class rather than race—though as anyone who has received a liberal arts education at an American university in the past three decades should be able to tell you, the two are inextricably linked.

Most of these events have flown past the radar of Cheb, a thirty-one-year-old art critic who has spent most of the past few months in a Berlin apartment working on a novel he will never finish and

snorting lines of heroin he scores from a Sicilian fuck buddy. Still, Cheb—of Hungarian descent (hence the name), but in actuality equal parts English, Israeli, Afro-Cuban, and German (as these things go)— manages to arrive on time to Tegel Airport, for his Alitalia flight to Venice Marco Polo scheduled to depart at 9:25 a.m.; he is on assignment (needs the money). On the plane, he is seated next to a blue-chip Berlin gallerist whose program largely consists of German conceptual artists making cerebral art of the most yawn-inducing variety (to Cheb at least), most of whom peaked in the 1990s, with a couple of American classic Conceptualists from the 1960s thrown in as a justificatory affirmation. Although she doesn't really need the press, she recognizes that Cheb is considered "hot" at the moment, and is constantly nagging him to review her shows. Troublingly, he has ignored all of her dinner invitations for the past year. "What a surprise!" she exclaims as she nestles her ginormous posterior into the seat next to him. They make small talk about the Biennale as the plane ambles its way down the runway in preparation for takeoff. Cheb absolutely cannot miss the German Pavilion, she insists, where two of her artists are presenting. Cheb delivers the disappointing news that his assignment is to cover solely the main exhibition, "All the World's Futures," on which she nevertheless has a prejudgment to deliver: "Oh I do love Okwui [Enwezor, the aforementioned curator], but we all know what that one is going to look like. If only he didn't have to play the *race card* all the time!" There was a time when Cheb would be stunned by such a statement. Cheb has never considered himself white, though everyone else does. Naturally, he understands perfectly well that passing as such his entire life has at least partly enabled the modicum of success he enjoys in the art world. (Part two: while he is certainly not rich, he also does not give off any obvious signs of being poor.) It would be easy to call the gallerist out, to give her one of those dreaded reality checks, one of those insufferable moments of sudden *Angst*, tell her, "Hey, I'm a nigger too, you dumb white bitch," but lucky for her, Cheb is coming down off a three-week heroin binge

and simply does not have enough endorphins, at present, to properly enjoy the scene of her humiliation. Instead, he takes advantage of the awkward lull in the conversation to nod off.

The art world is run on fear: this is something else Cheb has figured out over time. Having studied Marx in college, Cheb knows that from a purely materialistic standpoint, this can be attributed to surplus value, that reason-defying concept upon which the entire art game is premised, and which creates a constant state of uncertainty and insecurity among all its participants. So omnipotent is the force that it leaks out of the realm of the "merely" economical to contaminate not just the aesthetic integrity upon which everything is ostensibly based, but more importantly the information economy through which art travels. Knowledge thus emerges as the highly valued product of the socialization network known as the Art World, the oil that fuels the fear engine, giving rise to an environment characterized by a high level of desperation, regardless of whether one finds oneself on the buying or selling side of the equation. You don't have to have a strong opinion—in fact, it helps a lot if you don't—but you do have to know *everyone* and *everything*, or at least pretend to—or else you're simply out of the game.

In Venice, he checks into a tiny bed-and-breakfast in Castello, which he learns was the former apartment of Alberto Gianquinto, a little-known Venetian painter who passed away in 2003, whose expressionist paintings, featuring a muted and largely pastel-based palette, adorn the walls. All of the furnishings have been kept intact—in one of the large, airy bedrooms, Cheb spies a grand piano—though Cheb has booked the sole single-occupancy room, which is the size of a monk's cell, with shared bathroom. Still, at sixty-five euros a night, it's the best accommodation deal in town.

Already on his way into the Arsenale, he begins to hear the whispers. "It's so *dark*, so *pessimistic!*" a middle-aged white dame in fake pearls and Gucci sunglasses exclaims to a famous New York shark dealer Cheb passes at the entrance. Cheb skims the wall text in order to

get the gist of the layout. Enwezor has conceived of his exhibition as a composition of three intersecting filters: "Garden of Disorder," "Liveness: On Epic Duration," and "Reading Capital." Cheb intuits the *intersecting* bit to mean that they won't be delineated, so he knows not to look for signs, but to try and absorb the thing, at least this first time through, as a whole. The idea, the text maintains, is to use the *filter*s as a means of reflecting on both the current *state of things* and the *appearance of things*—so, conditionality and appearances, rather than the things-in-themselves; a defiant neglect of ontology in favor of context, with something about a "parliament of forms" thrown in to give it all a democratic flavor, perhaps satisfying some EU funding requirement; everyone who can afford to be in Venice at this moment is, in some sense, equal.

If the rich woman's complaint sparked his interest, the starkness of Enwezor's production turns Cheb on right away. It begins with a room of Bruce Nauman neons (such as *American Violence*) in concert with *Nympheas*, a series of swords and knives grouped together in bouquet formations across the floor by Adel Abdessemed. It's dark, it's edgy, it's rife with depictions and evocations of violence and human misery—all the things that Cheb also loves that the art world either tries to conveniently ignore or else dumb down to avoid dealing with in full. There is no dumbing down going on in the first rooms of the Arsenale, it's all there: the futility of labor, the draconian nature of war, the absurdity of the harsh and drastic inequalities permeating every aspect of life in the twenty-first century …

Cheb moves on to the majestic wall sculptures of Melvin Edwards, made out of twisted welded steel: heavy metal. The black paintings of Daniel Boyd, which Cheb will also encounter later in the Giardini, further enrich the allegations of bleakness (blackness?) being hurled at Enwezor, as do the *nero* chainsaw sculptures of Monica Bonvicini, *Latent Combustion*, which Cheb will be reminded of when he sees the large, drooping oil rags of Oscar Murillo adorning the Giardini's entrance.

Then there's the moving image work. Cheb already saw Antje Ehmann and Harun Farocki's *Labour in a Single Shot* in Berlin, so he can skip that; actually, another room in the exhibition is given over to Farocki's entire extant cinematic oeuvre, which seems fitting, concept-wise, though it also seems to Cheb like one of those typically impossible Venice Biennale gestures—who the hell will have time to watch the entire thing? (On that note, the same might be said of Alexander Kluge's 570-minute-long adaptation of *Capital* in the Giardini.) Much more manageable was Raha Raissnia's *Longing*, a beautiful and moving 16 mm print comprised of blurry overexposed black-and-white ghost images bleeding into one another, the soothing sounds of a motorized hum forming the soundtrack. An abstract, seemingly diaristic collection of fragments, fugitive images occasionally coalescing—an arm hanging down holding a cigarette, the newspaper photograph of a bearded revolutionary, the rectangular block of a city street—before fading back into shapes and blurs whose semblances cannot be discerned.

So far, there is an aesthetic unity in the curation of the Arsenale, with its favoring of a dark palette, dim lighting (exacerbated by Philippe Parreno's *56 Flickering Lights*, installed throughout the exhibition), a dramatic obsession with the casting of shadows (Cheb can't help but read this as a metaphor for the "dark continent," the Occident's otherization of Africa), sharp angular forms, and a general privileging of the sculptural over the painterly. Unfortunately, the effect is ruined the moment Cheb walks into the third *corderie*, which has been given over entirely to Katharina Grosse for one of her rainbow installations. It's stupid, it's tacky, and it makes no sense. It all goes straight to Cheb's stomach. Thankfully, there is an exit. He makes his way outside to the toilets, where he will vomit, shit, then pop six Nurofen Plus, ibuprofen tablets with twelve milligrams of codeine each, sold over-the-counter in Britain; very little compared to the amount of opiates he has been consuming in the last few weeks, but enough, perhaps, to get him through this. Along the way, he

passes through one of the most impressive (read: largest) works in the exhibition, Ibrahim Mahama's *Out of Bounds*, hundreds of coal sacks stitched together and hanging on either side of the very steep outdoor corridor next to the Arsenale. That's right, thinks Cheb as he makes his way through the crowd of journalists and Art World Professionals taking selfies among the sacks in their designer sunglasses, we're all just lumps of coal.

When he resumes from where he left off, things begin to go wrong again post-Grosse. This time, the problem is David Adjaye's exhibition architecture, something of a calamity. Perhaps this is the promised "garden of disorder." Too many walls form an incoherent maze, perhaps unwittingly mimicking the layout of Venetian streets. Enwezor is perhaps partly to blame for simply including too much stuff. But the problem is inevitable: it just doesn't *flow*. Cheb is constantly having to backtrack, retrace his steps, and is still not certain he hasn't missed something. This state of bewilderment is unfair to the artworks; as a result of the strange architectural walls, works of art (sculptures especially) become barriers you just want to get around, and thus lose their effectiveness. As his attention begins to drift owing to the confusion of the layout, Cheb begins to suspect that this is where Enwezor has stashed the weakest work, the more mundane exercises in cultural anthropology that serve as rather typical examples of "political art," such as Oscar Murillo's display of canvases he allowed schoolchildren of various Third World or politically troubled countries to draw on for a few months: a rich artist's Arte Povera. There are plenty of these middlebrow efforts, then there's the just plain callous—such as Sonia Boyce's annoying and stupid video of people screaming, *Exquisite Cacophony*—and the just plain strange— Cheb at one point found himself in a room of floor-to-ceiling Baselitz paintings, which, like the Grosse, have seemingly nothing to do with anything that has come before, though it is true that they serve Enwezor's decidedly masculinist agenda. (Then again, Cheb realizes later, Enwezor is the director of the Haus der Kunst in Munich. So:

Grosse, Baselitz; and in the Giardini, Hirschhorn, Isa Genzken, Andreas Gursky—all instances of "social curating.")

While the layout makes the Arsenale an ordeal to get through, there are a few small rewards scattered along the way: the always wonderful Chantal Akerman's new multi-channel video installation, *Now*, consisting of desertscapes shot from a fast-moving vehicle, the occasional snap of gunfire in the distance, inferring a lingering background conflict without overwhelming us with documentary evidence; *Fara Fara*, a two-channel video installation by Carsten Höller and Måns Månsson exploring Kinshasa's hopping music scene; and Karo Akpokiere's lively and funny comic-style drawings exploring his own experiences as a displaced person living between Lagos and Berlin, which Cheb has lingered in front of for several minutes; the brilliant and witty sculptures of Eduardo Basualdo, an Argentinian artist Cheb had never heard of before, who has invented a sort of Kafkaesque minimalism. In general, though, Cheb has the impression that the middle is a place reserved for the less meaty bits—which does not a good sandwich make.

The highlights of this sandwich are the bread. In addition to the kick start at the beginning, the end crescendos with *Passengers*, the late Chris Marker's moving photographic series of portraits of people on the Paris Métro. Then there's Tania Bruguera's installation, which many of Cheb's colleagues missed, he'd find out later, owing to its positioning at a remove from the Arsenale's main exhibition, in a cavernous room on the other side of the restaurant and bathrooms. Indeed, most of the crowd on the second day of the preview seems unaware, as there is no line before the velvet rope marking the entrance. The gentleman guard informs Cheb that photography is forbidden, as is the use of mobile phones, before opening the rope and bidding him welcome. Cheb enters the pitch-black space. Contrasted with the glare of the Italian sun outside, the effect is one of total momentary blindness. The space is silent except for the sound of the gravel beneath Cheb's feet, which he slowly drags, trying to find his bearings and

figure out where to go. (Later, when reading the catalogue, Cheb will discover that the perceived gravel is actually bagasse, fibers left over after the processing of sugarcane, Cuba's chief export.) He discerns a tiny glow before him up high, which he moves toward until the image becomes clear: a small monitor playing sepia-toned imagery in slow motion of a triumphant young Fidel Castro doing his macho posturing. Cheb thinks he is alone, until he begins to hear noises that sound like skin being slapped, but he cannot discern its source until he reaches the end point and is positioned just below the monitor, when his eyes adjust to the appearance of four young men, naked, standing throughout the space with their heads hanging down, frantically brushing their skin as though trying to rid their bodies of the dust of time. There in that dark space, Cheb realizes what he has been missing this whole time (besides drugs), the very thing that has been inferred flauntingly throughout, only to be delivered in flagrante at the very end: dick.

2.

The total product of our community is a social product. One portion serves as fresh means of production and remains social. But another portion is consumed by the members as means of subsistence. A distribution of this portion amongst them is consequently necessary.
—Marx, *Capital*, Vol. 1

If on the placard there's a gallery name beneath the title of the work and the artist's name, that means the work is definitely for sale.
—overheard by Cheb in the Arsenale

That night, Cheb attends a dinner for the Japanese Pavilion, where he is seated next to a colleague who often writes for the same magazine that has sent Cheb to review the Biennale. Over dinner, they

discuss *Artburn's* famously heavy-handed editorial policies that, to Cheb's colleague, leave the reader with the impression that the entire issue has been written by the same person. She goes on to recount a discussion she had with one of *Artburn's* editors, who threatened that if she ever wrote for a certain other art magazine, he would shit in her mouth. They laugh nervously at the exaggerated vulgarity of the remark, though they are both certain that the editor didn't exactly mean it as a joke. Again, Cheb remarks, fear; what would the information economy look like without it?

The next morning, Cheb has breakfast with an old friend from Norway who recently landed a job with that country's consulate. She regales him with stories of the night before, which she spent at the lavish dinner thrown by *Artburn*. Cheb is momentarily stunned that the magazine hadn't bothered to invite him, given that he is here on assignment for them, until his friend delivers a much-needed reality check. "But of course you weren't invited!" she laughs. "You're not a gallerist or a collector!" On the Grand Canal near the entrance to the Giardini, the black chrome of the Zabludowicz yacht glistens in the morning sun. Cheb snaps a photo with his iPhone, which he uploads to his Instagram feed, with the caption "BBBC (Billionaire's Big Black Cock)."

The central pavilion in the Giardini opens up on the theme of displacement. Big Black Canvas material has been suspended from the Neoclassical facade of the building, forming a sort of curtain spectators must pass through in order to enter the exhibition; they are by Oscar Murillo, so Cheb assumes they are worth Billions. Inside, it begins with *the end*: that is, Fabio Mauri's series of drawings of these words. They surround *Il Muro Occidentale o del Pianto*, a freestanding wall made out of suitcases of various materials, naturally calling to mind the Holocaust, but also the more recent arrival of dead bodies, failed refugees, washing up on the shores of the EU. In the next room, Christian Boltanski's *L'homme qui tousse*, a disturbing film of a grotesque masked figure seated alone in a decrepit attic space retching up blood: the effect of exile on the human soul?

Perhaps responding to the more classical layout of the pavilion (as opposed to the open-warehouse format of the Arsenale, where some architectural interference is required), the arrangement here seems more scattered, with each room containing its own universe, without any pretensions toward the flow that Cheb found so lacking in the Arsenale. This turns out to be a gift to the memory, as on repeated visits, Cheb will be able to brush through the rooms directly to the sections he wishes to revisit: the strange pairing of Walker Evans photos with Isa Genzken's models for unrealized public monuments (her *Deutsche Bank Proposal* is roofed with two robotic antennae sticking out into the heavens); Chris Marker's 1973 film *L'ambassade*; Marlene Dumas's skull paintings. If Philippe Parreno's flickering lights were the recurring theme of the Arsenale, then Walead Beshty's sculptures play a similar part in the Giardini, arising in two formats: shredded bits of tabloid newspapers, hate-fueled headlines sparring with centerfold tits, dangling from metallic support structures—very Cady Nolandesque—and spectacular melty ceramics. The biggest hit—throughout the preview, the screening room is consistently packed—is John Akomfrah's three-channel film *Vertigo Sea*, an epic poem about that element that connects everything: water. This is one of those rare instances where looping really works—Cheb is unaware when the film begins or ends, or whether it ever does—and he doesn't care—rather he loses himself in the rapturous footage that addresses the melting of the polar ice cap, the hunting of polar bears, slavery, mass murder, dolphins, and whales, oh my; the ravages of time. There's Kluge's film about capital, Isaac Julien's film about capital, then Julien's staging of readings from Marx's *Capital* … So much capital, so little time!

Which brings us into Cheb's favorite place, the Arena, taking up much of the center of the Giardini's main pavilion. Cheb enters to find the words *Evil Nigger* projected on the screen above the stage, next to which sits the fat German gallerist staring with rapt attention to the four grand pianists bringing the *klang* out of the klavier

for Julius Eastman's 1979 Minimalist composition. Cheb heads up to the balcony for the second half of the concert, which consists of Eastman's *Gay Guerilla* from the same year, watching as the spectators wander in and out, take selfies, answer emails on their iPhones, and occasionally even sit down and listen to the music.

The Gay Guerilla has no friends: a story Cheb makes up to himself and starts writing in his notebook as he listens to the Julius Eastman composition. The Gay Guerilla wants to go everywhere at once and change the world, sucking lots of dick along the way, therefore nobody likes him; his ambitions are too putrid, too blatant for the world to discern any higher meaning from them. Were the revolution finally to occur, would that mean there would be no more heroin? Cheb attempts to make a list of all the forces in this society that are designed to keep people down: drugs, art, technology, fashion, sport— all manufactured needs, wants. In the end, *desire*, pure, is the only sure thing, where commodities are concerned. (How many bags of heroin is a Damien Hirst butterfly painting worth?)

Once he realized that the entire spectacle was run on fear, Cheb had a choice to make. Cheb was already, in a sense, *numb*; his ambitions had never had anything to do with success or popularity or being the guy who knows it all. Cheb only ever wanted one thing—to look at art, and then to write; sometimes writing about the art that he saw, at other times writing about things that only appeared in Cheb's brain, nowhere else. That's all. In that sense—in the vision of the art world— Cheb's ambitions were rather limited. Therefore, he felt early on that he could never, would never be accepted by that world. Heroin is the perfect drug for Cheb; it matches, in the distancing effects of its neuron-flooding totality, the oblivion to which he has been consigned.

The Arena, Cheb learns, will feature a constant program of talks, performances, and film screenings throughout the duration of the Biennale, the lauded highlight of which is *Oratorio*, readings of Marx's *Capital* staged by Isaac Julien, which Cheb is curious to see, though that turns out to be a bit tricky, as the program doesn't seem

to be fixed, and even after the Eastman recital, when Cheb asks one of the Arena organizers what will be coming up in the next five minutes, she shrugs and says she has no idea. It is Italy, after all.

And it is *Capital*, after all—or a thirty-minute sliver of which—book I, part 3, chapter 7 in Ben Fowkes's translation, to be precise, read in part by two performers. Unsurprisingly, the room clears minutes into the reading. The density and difficulty of *Capital* are legendary; the inherent impossibility of the project was directly experienced by Marx himself, one might fathom, as he was unable to finish writing it. Cheb decides to tough it out; rather than attempt the impossible task of comprehending the content of a spitfire rendition of a work that is really not meant to be read but studied, he closes his eyes and transmutes the words into a flow of poetry: labor bleeding into objects; labor itself a product, a raw material; labor being time, the flow of all objects; time bleeding into objects … One fifty-euro wrap of heroin is equal to how many dead Afghanis?

Given the prominence given over to *Capital*, Cheb wonders whether either Okwui Enwezor or Isaac Julien have actually read all three volumes of Marx's *chef d'oeuvre* in their entirety. If so, they are among the very few people who have. "The Communist Manifesto," cowritten with Friedrich Engels, on the other hand, could be seen as a distillation of *Capital*'s most pressing analyses, spotlighting its central polemic in less than a hundred pages, making it more readily digestible for a non-scholarly crowd—or, more pivotally in regards to the context of Venice, an audience that does not necessarily have the luxury of time. Why, then, choose *Capital* over the manifesto, if indeed what it is you wish to highlight is the content, the message, rather than the mere reference, the signifier; if you really want to communicate a message about how value comes into being, and how it is deployed systematically as a tool of oppression, to "the People," rather than the people Cheb finds himself surrounded by at the invite-only preview of the Venice Biennale, people who stand to benefit the most from capital and therefore prefer to keep their inquiries in the safe

zone of the theoretical? Perhaps the "epic duration" that Enwezor's second "filter" refers to is the burden of empathy that Cheb and his colleagues are meant to be reminded of, and submit to, while seated in this air-conditioned enclave, Marx's words *filtered* through the glow of iPhone screens displaying the evening's party invites.

Perhaps these issues would be hashed out in greater detail at the party for Julien. Sadly, Cheb would not get a chance to find out, though he wonders if Julien is at all bothered by the fact that it is Rolls-Royce who is throwing the party. On his way back to the bed-and-breakfast, Cheb bumps into Renzo Martens outside the Dutch Pavilion. Martens is an artist Cheb has limitless respect for. His position is simple: political art, so-called, is too often the mere gesturing of armchair philosophers. Specifically, art about the oppressed and impoverished never really aids the subjects it purports to address; instead, its effects—namely, the generation of capital—merely benefit the locales where it is shown (such as the Venice Biennale). For the past few years, he has been using the much maligned neoliberal tool of gentrification subversively in an effort to build a contemporary art center on a former Unilever plantation in the Congo, providing one of the world's poorest communities with a means of sustenance. Surely this is a project that Enwezor would want to stand behind. But no. Martens is only in Venice, he says, to raise funds for the project. When Cheb registers his surprise that he hasn't been included in Enwezor's show, Martens just shrugs. "The exhibition is great. If you have two thousand dollars to spend on flights and hotels," he says, gesturing toward a group of Art World Professionals taking a group portrait with a selfie stick in front of Murillo's oil flags, "you can come to Venice and learn about economic inequality."

Cheb wonders how much the people he is surrounded by have learned. Then he wonders where they have come from and where they will go next, now that the next big art spectacle, Basel, is an entire month away. Going everywhere, all at once, all the time, seeing the exact same people, one really ends up nowhere. Even

Enwezor's political correctness has its limits; after all, there are zero displays of blatant ass-banditry (e.g., what about the *bodily* shapes/manifestations of commodities that Marx often hints at throughout *Capital*? The expression of value, which must necessarily be considered in relation to the body, and its—erstwhile deviant—processes?). Although Enwezor has conceded to allow Mark Nash, Julien's longtime partner, to lend a helping hand with curation of the Arena, still Cheb wonders whether Julien ever feels the need to butch it up when meeting with Enwezor, much as Cheb often feels compelled to do the same when he's traveling in Latin America, or the Middle East, or Africa ... well, whenever he is anywhere in the three-quarters of the world where the entire country's population hasn't yet bent over to take it doggie-style from Euro-American neoliberalism. Outside the Giardini, he studies a poster advertising the Copenhagen Biennale. It consists of a photograph of a tent outside some protest site, a handwritten sign taped to the front: "Now is now," it informs. Cheb squints thoughtfully, then gives up. The work is untitled; the location cannot be discerned.

The obje**C**t

He wonders how he will ever begin to write about the object. A bit like writing in the dark … The object is there in front of him, and yet isn't. Both at the same time. How can that be, that state of simultaneity. Oh, very simple: it isn't. He drinks all his thoughts up, visits his feelings. No, not there. Feeling a place to run away from. Objects have no feelings … but could they? A question of investiture. So shitty to be left to wonder. Leave the wonderment at the beginning (i.e., "He wonders how …"), let's not go back there, not yet at least, too soon. Must move forward. The object—contend with it. Let this moment be defined by it. Rather: let the object, its thingness, contaminate this temporal structure, he thinks, and thereby give rise to the formation of a moment. The beauty of a moment is that it passes a delightful turd. The turd is an object, but it is not the object he is now contending with. Contend with the nonturdness of the current object. In the moment. The moment of running away. Running away from feeling. The moment he finds himself facing the object, seated before it, forcing his thoughts to coalesce into something— words. Words, the physical manifestation of something: the object. The object's bluntness. Not a copy, not a simulacrum, for that is not something *his* words could ever be. His words, he thinks, he knows, are always something else, even when they purport to represent, to critically engage with, the object and its thingness, what it purportedly *is* outside of all possible and potential representation. And yet he—not

subject (for he recognizes the imperative to momentarily suspend his own agency in order to engage with the task to be elucidated henceforth), but *another* object, another possible thing that things outside its particulate thingness—is not, in a sense, there. Not in the sense in which the object (the originary object, made originary by our writing of his writing of it, naturally) is there. The thing is, the goal he has set himself (his manic delirium, his sense of physicality, his manifestation of doom—his own private version thereof—through his manifestation of time, his awareness of spatiotemporal limitation) is to get *beyond* both facile representation but also and even mostly the "critical engagement" that the majority dismiss as the only possibility of *interacting* (he hates this word) with the object, and to enter into a state that would actually enable him to *inhabit* the object. And this, through writing. And for him, this writing, this striving-for-inhabiting, resonates with his current concern, to get beyond all the materiality— the thingness, the objectness—of writing—to contend with writing's failed project of transmitting meaning.

How do I *write myself into* the object? he asks himself.

(Always a failure, then, every instance of writing, and yet how to overcome.)

Describe the object in its thingness.

He goes over, in his mind, all the pathways through which one might approach the object, positioned as it currently is, in the room, on the floor, at the center of the black cloth, not far from where he rests his feet. It is a kind of hunger, this desired transformation, transmutation, transubstantiation, but then no, that's not it, for then what would the writing be? Shit? Is it: To find a way to put the writing *inside* the object? No, but to make it (the writing) *come out of* it (the object)—and vice versa.

No eating, no shitting, he says aloud.

To inhabit means some encoding. Break that code to reseal it. That's what the process will look like. The thing things itself thingingly, he quotes Heidegger. A certain bluntness of proprieties, yes, that will do. Nietzsche lost his mind, Heidegger found it, gave it back in hideous form: an object of a subject called loss. He steps outside—*to get some air*, he thinks. Fat man in a wig comes pattering down the cobblestones, waving a book over his head. It is Leibniz. EAT MY MONADS, SCUM! he screams.

He slams the door in the philosopher's face, runs back in to the object. *Into* the object, he would like, but he can't have. The object wills, for certain, but not beyond itself, that is certain also. My thingness not for you to take, it seems to call out … or was that Leibniz out there, tormenting him. That book he was waving over his head, what was it. Go have a look. A glance through the window … but Leibniz is gone, you'll never know what book it was now. Perhaps

it is better that way. Can substance be defeated? He knows: desire to attain a state of total selflessness through the act, and yet this risks reducing writing to a sort of gratuitous masturbation. Cancel the second part of last thought. For this stab at conceptualization here is, admittedly, a means of propping up—propagating—excess.

The majority.

He initially wanted to call it "object-oriented criticism," until he realized—not just that he had the terminology wrong—but that his misuse of the word *criticism* would only serve to confuse this invisible majority *for whom he was writing against*. For this—this obviating the decision-making process via the thereness of the object—is to be an *act* of writing: a writing to come. No, criticism, critique, too specific the terminology; he favors the *openness*, the *activeness*—the *act*ness—of writing.

He is against control. He remembers reading a blurb on the jacket
of the first edition of Barthelme's novel *The Dead Father*. Something
like, *Well gee, folks, it might look wild and crazy, but its redemption
as a work of art is that it is all actually tightly controlled by the author;
that makes him a genius, by my validating authority as a critic ...* Why,
he remembers thinking, would control ever be regarded as a positive
value in writing?

And of course, the answer to that is quite simple: we live in a society of
total control, so it is only natural, from a psychological standpoint, that
the invisible majority seeks out forms of (what it perceives to be) control
in art, and that *authorial exercise* (as opposed to insane or other-worldly
channeling) be its defining characteristic of genius.

Thus, in writing the object (never writing *of* the object): deny all
perimeters.

The object and its mysterious anti-nature, he thinks. Object consid-
ered as manifestation of mind—no that's wrong.

Object and world, okay: he thinks that's something he can do. Hesitating to proclaim it in these terms, but since so many mispronouncements have already polluted the stratosphere, perhaps his will serve as a cleansing agent. (Or else risk collapsing the unity of the entire multiverse by further polluting. A risk taken every time one opens one's mouth and squeaks.) It is

a question of domains.

Treat myself to a fresh shirt, he decides.

When we *write the object* (and here, the definitionality of what's being said matters because we are not channeling classical exchanges of phenomenological wankery), we transiterate the resonant hallway of psychology to verify the made (constructed) status of objectitude (in its pure sense) and effectively emerge from this processual act as producers of a reality. He sees this as a completely viable anarcho-individualism that resists the fetishization of edges that gives the object its definitional status in our limited perceptuotactile exchange field therewith, and thus unleashes the animality that resides within the object's previously controlled essence. And within that animality resides a will ...

Once the object is written—and liberated thus—we may begin to speak of objectity, he reasons. Now, objectity goes beyond mere thingness in its necessitude to claim a spectral identity. Identity, in the majority's way of thinking of it, always comes with an I. Expend your shit logic across the evening sky. Objectity neologistically combines the object with identity, but also reality, to lay claim to a *scape* that evades the perceptual diminutive that typically derogatorizes the object in the field of the major Them. The object, then, *is* vision, it is a surface filled with ego eyes. Its constructedness matters less than the way it goes about reconceiving our own willed surfaces.

But of course, he reasons, his object thus edified will most certainly clash and cocirculate concurrently with others' edification of the object. And so the route becomes short-winded, a show flourish—it is meant to be, in its measureless metonymity. No metaphoricity. Chains of difference overflowing, gather them up if you want into assorted cycles. Play god by defeating yesteryear. The answer, he suddenly conjectures, to Husserl dodging the intersubjectivity bullet: Everyone produces their own reality through their reciprocal arrangement of object-perceiving. Thus, in concept production, each concept is only designated for use by its original creator/inhabitor. Use exhaustibility. There are limits to this applicability: Why I Am So Unpopular. All these different realities clashing into one another. And the sparks caused by the interaction. No more human/nonhuman divisions, a rebirth of agency. All this, through the writing. He closes his eyes and sees thick blobs of text on paper. Pen rolls out of hand. From across the galaxy, the room, the object stares at him and sighs.

Carbs

When crossing the street, you get hit by a car and a brass band plays. If the world is really coming to an end, why must it take so goddamn long? You put it all into a box in order to FUCK IT and not feel so sad. Sad about which way you seem to be headed—the journey downward oh so lonely. The paradox of originating anything, even when it's a mistake; the reward is to march to a ding-dong no one else can hear. Everywhere expressive of those dignitaries that tell no lives. Lives apart—a burning match. It seems you were almost ready for it—the excess carbs—a sound you cannot actually hear. Still, you chase it—as though there could be any alternative on a cold dark night. Reminders of summer again—everyone lost, horny, desperate. Those cravings for fulfillment that can't actually be met. Soon you will return to the loveliness of the bedroom, have a spine once again. Hear me, smell me, be myselves and a part of all this. Apart from it, too. The rats on the floor.

The rat is a city you have been invited to invade.
Invade that rat with the wrath of the uninvited.
A city has not ploy; it is only a play.
Devastated to be a part of it, you seek refuge in the infantilism

of decay. The floor is your best friend. That is why you were allowed to eat it.

Think of it as a rat biting its own tail in order to avoid having a love affair. You have to singe the connections among disparate elements to imbue the whole with the bisexual burden of texture. A horse's granular animosity toward its own gene pool won't prevent it from having children—nor should it.

You imbue the city with a ratlike texture in order to feel alive once again. Not run over. You lie on the bed, a string quartet. A city has excesses tough to digest. Fattens you up while making you stronger. Rats have spines also. Stay far far away from the rattrap. In some cases, knowing from a distance suffices.

We are without the burden of logic. That's because we are that burden. You can't own something that you are.

Burden bangs a bog—the stemliness of fog.

Everytime a nighttime array. Once you have shattered the force of a day.

The body blobs, a thing. Sometimes you wish you could cut out all the excess and make it into something, a sculpture. To be externally extended—all that excess out of you. You sit at home in your cage in the city with your pet rat. There are so many variables—their elasticity—it's amazing. What emanates from the sky each time you close your eyes and try to eat it. Your best friend is the floor. You're becoming-rat while a folk song plays.

The feeling of defeat is not limited to those lesser beings we tend to regard as being variable-challenged. An alligator's tonsils might be repurposed as the material for a globe: the minute a city quickens its pulse, it has already run past us. In the malignance duties of a stale forecaster, opportune eye-chafings await their momentum. Zigzag tree branches don't necessarily cause a forest to happen. In the internet of a beesting, lovebites end up being too much a primordial thong—particularly when that thong is made out of lint.

You have no more friends. You are only a city.

Very often, you put your foot on display in the hopes that it might morph into an ax.

Syntax is amazing. Just think of all the little hairs.

Exacerbate the typography once before it starts to form you. You hid from the lexicon while a rat licked your brain. Seconds are green,

minutes are yellow. Yesterday was a hot-pink bathetic burden, and you refuse to shave when you're inside of a decade.

Rat entropy is such a sexy guise. Especially when the sum total of your being amounts to a puddle on the floor—little ribbon down there with a handwritten "Wait!"

You gave up on yourself before you even became part of the rat race; celebratory trumpet blares. Now you've found other selves to give up on, other species to eat with; a lone violin.

Soothing, the being-standard of the thing.

Get it on out, so you can blare it, blast it. Diet on ratcarbs to lose the blubber that binds you. Unbegotten to the deadened line. All a part of it, this creation. So that nothing might fall out: an empty avalanche, this day. Subscribe to disorder so that the lifeblood …

Just a tiny bit of seethe.

The waiter asks for something. Slimy hint of indifference, like a politician's decision. Tonight you count away the hours, until they come to own you: that's the simplicity of defeat.

The sky is an envelope, you see, and we are the contained. Not the contents, but the contained. For we are done with inventing ourselves—some other god now controls us. We were sold off, like slices of bad debt, to pay for the cosmos's makeover.

Tomorrow night you'll dream a satellite. The way a voice echoes in a vase.

Crystalline substance had its heyday—until it was over.

New rocks a shade of wooden granite. Clover.

Don't tear up that envelope—it might have a paycheck inside.

Magnetic fire hose has no idea.

Pant elongation not necessarily a boner. The sunny fade that made a day disappear. Filthy weapons that are sure to invent their own mothering device without the aid of heaven. End the mediation process before it collapses all molluskesque. Rat with no friends gets hit by a car.

The sky is a boner. Without the sunshine to get away from you. The rat goes on a carb-free diet. Roiled upon the fence, we are there. The light was bright before it had a chance to attain yellow and green. What you meant to say was before you got away. Turn the light off to attain it better.

The sky's protein. Despite what its name may conjure, gluconeo-genesis is actually not in the Bible. Nor are ratcarbs synthetic; rather, energy should be thought of as an enveloping blaze that extends our past lives into the intension of yesterday morning. You don't have to be drunk to know this. You have to go on a diet to understand.

Instant-shadow your fair fidelity flop. Colonial misanthropologist off the beaten trailface. Leaning in to figuration so grim, it is a transfer: a germinal faggotry extending its finesse against ostrich-fur magnets.

Tomorrow bends superiority in the alightness. Webs of interiority not built to be forgiven.

Deliberately ignore what you hope to expect.

Busted surmise lapped up with the callous breath of animal-object's enfrothed latitude.

Hazing crooked upon the shadowware, a starred silence greets these impeccables like a hidden protein.

We don't deserve to breed copies of the home we've forgotten about.

A car in the city hits you. No brass band plays. Mushroom machinery undoubted. Were the prophylactics devised on the field, could we still speak of a plane?

Among other questions you forgot to ask in the process of becoming alone.

Biological holocaust a pale yellow.

Rats, too, have their misgivings. The memory of a thing is what cannot be proven. All those hovering quinine lodges where the stink breeds gayishly. A risible occasion we might all run away from. Into starch, which is where the rat plutocracy farms meaning.

Scale versus texture: the eternal gut rebellion. People laughing at their own fur. A world of objects unbridled. Resting on your best friend, which upholds them. Fabrics and stone competing. Who will win King of the Rats. There are rubies in that dungeon, and they caress you equanonymously. Like a folded-up blimp plinth, they denounce you to your fellow line-inferences.

Mechanicity of deadweight survival in a world to blame. Smell the architecture inside your brain. Know the floor is still your friend. Symphony of ding-dongs, ticktocks, voidful vibrations.

PLinzHSPLaz

When we are "held up," the condition. The condition of holding, and being held. Also: the matter. Go into substance and bleed. Gone into the structure in order to feel desolate. These concerns currently occupy the Projection Architect.

Do not look at this thing I hold; it does not want to own you. Only your glance is deicidal—real supernal elements require no paradox, they benefit from the confusion of static context. I am moving your hand away from your eye, building on to what you forgot—misguided attempts at naming chaos—placing throat at back of duplicate self structure—each invocation of the figure a novel forgery of humanoid horror—mordant anti-nature shits on commission contract clause splat—that's when the burden bites us—Appearance Police emerging from the discarded thought ether. We were

in flight when the thought occurred, *being held up* by the splatter of static, the Appearance Police came in and removed us from the support. And all we ever wanted was to be inside!

The figures fucked like robots on the plinth. A jejune jock named Severance, dressed in drag as a nun or perhaps an even more famous virgin, ate a bagel and farted. The Architect craved more dimensions; three just weren't good enough. We, the materials, wanted only to be governed by the plinth. We were inside aside at last and ill to spill the valor of the infantile. Paradise does not belong to the world of appearance, and neither do we. It was more BIG VALUES time, which is why we so adore the texture—I mean, we embody it, right? Us and no one else. Okay, maybe the goons that stand around and protect us from future potential impotent art fair tramplers ...

We never read yesterday's poetry.

Flat falling, bamsplat, spunky, and free. Would convention fall out, it would defy all of terror's orthodoxies, and what leverage would we then have left? My best friend

inside the silence, touch the plinth to heal the splat. Plinth, after all, is delighted as a sexual object to be receiving you here this belated evening, with all the holes of telescopery in the whirl to heal you into holding that pose forever! Wait what's that beeping noise? The sonic violet of a floral pattern, synaesthetised via sodomy. (Each instance of the void must be recognized as a distinct object and preyed upon by a different fanatic of each of the world's major and minor religions.) The only stability one finds in art is when it is broken.

Little children manifest to surround the object, the inconsequential stare-down of the Attention Span Depletion Elite (ASDE), whose silicon no longer sears. Mash vengeance into a plastic play object the world might come to find some value in before it is engulfed in gulf snake's spare tissue and then discarded—dream of an object that cannot be left alone. When I come home, you will recognize my absence by its smell—empty feelings 're lasers scraping the ceiling of my name. The wavy lines form a sort of fake plane: there, now you have something to lie down on, so go away please before the night rodents invade the museum and make the next decision for you …

Lesson learned: The exhibition context is always a failure. Leave frame alone.

=

Consider all sculpture liquid—*yet solid form* also. This somehow leads to de-neutered comprehension that needs not gas of concept.

Like most things that splatter, plinth attains understanding through self-denial. Plinth as sobject, object with agency, denying razorstate of common noun. Anything designed that begs to be ignored. Begging to be following. Plinth holds sculpture's hand. A score.

=

The Architect of Projection wants a new body. The old one hasn't done enough to uphold his defenses; this is detrimental to the cause of projection. The sculpture had an island to it that must be denied. For all the conflicts of island nations, their inhabitants' suffering, their dependence on larger land masses for supplies, the threat of sanctions— all this can only be UPHELD when the plinth becomes an ocean. Sordid legacy of upholdance ... Teenage Savior's feet walking upon it. For the plinth must be organic, and that means it *feels* those teen feet

stomping across its substance, smells whether they're grimy or grim. Keep moving past the dialecticians and their disavowals, their pregnant vowels—their transubstantiation miraculars. Imagine a tree

bursting out of your gut and all you wanted was to lie down, see and smell something—there is no graven familiarity on proffer in this particular project, you must imagine something else. The waterlog confusion that enters and sets itself upright as a player in her majesty's not-so-calm kingdom. What matters, plinth or sculptural arrangement, is the automaticism of *doing* led through the wrong door so that a crack emerges in whatever being's structure, and then one must swordfight one's way back into the understanding game with clear concept in mind. Less mind, mindless. Like a pterodactyl spinning to drink the stars. The money is on the table, the ashtray is the object upon it ... but then which is the sculpture: ashtray or money?

=

There always needs to be a conflict, or else nothing happens. Like the objects we create, we are also being eaten within by termites, cancers, those little unknowns feasting on our substance as we uphold feasting on our unknowingness. One might pray for the development of a genetically modified dog that would be able to suck the unwanted

out of whatever minuscule crevice might present itself or else emerge as an exit event—a sobjected life in the future.

=

Plinth splatters into a thousand annihilative failures; let us hail the new confusion. The Appearance Police won't burden you to testify—their desires are entirely separate from ours. There has to be a tally-toll that's ready, and an arm that goes deep once the substance is still malleable enough to accept foreign appendages.

Enter Projection Architect, idea on his back weighing him down. His goal the lightswitch, move arrows.

=

Architect, being a proponent of the impossibilities inherent in *the very fucking idea of projection*, waging a virulent battle against the

tonguey glances of the Attention Span Depletion Elite (ASDE). Eyes got tastebuds deadened by the starch of malignant repetitions: the century's audience. Why am I here? Projection Architect whispers to the one self that masturbates the other, the priestly one that absorbs all fat only to give it back to the body-bearing one in the form of cancer. Projection Architect can't reconcile his sobjectitude with his involvement in the world of ideal forms. What is false is relative; ... run the risk of vehement denial.

Are the Appearance Police now requesting the fiction of an answer? Lines don't cast shadows—only planes do. In the absence of the frame, you get the assertion of verticality. Plinth being cockring or bra—sometimes even both. The upholdance that leads to a splattering: frown face, forms no longer ideal.

=

Do you (serious gravelly voice interrupting the silence) feed on me when I am not there, innocently pretending to be alone? Sad ballad in minor key,

Architect realizing the message can never be properly displayed, proper in the sense of what constitutes the *edges* of the sculpture, which for the moment become the edges of all artifice, edges that have a tendency to *will* themselves into disappearance. (Is that what they mean by a fade? Fade frenzy?) When you disappear, it just means that there is a zone that suddenly constitutes you. Disappearance is a *being of the situation*, particular in its fuzzy abnormality—smack a frame around it—get up and go around it once again. The beauty of the frame/plinth was never what was doubted; it was its tendency to become a fountain we all wanted to run away from.

The Architect of Projection's latest project was an art gallery for the animals in a zoo. He regarded it as a going back to nature, only for humans. If we could unevolve in a way that was different from *devolving*, call out to the dolphin because you want to become it. There are less cruel ways of invading a space—the giraffe that was sent to an orthodontist. Or

a plinth that was actually a desk made out of steel. But really, this is only the beginning. A way of asking the space gods for additional logistical support before ripping up the contract. We never voided to become a world. We were too preoccupied with Tenor's sound in the madrigal—it was *that* projection he wanted. If you get eyeball soup, does that mean the soup is seeing you before you eat it?

The Architect put all of his feelings into the plinth.

=

Unevolve. The Architect of Projection engages in a Socratic dialogue with the teenage captain of the Appearance Police—that force that, through a denial of the sexuality inherent in all objects, is conspiring to bring us all down:

POLICE CHIEF: I stare into what's left of you, being the tomorrow that you crave.

ARCHITECT: For a teenager, you've got a razor-dull wit, I must say.

POLICE CHIEF: My fears position me on the opposite spectrum of tomorrow.

ARCHITECT: Which would be?

POLICE CHIEF: … Tomorrow also.

ARCHITECT: I'm starting to feel as though I'm rehearsing for a Tom Stoppard play.

(That dialogue failed, hence its inclusion here.)

Architect was out on the street again, being alive and flailing. He decided to fill the space up with yellow light. He would end up another dismal success story. He had no cause to be innocent. He dreamed a multiplicity. Spade of plinths called out to him: wanton neurosis. The only way forward

to be dug into the earth, a heavily salted burden that would somehow manage to escape the attention of the ASDE. Through a combination of earth and sky, one arrives at the figure. There would be new challenges facing forward, flat-out and ghosted—a clear target for the machine's future embrace. Up above: the ground. Down below: sky. Envelope me in your failures, sculptural material cried out to the plinthmaker, your variabilities know not substance. It is elastic, process, and we do love the thwack. Two hands touching, belonging to the same creature, become a robot through stasis. Even if the sculpture does something illegal and has to be taken away, it is insured: we can always uphold its ghost.

How late does it get in the future? He asked himself this and maybe a couple of other questions. The page being blank, his task was nearly complete. Maturity, in the supposedly cerebral world he belonged to, meant a refusal to see orthodoxy as a burden. There are no awards

in the field of plinthsplat design. Dream of the machine's primordial fellation. The splinteriness that gives the sculptural mass its arisal. By the time

we finish speaking, what will there be left to raise? Plinth come alive, I only want to be destroyed. What is expression? Joy in fading. Sacrifice of self at the altar of the ideal. When the altar itself is sacrificed. Those wavy lines, the negligence of the horizon. Giving way to a cracking sound, the symphony of the withdrawal into force. Calm, those lights that exaggerate the sweetness of the plinth's stature. The magnitude that soggens a little, impelled by the rays, sinking yet further into the ground's surface deception down below ...

Thank you for your support.

gg^LLin ►■ ajL$a ℂaᵭ

First he got high enough to taste the ceiling. Poster announces live murder onstage. The city is a wild animal—voice of the police broadcast on shortwave frequency. Paranoia wears leopard-print pants. My friends address me as asshole. They told me I once belonged somewhere. So I let them follow me. Only to find the streets were lined with saliva: pizza by the slice.

Drunk saturation mobility. You love him more than you drink. Sally Salacious sings the boyfriend medley, no one will get in her way. Everybody competing to get heard. Repeat it hard enough and they'll all go away.

I am here together with you, hairless and honest. Is that her real voice? The Hair Goddess. Coprophiliacs on parade. My life as a follower.

Maybe you forgot to put your arm around her at the right moment. Lead the children down the toilet of your thoughts—all the rats that once offered a definition. And the black-haired girl who just wanted a daddy. Even went on the daytime talk show beside him. Cancer rains down like garbage in the streets. This is a story of New York City.

I was always the one to be prepared. On time every time, the voices. Puerto Ricans playing soccer in the cage. If I can't wear women's clothing I'd rather go naked. But no the men in blue will get you. Don't get feces on my leather jacket; I am walking down the street.

Everybody talk at once please, I love it when that happens. Houston Street has gone to the pilgrims: this is what their children smell like.

They named him Jesus Christ.

Oh, death is such a non-spectacle at times. Whether in the jungle of cities or the desert of thought. I'm the living switchblade, sandwich-breath, syphilis on the docks. He stepped over a transparent Braille Bible on his way southward aiming for the towers.

Borders never disappear; once trespassed, they are merely reset. A video-game version of blood.

His brother fucked off into a bottle of whiskey. Man those girls were haunted. Song of certainty goes like this. Look into my eyes and extract an emotion. Let it be known you can never think fast enough. The law doesn't require tennis shoes.

Can you play my favorite song. The concert consisted of two songs and a punch in the face. Most of the audience had already run away by the time he shit on the floor, the sound had been turned off. Don't invite violence into your gas station, kids. This is a story of New York City. The day was an ultimate example of one. Let me out into the junkyard. The Hair Goddess is squealing.

That bitch's son got born soon after. She would've named it after him, had she been able to spell his name. Jesus Christ was someone else. There aren't too many white kids around here. He'll have to eat it with salt and pepper.

Things were never so direct, rock 'n' roll. Shadow forecast, then night-fall. I wanna go to Drugland before it gets too dark to think it through. This makes the sixteen-year-old beside me snicker. I've met her father, I know what she's looking for.

Life would be so much easier if you could fry it. Next week I'll go down south with my boys there, record an album. With my brother I'm gonna tour Europe soon. Plans are underway. No, I don't speak no German. They can jail me but they can't jail hate. He was a worth-less son of a bitch. Get these motherfuckers away from me, we can't bring them all with us. There's a taxi, I'm going uptown. I don't want to go to Brooklyn.

Dimensions variable

There was a world and it was a place that could hardly be measured, as its contents were gestures with living objects attached.

A revolving door is made of things moving. Those things are people. The faces on them as the wood the paint on an actual door: a movement without expression. A blocking out of emotion a becoming-utilitarian, an engine or a part of one, a one that is pulling apart and coming together again. A door … Movement might mimic the march of soldiers. Body-barricade this porous thing. Could there be a world without man-made barriers? Philosophy is thinking about thinking; art is the thing that imagines imagining.

That clock doesn't know what time it is. All these, I don't know. The references aren't embedded, they hurt too badly. Its hands going everywhere, and why do we let them. It is because we want Time to make a symphony. The clock hands are like the conductor's hands, and we have already run out of it: Time …

Give in to the language of breath and feeling, rather than intellect and knowing.

Enter the room the flowers white. A phrase on the wall. Objects speaking with a pornographic insistence. Tripping over the rolled-up carpet, scream, "The TV's broken!" There is an art inside that carpet, but you can't see it. Maybe even mites. TV forgot to have an image. You want to watch your stories. There are no stories here.

Plastic flowers never get to know what time it is. That means they're wanting something all the time, looking pretty. Real flowers rot and know no innocence. Process akin to World without replenishment. Fill a vase with water made of plastic.

That porno vase the holes and erections covered up with blue dots. A collaboration with some absent censor. Now you are safe you don't have to look at the organs. I am the fake fluid that resides inside the container. A fluid with eyes. The dots are feelings, craving release. Follow the barricade of bodies ringing the rim to discover the whole.

It is as though everyone had a gesture and each had their moment to hold it up. Only that moment was a space and ... everybody had one, it is true.

There is stuff on the wall and there is stuff on the floor and there is matter and there are accidents also. A frame of mind, and each person who enters is both container and contained. There are pairs and arrangements. Messages. A thing writ upon a wall, a suggestion: LOOKING IN ALL THE WRONG PLACES. That is useful. The message will soon be erased, and another to take its place. Feeling can be voided also. In this sense, the wall is a robot. Reprogrammed by a mysterious human process each day, every day a new becoming. When you see it anew, falter. The ribbons outside, fluttering.

The eroticism of an object that can't move or be defined. Seems ... The wall writes itself. A poem of endings, poem that forgot that there ever was such a thing as a beginning: never again, for the last time, ever again, for the first time. That first is last. There is sentiment and it is almost upon the ceiling. Saving grace is that there is no heaven to call home. A masterpiece of going and movement. That human door moves across the floor.

To have a genuine interest now is very nearly a revolutionary thing. A thing is an object, round, next to it is the cosmos. Cosmos stone.

To be written is creation. A series of definitions. Blueprint of that flat that nearly got exploded. Memorial to a memory, a lived and lived-in space that spontaneously disappeared. Will these walls remember when they are gone.

A pile of books sitting upon a chair. One of them announces itself: Regarding the Pain of Others. Regarding always a hierarchical reduction. These books are people, a revolving door, they will never stop going. A zoo where you can take the animals home with you.

My memory translates everything into something else. Regarding the pain of others. White cube piñata sprayed! Rectangles and ribbons, shiny plastic lollipops for stabbing someone's eyeball out, gay homosexual confetti. The room has a purple thing to its edges. But look at all the pretty ribbons!

Wanting to go where something is pure and there is none nothing anymore. Two clocks parked next to each other upon the wall're supposed to be perfect lovers but what happens when the battery on one of them dies and the time starts to slow down and eventually both of them will die not knowing what the other is, the time.

The Muslim and the Christian love each other: two warring forms of puritanism, united on a bookshelf. The so-called Islamist and the so-called Freedom Fighter. Ignore the battle scars that force themselves upon the body. The supplement the remainder in a long-division problem. When empathy is the natural result of a lack of understanding.

We pick them apart, slowness, moving.

Let us consider another object. An object in its otherness. A phone is an object for devising and relaying. For lying, also. Now, we write things on it, with it. Messages for ourselves and for other people. Objects can be hard or soft and we use them for deciding the fate of things. The objects we use them to play god. Objects that give a sense of a possible future we mightn't perceive otherwise, other-worldly ... An object that gives us a future and the sky simultaneously. Flags fluttering in the wind, suspended and moving ... An unvexed simultaneity.

Like god, we are estranged from the objects, our own creations. We know at once too much and too little about them. In the mistaken belief that we can think through them, we forget to think of them: the objects in their nakedness. Consideration is always vague, a hilly plateau that is neither ground nor sky—suspension in a middle strata that is agency's victory alone. One god wants to make a hole in the

moon. One option is to turn yourself into a moon. Creation is never complete: we are only (w)hole in our becoming, in our defiance of fluidity's entrapment.

Let us learn a lesson from the thousand contradictions that every relation yields. Let us go on a picnic and commune with the objects ourselves. Each contains many and thus can never really be contained. Yet we crave this illusion of containment, the safety blanket we sit upon to separate our asses from the ground and its chaos of symbols. Pecking order of natural and human-made and human, eroded by indeterminacy of time, the unknowable finite. We get to the top of the summit and there's a bunch of stuff everywhere, furniture and plants. It is like an Ikea showroom: everything is on display. I'm going to go into the other room now, you hear someone say, and then you disappear into the wall.

The rustling of leaves, a thin mist. Every once in a while, a startling emission from the fog machine, though it comes to be expected, like the fat drunk uncle's farts at a family gathering. The colored lights, LED, that make the dimensions variable. What are they there for. A new life in the trees. It is a dance piece. You want to dance with the trees, to feel this alive. Sometimes the trees molest each other. That's what causes the rustling. Tree porn.

There are no positions available. Engagement is by necessity free-lance, impermanence. Value produced by the perception machine, a light froth and the dance that gets undone the moment we step into it. Ribbons dance also; a swirl. The flags are lessons: every nation has its own design. Needing delineation to stave off the implied discomfort of otherness. Put them all together and lo, inside the curve, the soft corner.

Liquids are contained, and then we drink them, becoming the container. But even this is a lie, because what we are in fact are tubes. The liquid passes through us, a liquid derived from a solid, soy, and then we piss out the remnants, and what we keep with us will eventually dissolve also into the closest thing we may have to the divine, the earth with its processes. How's that for a picnic?

That jacket is too big. It must belong to a very wide person. It is okay, because ultimately, it is a thing that belongs to no person. That is what makes it an instance, an art. The jacket expanded over a very wide OMG void. Jacket becomes a river across that chair, and the only thing that flows is our fantasy of the fabric.

What happens when a hill disappears? It's like the earth, once pregnant, has had an abortion. Now memories instead of fears. There is a place called Hong Kong. It is a place that is many things: a city,

a territory, an island, a series of islands, a semi-autonomous zone, yet still part of a bigger country. A country it does not all the way identify with. Something happened; flag confusion; those hills. If there were an island reserved solely for color-blind people, would they be able to find it on a map? On an island, people learn self-reliance.

"No Positions Available" and yet "Negotiation": two signs that oppose and complement each other. Each other is a dismal implication that a break is on the way, a break that offers a possibility in the second case, a denial both actual and perspectival in the first. One door closes, another opens. A revolving ballad of forms, with the faint promise of a tube that allows us to see inside the machine's workings.

Can it be that exhaustion is the ideal state? When a train goes off the rails, it is like a reply to something, a moment for reflection. A blunt stasis imposed by the regimen of "accident," now made so commonplace by the frenzy of the news cycle. The map is overflowing with dots, it becomes a Color Field painting. The contract a shower of clauses raining down upon us. Those of us in love with the void resigned to settle for art instead. We are in the gallery of thought. In the marketplace, crossed out by red and blue lines. There are no available positions; dimensions variable.

Sometimes art happens in liquid format. Not just rivers, but fountains of tea. To be cleansed is naive thinking, and thus belongs to the domain of religiosity. A stack of colors proselytizing. Wear a boat on your head the next time you go to the market. This will help the negotiation, especially if it begins to rain.

We were all content superseded by chance. Here in this room you can do another dance. For your partner, choose from a creature made of nickel or one made of brass. That way, your partner jingles out the rhythm as you move, so there's no need for music. I will play you a song anyway—four minutes thirty-three seconds long and too light to hear. Music can exist on paper also. A blueprint for a sound not meant to be heard. Look at that sound. Proves there is always something.

Once inside, chains decide. You can lock yourself in, but world leakage is the silent inevitability. This is the end: my only friend.

Up close, a door is a wall. Think of public space as an intended blockade to interiority. The definition is in the mapping; too many thoughts. Once cordoned off, we give way to the simple action, the turning of the handle. Know everything there is to know about a single surface, you will no longer be able to see it. Coming Soon, the sign blazes in the near-far. Sometimes even blank surfaces need their subjectivity, while at others, we require the luxury of release from sensation.

A place to sit and a place to stand. Some places for neither. The girl walked for a very long time, she forgot she was supposed to be in a marathon. Will time do its thing to us, for us? Inevitably. Time is nothing to be a part of.

Found in the re-creation. The people in the unactual photograph exude a thereness. Scratching her back inside the photo, she no longer belongs to the past. She doesn't need a prompter to tell her. She was made to be seen.

What is this belonging. In the middle of the desert, time loses its supposed dignity. Each time breath comes, we get closer to that desert.

Coming soon.

Against Unity

The world had its own ideas once, and now it has run out of them. This is why we love it so: it's alive. An animal, to be sure, and lodged in the free-floating that is an apparatus we might grasp on to even while it is eating us raw.

Our virtues had been forgiven and forgotten, a place on the strand offered to us, whence we might withdraw, unblemished by the limits of our placedness. A stance from which we might shout. Hardened generation of time's siftliness.

He saw himself as a river, and that is how it got introjected. Introjection is projection backward, internal. Spines with strings attached, suspended from clouds. The sun gets injected into the brain.

It takes an entire lifetime to learn how to dream properly; in the meantime, we have the violent act of translation to carry us. The inadequacies. There is a corollary to lust here that remains perennially unexplored. Were we to traverse the possibilities, crossing them out one by one as we trespass our way through them—suddenly yr foot is stuck in the sand, so deeply there is no choice but to detach it from yr body—the process completes itself just as the shore empties of its human occupiers. Yr time, you learn eventually, belongs to the machinery of someone else's longing; the "other" is all those who endeavor to convey yr meaning.

You immerse yrself in the task of definitionality: the splatter-spatialization of all languages, human and other. The symbols with their intentions, bleeding all over the climate. Two figures: Hermes Hermaphroditus. (Splatter-*Sprache*.)

We are confronted with a map of the present and it frightens us into being, a cartography too real, because within its coordinates a photographic likeness of all our mistakes has been implanted and the green of the poisoned skies hums its radiated forecasts at us—the sort of dream that won't allow you to sleep. The body without unity. Shattered glances that become a pool for the spectators to swim in— the spectatorial pool … And now, the grayness has returned to the sky, marking out a familiarity—a rat-object known by all the rest for the shrill of its squeals. Pretty soon it will swallow what's left of us. (Ode to a poet who was recently swallowed by death.)

And then time was little more than the matter the substance that we would have forgotten had we not all been there counting wasting away the idle hours that knew no heroes only the losers among us could ever succeed at fathering up to speed the low-level countenance that was, at best, a present to the heart … but too many people had had their excitement driven out of them by outside forces whose voices resounded a basso profundo an allegiance to the absolute bottom, yeah that was the thing we thought we knew when it mattered to be a collectivity, the thing to be asserted—and me, I was lost before I even got a chance to find myself, a ceramic object submerged in the sand—found by someone else, the stranger, the bomb, the loss, what was left of the feeling of love …

There are two artists in the mindeye of the socius's inner rot and only two, but projection and introjection infrequently collide, and then the work that bursts out of it is an animal, and the sand I am walking upon is more alive than the foot I gave birth to in the urethral splat of godliness that is lacking a proper name.

"This is truly the life force," she said, but she was looking at someone else. He had a vagina that looked just like hers, and someone took a bath in it, there were marble ruins all around, a police officer arrived midsubmersion to inscribe an antisignature into his labial folds in a language that cannot be spoken.

The lexicon consisting wholly of ambivalences. In the village whose entire architecture was constructed from word formations, its inhabitants pathologically illiterate.

Which language are you currently speaking. As I stare out at the world, the language floats away. A self-broadcasting that floats. That floods. Here, on the other side of the void. In the land made of orifices. The ground swallows you as you are walking. The ground is made of god. Absent father who put you here without celebrating. Preselection, to be drawn upon: worldvoid. To die without thinking what's coming next. Without thinking.

Why can't life perspire in the same way I do—because there's no true freedom, that's why—this neoromantic cult of the lost macho adolescent, sexless and private in his guise—arid sounds that can't be unhatched because the shell is shattered. Fear that you might one day run out of things to die for.

What is death but a person to go inside, another species.

There is an animal inside that speaks to me in the rot's language. When I stand in the sand and hear the sirens shrieking, I will take off all my clothes and become an inanimate object for you.

Life has meaning insofar as it eats our fears for us while we're standing in the sand dreaming. Were we to translate the sky into a language you might recognize, would you actually take the time to read it?

For some, research entails staring at a blank white wall until it collapses.

Represent one kind of freedom and it is there there before you you are dying a large stone a rock having replaced yr foot and the desire to escape the knowledge that you can no longer be a part of this and everyone out there, they all want a thing from you a thing you are tired of giving, and so why go on living you ask yrself but no, perhaps that's not it either and there you are lost once more and there are children everywhere, the dispersal, mixed variables scattered about—

At the end of the sun, the rain, stars raining down upon all yr fears, an ideological snowstorm of fuckography, this is not me I am not the

entirety that spells out that forms a riverscape for me to collect my weepery, yeah a giant genital forecast me on top of the world and no more lies, no more victors, who is there now to represent our fears.

Faciality is a graveyard you can swim in. The corpses all boats of joy.

Inanimacy as the liberating factor. In the days before gender.

The hermaphrodite came over to map me. But ended up getting mapped instead. The void was made of paper. The better to make ashes with. Erasure happens on so many levels, one has to do little more than breathe before awareness kicks in.

There's my name in another language. The ache of definitionality. I want to own this day so bad. So tell me why I am speaking—to deliver a message?

Me in countless versions, the language of the multiple—my selves and their inherent otherness—I as an army of ghosts, I as a flood. I framed while simultaneously leaving the container: anti-signature.

The river bled into a sea. Actually, the sea feeds the river. The key to all this being the way in which we fall. The bottom-up direction, the reverse spill. Staring at the world is great; it makes nothing happen so lightly. Without force, speculation becomes a constancy; it never ends. Never wanted a body—just a presence. A heart so fuckless as to be pure.

Wake up in the haze of days, yearning to be an escaper. Dog with three heads won't let you. He's all quantity, no qualities. Outwit hermetic dog-god, be humanity's savior. It's not just a fantasy. We aren't the products of the sunless world, the endlessness of time, the triumph of the unknowing, the light that knows no time. All the seeming that goes into each effort. Erased by a cloud of ink while three heads bark in simultaneity. Whinnying lightness: a horse that floats. Air is like water—each time you breathe, you drown …

Wash the blood off yr meaning.

My god is a dead fucker whose face has wheels on it. You need something from me? I'm gonna teach you how to be the universe's whore. I don't want something; I own it. No and not really; both at once. When I was a serpent, the gods were after me constantly. Yeah, I had an entire army of unknowing backing me up. Performing raids on the superfluity of the quasi real, which is clogging all the drains. Quit fucking owning me, I will give you a prize. No one really knows for sure how deep to go; the stature of the situation we now find ourselves in. Wrench apart yr claws, the legs of you, to reveal the entrapment of the ideal. Every sex act is a mapping of the impending era that has arrived in order to be destroyed.

A Symmetrical Tattoo

If you want a small taste of my mind, open up your eyes just a bit wider, until your eyeballs fall out of your head and perhaps land in the bowl containing your morning yogurt: that's what I want my new tattoo to look like. Not a representation or a design, but an experience. The path we strive to discover, we ache until we find it. When we do find it we see it is the wrong one, and have been mistaken all this time …

Can you make it a sort of splat? I ask my tattoo artist. I can tell from his expression he has no idea what I'm talking about. Splat is a word for which you must have a very high comprehension of the English language. My tattoo artist is from Switzerland.

My cat stares. He is looking at that empty blot of skin where the tattoo was supposed to go. What is he thinking. Cats understand absence. Blot, splat. My life as an extended series of special effects engineered by some Hollywood master.

We like to think of collectivity as something mattering, I hear someone say in the next room. I think the radio's been left on. There is an empty space on my body, so I write on it. Write words, detached, meaningless words, just to fill the space. You write for one reason and one reason only: out of dissatisfaction with all the other writing out there. A ridiculous claim, and yet not: how else to explain that inner restlessness that leaves you reading all the time, throughout the day, six or seven books at once, just one like a normal person would do is

never enough, the ache is a hunger, horniness is a disease, there are too many cops on this island and not enough killers to make it interesting or worthwhile—there I go digging up meaninglessness again.

I go over to the desk, I touch the device, I open up the music folder. Some mystical dings dong out. Ding, blot, splat. Some avant-garde composer I'd never heard of before, an article in an art magazine told me to download him. Now he is in my living room and attempting to take possession of my body, my body is resisting. Sometimes I forget to have a soul. That's because I exist in a sort of permanent nighttime in order to avoid the hostile forces that would squelch my existence were I to flaunt it during the day. My tattoo artist works at night also. There's something about people who avoid sunlight at all costs. As though allergic. It's like going into a thought-dream and staying there for a very, very long time. Shadows on the wall form a vision: pig lungs, I say out loud. Cat's head perks up. The tattoo must be symmetrical, the tattoo artist tells me. I only do symmetrical tattoos.

He was very proud of his symmetry, and that's because he came from Switzerland. He wanted to go into a mountain and die there, like some Chinese literati painter in a century far away from ours. He wanted to tattoo an entire landscape across a pig's behind, but whenever he tried, both sides were never equal. Razor-sharp images often x'd out his vision, so that all he could see was the ink and no skin beneath, the person he was cutting into said ouch. He wanted the sky to have razors for clouds. Time as a liquid that spills from a broken bottle onto the floor of the kitchen that other room where the detached voices, whispering unknowns, come from. If I could burn a hole in the wall separating here from there, the hole would be in the shape of pig lungs. My cat is an animal that taught me how to breathe. Here I sit with my ding-dong-splat in the space of no-writing.

Acknowledgments

To Ping, my husband, for the constant inspiration;

to the Arts Writers Grant Program of Creative Capital | Andy Warhol Foundation, whose funding helped me complete this book;

to the present and former faculty in Critical Writing at the Royal College of Art, where some of this material was developed for my PhD thesis: David Crowley, Brian Dillon, and Jeremy Millar, and to my external examiners, John Russell and Jean Wainwright, for their helpful comments;

to Tess Edmonson for copyediting the manuscript;

to the fantastic and razor-sharp staff of Sternberg Press for the utterly enjoyable and stimulating process of transforming the manuscript into a book;

to my friend and agent, Miek Coccia;

to Mario Dzurila for his superb design work;

to Kevin Killian for introducing me to George Kuchar in San Francisco;

to all the subjects of these essays, especially those who are no longer around to read them—and most of all George Kuchar and Christian Schoeler, the memories of whom I continue to cherish. Here's to immortality.

Bibliographic Note

Nearly all of the previously published pieces in this book underwent at least minor cosmetic changes, while the vast majority of them were heavily reworked. Titles of pieces are usually the first thing changed by an editor, and in most instances, earlier versions were published under a different title. In the case of some pieces, material that was cut for whatever reason has been restored in this book. To the best of my ability, redundancies have been eliminated. In the case of some pieces, texts, notably on James Benning and Bjarne Melgaard, I had written on their work on more than one occasion, and, for this collection, edited material from those numerous instances into a single piece.

I am grateful to all of the editors and publications who played a formative role in this collection through commissioning and working with me on earlier versions of these texts.

"Fail Better" was published, in slightly different form, in *Review of Contemporary Fiction* 31, no. 1 (2011).

"Zombie Criticism" was published in *Spike Art Magazine*, July 2015.

"The Language of the Toilet" was published in the anthology *The Bodies That Remain*, edited by Emmy Beber (Punctum Books, 2018).

"Imploding the Frame" was originally published in the Polish in *Museum of Contemporary Art Krakow Forum*, and later appeared in the anthology *Moving Image*, in the Documents of Contemporary Art series (Whitechapel Gallery, 2015).

"Becoming Sobject" was published in *Don't You Know Who I Am? Art after Identity Politics* (Museum of Contemporary Art Antwerp, 2014).

"Frankenstein Figuration" appeared in the exhibition catalogue *Winston Chmielinski: Whole Is a Hand That Shakes* (Galerie Thomas Fuchs, 2015).

Parts of "Trance Cinema" appeared in two different pieces for *Ran Dian*, 2016, and *Artforum*, 2014.

"Forever Okay" appeared in a brochure published on the occasion of Jimmy DeSana's exhibition at Wilkinson Gallery, London, in 2013.

"Walden" was commissioned for the exhibition "Jonas Mekas: The Fluxus Wall," BOZAR, Brussels, 2013.

"Goddess in the Machine" appeared in *Afterall* (Spring/Summer 2016).

Extracts of "Splat" appeared in *Artforum* in 2015.

"Reading Capital in Venice" appeared in *Art in America*, September 2015.

"The Object" was a limited-edition chapbook published by 2nd Floor Projects, San Francisco, as part of the 2016 exhibition by Dietmar Lutz and André Niebur. Another version appeared in the anthology *A Solid Injury to the Knees*, edited by Maya Tounta (Rupert, 2016). It first appeared in the Whitney Biennial 2014 catalogue (Yale University Press, 2014).

"Carbs" appeared in the exhibiton catalogue *Helen Marten: Drunk Brown House* (Cornerhouse Publications, 2016).

"Plinthsplat" appeared in the catalogue to accompany the exhibition "Mike Nelson: Again, More Things (a Table Ruin)" (Whitechapel Gallery, 2014).

"GG Allin Hails a Cab" was commissioned by *3:AM Magazine* in 2009 for a series in which writers were invited to pen a fictional text for a YouTube video of their choice; I selected a video documenting GG Allin's final concert and its chaotic aftermath in New York City, which was shot on handheld VHS camcorder just hours before he died of a heroin overdose.

"Dimensions Variable" appeared in the anthology *End Note(s)* (Witte de With, 2015).

"Against Unity" was commissioned for the exhibition catalogue *Michael Müller: Who's Speaking?* (Hatje Cantz, 2016).

"A Symmetrical Tattoo" appeared in the anthology *Stationary Stories* (Spring Workshop, 2015).

Bibliography

I. Bad Writing

Fail Better

Baselitz, Georg. "'80s Then: Georg Baselitz." Interview by Pamela Kort. *Artforum*, April 2003. https://www.artforum.com/print/200304/georg-baselitz-4475.

———. Interview by Jean-Louis Froment and Jean-Marc Poinsot. In *Georg Baselitz; Collected Writings and Interviews*. Edited by Detlev Gretenkort. London: Ridinghouse, 2010.

Cole, C. Bard. *This Is Where My Life Went Wrong*. Berlin: BLATT Books, 2009.

Foster, Hal. *Bad New Days*. London: Verso, 2015.

Godard, Jean-Luc, dir. *JLG/JLG – Autoportrait de décembre*. Gaumont, 1994.

Hughes, Robert. "The Artist as Entrepreneur." *New Republic*, December 14, 1987. https://newrepublic.com/article/105864/the-artist-entrepreneur.

Indiana, Gary. *Last Seen Entering the Biltmore: Plays, Short Fiction, Poems 1975–2010*. Los Angeles: Semiotext(e), 2010.

Mayer, Bernadette. "The Obfuscated Poem" (1983). In *Postmodern American Poetry: A Norton Anthology*. Edited by Paul Hoover. New York: Norton, 1994.

Nietzsche, Friedrich. "Why I Am a Destiny." Translated by Walter Kaufmann and R. J. Hollingdale. In *Philosophical Writings*. Edited by Reinhold Grimm and Caroline Molina y Vedia. New York: Continuum, 1997.

Shivani, Anis. "The 15 Most Overrated Contemporary American Writers." *Huffington Post*, August 7, 2010. https://www.huffingtonpost.com/anis-shivani/the-15-most-overrated-con_b_672974.html?guccounter=1.

Zombie Criticism

Genet, Jean. *The Studio of Giacometti*. Translated by Phil King. London: Grey Tiger Books, 2014.

O'Reilly, Sally. "On Criticism." *Art Monthly*, May 2006. https://www.artmonthly.co.uk/magazine/site/article/on-criticism-by-sally-oreilly-may-2006.

Saltz, Jerry. "Zombies on the Walls: Why Does So Much New Abstraction Look the Same?" *Vulture*, June 17, 2014. http://www.vulture.com/2014/06/why-new-abstract -paintings-look-the-same.html.

Stein, Gertrude. *Matisse Picasso and Gertrude Stein with Two Shorter Stories*. Barton, VT: Something Else Press, 1972.

Bad Writer

Deleuze, Gilles, and Félix Guattari. *What Is Philosophy?* Translated by Hugh Tomlinson and Graham Burchell. New York: Columbia University Press, 1994.

Dydo, Ulla E. *Gertrude Stein: The Language That Rises 1923–1934*. With William Rice. Evanston, IL: Northwestern University Press, 2003.

Flaubert, Gustave. *Letters of Gustave Flaubert, 1830–1857*. Edited and translated by Francis Steegmuller. Cambridge, MA: Harvard University Press, 1980.

Gass, William H. "Gertrude Stein and the Geography of the Sentence." In *The World within the Word*. New York: Knopf, 1978.

Greenberg, Clement. *The Collected Essays and Criticism*. Vol. 1. Chicago: University of Chicago Press, 1988.

Hejinian, Lyn. *The Language of Inquiry*. Berkeley: University of California Press, 2000.

Hemingway, Ernest. *A Moveable Feast*. New York: Charles Scribner's Sons, 1964.

Martin, Agnes. *Writings*. Edited by Dieter Schwarz. Ostfildern: Hatje Cantz, 2005.

Mellow, James R. *Charmed Circle: Gertrude Stein & Company*. New York: Avon Books, 1974.

Newman, Amy. *Challenging Art: Artforum 1962–1974*. New York: Soho Press, 2000.

Skinner, B. F. "Has Gertrude Stein a Secret?" *Atlantic Monthly*, no. 153 (January 1934).

Stein, Gertrude. *Geography and Plays*. Boston: Four Seas Press, 1932.

———. *The Making of Americans*. Normal, IL: Dalkey Archive, 1995. Introduction by Steven Meyer.

———. "Plays." In *Lectures in America*. Boston: Beacon Press, 1985.

————. *Tender Buttons*. Mineola, NY: Dover Publications, 1997.

Wilson, Edmund. "A Guide to Gertrude Stein." In *Literary Essays and Reviews of the 1920s and 1930s*, edited by Lewis M. Dabney, 874–79. New York: Library of America, 2007.

The Language of the Toilet

Hoy, Dan. "The Virtual Dependency of the Post-Avant and the Problematics of Flarf: What Happens When Poets Spend Too Much Time Fucking Around on the Internet." *Jacket*, no. 29 (April 2006). http://jacketmagazine.com/29/hoy-flarf.html.

Magee, Michael. "The Flarf Files." Electronic Poetry Center, August 2003. http://writing.upenn.edu/epc/authors/bernstein/syllabi/readings/flarf.html.

Mesmer, Sharon. *Annoying Diabetic Bitch*. New York: Combo Books, 2008.

————. "I Wanna Make Love to You on Mission Accomplished Day." In *Postmodern American Poetry: A Norton Anthology*. Edited by Paul Hoover. New York: Norton, 2013.

Mohammad, K. Silem."Yankee Doodle Fuck Machine." Flarf Festival 2008, April 20, 2008. http://flarffestival.blogspot.com/.

Sullivan, Gary. "A Brief Guide to Flarf Poetry." Poets.org, February 14, 2011. https://www.poets.org/poetsorg/text/brief-guide-flarf-poetry.

————. "Grandmother's Explosive Diarrhea." Flarf Festival 2008, March 9, 2008. http://flarffestival.blogspot.com/.

Watten, Barrett. "How the Grand Piano Is Being Written." Wayne State University, Department of English website, May 11, 2007. Link discontinued.

Žižek, Slavoj. *The Plague of Fantasies*. New York: Verso, 1997.

Frame Fetish

Alberro, Alexander. *Conceptual Art and the Politics of Publicity*. Cambridge, MA: MIT Press, 2003.

Barthes, Roland. "The Death of the Author" (1968). In *Image, Music, Text*. New York: Hill & Wang, 1977.

Drucker, Johanna. "Beyond Conceptualisms: Poetics after Critique and the End of the Individual Voice." *Poetry Project Newsletter*, April–May 2012.

Freud, Sigmund. *The Interpretation of Dreams*. New York: Barnes & Noble, 1994.

Fried, Michael. *Art and Objecthood: Essays and Reviews*. Chicago: University of Chicago Press, 1998.

Goldsmith, Kenneth. "Conceptual Writing Was Intriguing and Provocative." *Harriet* (blog). Poetry Foundation, April 2, 2012. https://www.poetryfoundation .org/harriet/2012/04/conceptual-writing-was-intriguing-and-provocative.

———. "Conceptual Poetics." *Harriet* (blog). Poetry Foundation, June 9, 2008, https://www.poetryfoundation.org/harriet/2008/06/conceptual-poetics-kenneth -goldsmith.

———. *Soliloquy*. New York: Granary Books, 2001.

———. *Uncreative Writing: Managing Language in the Digital Age*. New York: Columbia University Press, 2011.

Lee, Sueyeun Juliette. "Shock and Blah: Offensive Postures in 'Conceptual' Poetry and the Traumatic Stuplime." *Evening Will Come: A Monthly Journal of Poetics*, no. 41 (May 2014). http://www.thevolta.org/ewc41-sjlee-p1.html.

Silliman, Ron. "Kenneth Goldsmith." Electronic Poetry Center, February 27, 2006. http://writing.upenn.edu/epc/authors/goldsmith/silliman_goldsmith.html.

Sontag, Susan. *Where the Stress Falls*. New York: Vintage, 2001.

Warhol, Andy. *a: A novel*. New York: Grove, 1968.

Imploding the Frame

Krauss, Rosalind E. "Sculpture in the Expanded Field." *October*, no. 8 (Spring 1979): 30–44.

Lauterbach, Ann. *The Night Sky: Writings on the Poetics of Experience*. New York: Viking, 2005.

II. Expressionisms

The Pervert's Diary

Deleuze, Gilles, and Félix Guattari. *Kafka: Toward a Minor Literature*. Translated by Dana Polan. Minneapolis: University of Minnesota Press, 1986.

Guyotat, Pierre. *Coma*. Translated by Noura Wedell. Los Angeles: Semiotext(e), 2010.

Finch, Mark. "George Kuchar: Half the Story." In *Queer Looks: Perspectives on Lesbian and Gay Film and Video*. Edited by Martha Gever, John Greyson, and Pratibha Parmar. New York: Routledge, 1993.

Fiske, Courtney. "Critic's Picks: 'Dieter Roth. Björn Roth.'" *Artforum*, February 2013. https://www.artforum.com/picks/dieter-roth-bjoern-roth-39361.

Kraus, Chris. *Video Green: Los Angeles Art and the Triumph of Nothingness*. Los Angeles: Semiotext(e), 2004.

Kuchar, George, and Mike Kuchar. *Reflections from a Cinematic Cesspool*. New York: Zanja Press, 1997.

Lerner, Jesse. "Storm Squatting at El Reno." *Cabinet*, no. 3 (Summer 2001): 66–67. http://www.cabinetmagazine.org/issues/3/stormsquatting.php.

Morse, Margaret. Introduction, *Weather Diary 1*. Video Data Bank. Accessed January 31, 2019. http://vdb.org/titles/weather-diary-1.

The Everything Artist

Barthes, Roland. "The Death of the Author" (1968). In *Image, Music, Text*. New York: Hill & Wang, 1977.

Deleuze, Gilles. *Pure Immanence: Essays on a Life*. Translated by Anna Bayman. New York: Zone Books, 2001.

———. "W for Wittgenstein." Disc 3, *Gilles Deleuze from A to Z*, DVD box set. Directed by Claire Parnet and Pierre-Andre Boutang. Los Angeles: Semiotext(e), 2011.

Deleuze, Gilles, and Félix Guattari. *What Is Philosophy?* Translated by Hugh Tomlinson and Graham Burchell. New York: Columbia University Press, 1994.

Dobke, Dirk, and Bernadette Walter. *Roth Time: A Dieter Roth Retrospective*. New York: Museum of Modern Art, 2003. Exhibition catalogue.

Gelber, Eric. "Roth Time: A Dieter Roth Retrospective." *Artcritical*, May 1, 2004. http://www.artcritical.com/2004/05/01/roth-time-a-dieter-roth-retrospective/.

Glozer, Lazlo. "Dieter Roth: The Nomad in His Time." In *Dieter Roth: Unique Pieces*. London: Edition Hansjorg Mayer, 2002.

Jud, Edith, dir. *Dieter Roth*. Filmproduktion Zürich, 2004.

Kimmelman, Michael."Dieter Roth, Reclusive Artist and Tireless Provocateur, 68." *New York Times*, June 10, 1998.

Kuspit, Donald. "Loosening Up: Dieter Roth's Tragedy." *Artnet*. Accessed October 24, 2018. http://www.artnet.com/Magazine/features/kuspit/kuspit3-22-04.asp.

Perl, Jed. *New Art City: Manhattan at Mid-century*. New York: Vintage, 2007.

Roth, Dieter. Interview by Irmelin Lebeer-Hossmann (1979). In *Dieter Roth: Diaries*. Edinburgh: The Fruitmarket Gallery, 2012. Exhibition catalogue.

Sontag, Susan. *On Photography*. New York: Farrar, Straus & Giroux, 1977.

The Anatomy of Melancholy

Butler, Judith. *Gender Trouble: Feminism and the Subversion of Identity*. New York: Routledge, 1990.

Clark, Larry. *The Perfect Childhood*. Zurich: Scalo, 1995.

Freud, Sigmund. "Mourning and Melancholy." In *The Interpretation of Dreams*. New York: Barnes & Noble, 1994.

Greenberg, Clement. *The Collected Essays and Criticism*. Vol. 1. Chicago: University of Chicago Press, 1988.

Rilke, Rainer Maria. *Auguste Rodin*. Mineola, NY: Dover Publications, 2006.

Schoeler, Christian. "Christian Schoeler Reinvents Ideas of Masculinity." Interview by Francesca Gavin. *Dazed & Confused*, October 2008.

Frankenstein Figuration

Deleuze, Gilles, and Félix Guattari. *A Thousand Plateaus*. Translated by Brian Massumi. Minneapolis: University of Minnesota Press, 1987.

Jeppesen, Travis. "An Ecology of the Primordial: Some Notes on the Paintings of Winston Chmielinski." In *Winston Chmielinski: The Whole Is the Hand That Shakes*. Stuttgart: Galerie Thomas Fuchs, 2015. Exhibition catalogue.

Trance Cinema

Benning, James. "James Benning, The Unabomber, and *Stemple Pass*: An Interview." Interview by Allan MacInnis. In *James Benning: Decoding Fear*. Edited by Peter Pakesch and Bettina Steinbrügge. Cologne: Verlag der Buchhandlung Walther König, 2015. Exhibition catalogue.

————."'You Think You've Been There': A Conversation with James Benning about *Easy Rider* (2012)." Interview by Alison Butler. *Lola Journal*, no. 5 (November 2014). http://www.lola.journal.com/5/benning.html.

Jeppesen, Travis. "On the Road: James Benning's Landscape Cinema." Translated by 王之浩. *Ran Dian*, no. 3 (Spring 2016). http://www.randian-online.com /np_feature/james-bennings-landscape-cinema/.

Walden

Thoreau, Henry David. *Walden; or, Life in the Woods*. New York: Dover Publications, 1995.

Vertov, Dziga. *Kino-Eye: The Writings of Dziga Vertov*. Translated by Kevin O'Brien. Berkeley: University of California Press, 1984.

Goddess in the Machine

Haraway, Donna J. "A Cyborg Manifesto." In *Simians, Cyborgs and Women: The Reinvention of Nature*. New York: Routledge, 1991.

Malik, Suhail. *On the Necessity of Art's Exit from Contemporary Art*. Falmouth, UK: Urbanomic, 2017.

Splat

Berman, Patricia G. "Melgaard, Munch, and Scriptophilia." In *Melgaard + Munch*. Edited by Lars Toft-Eriksen. Ostfildern: Hatje Cantz, 2015. Exhibition catalogue.

Melgaard, Bjarne. *A New Novel*. New York: Aschehoug, 2012. Afterword by Ina Blom.

Saltz, Jerry. "Saltz on Bjarne Melgaard's *Ignorant Transparencies*." *Vulture*, October 6, 2013. http://www.vulture.com/2013/10/saltz-on-bjarne-melgaard-ignorant-transparencies.html.

Sjåstad, Øystein. "Phallosophy: Draft for an Art Theory Based on Munch and Melgaard." In Toft-Eriksen, *Melgaard + Munch*.

III. Fictocriticisms

Reading Capital in Venice

Marx, Karl. "The Fetishism of Commodities and the Secret Thereof." In *Capital: A Critique of Political Economy*. Vol. 1. Translated by Samuel Moore and Edward Aveling, edited by Frederick Engels. Moscow: Progress Publishers, 1887. E-book, 2010.

Biography

Travis Jeppesen is the author of the novels *Victims*, *Wolf at the Door*, and *The Suiciders*, as well as two volumes of poetry and a previous collection of art criticism, *Disorientations: Art on the Margins of the "Contemporary"*. His book *See You in Pyongyang*, about his time living and studying in North Korea, was published in 2018. His essays and criticism have appeared in the *Wall Street Journal*, *New York Daily News*, *Artforum*, *Afterall*, *Art in America*, *Texte zur Kunst*, *Flash Art*, *Bookforum*, *Spike*, *frieze*, and *Mousse*, among others. In addition to his art criticism, he is known as the creator of object-oriented writing, a metaphysical form of writing-as-embodiment that attempts to channel the inner lives of objects. His first major object-oriented writing project, *16 Sculptures*, was published in book format by Publication Studio, featured in the 2014 Whitney Biennial as an audio installation, and the subject of a solo exhibition at Wilkinson Gallery in London. He is the recipient of a 2013 Arts Writers Grant from Creative Capital|Andy Warhol Foundation for the Visual Arts and has taught as a visiting lecturer in the Critical Writing in Art & Design MA program at the Royal College of Art, where he completed his PhD in 2016. His calligraphic and text-based artwork has been the subject of solo exhibitions at Wilkinson Gallery, London; Exile Gallery, Berlin; and Rupert, Vilnius. Jeppesen teaches at the Institute for Cultural and Creative Industry at Shanghai Jiao Tong University.

Travis Jeppesen
Bad Writing

Published by Sternberg Press

Managing editor: Niamh Dunphy
Copy editor: Tess Edmonson
Proofreading: Zoë Harris
Design: Mario Dzurila
Printing: Tallinn Book Printers

All artwork by Travis Jeppesen

ISBN 978-3-95679-410-0

Distributed by The MIT Press,
Art Data, and Les presses du réel

Sternberg Press
Caroline Schneider
Karl-Marx-Allee 78
D-10243 Berlin
www.sternberg-press.com